European Aestheticism and Spanish
American *Modernismo*

European Aestheticism and Spanish American *Modernismo*

Artist Protagonists and the Philosophy of Art for Art's Sake

Kelly Comfort

palgrave
macmillan

First published 2011 by
PALGRAVE MACMILLAN

Palgrave Macmillan in the UK is an imprint of Macmillan Publishers Limited, registered in England, company number 785998, of Houndmills, Basingstoke, Hampshire RG21 6XS.

Palgrave Macmillan in the US is a division of St Martin's Press LLC, 175 Fifth Avenue, New York, NY 10010.

Palgrave Macmillan is the global academic imprint of the above companies and has companies and representatives throughout the world.

Palgrave® and Macmillan® are registered trademarks in the United States, the United Kingdom, Europe and other countries.

ISBN 978–0–230–27809–7 hardback

This book is printed on paper suitable for recycling and made from fully managed and sustained forest sources. Logging, pulping and manufacturing processes are expected to conform to the environmental regulations of the country of origin.

A catalogue record for this book is available from the British Library.

A catalog record for this book is available from the Library of Congress.

10 9 8 7 6 5 4 3 2 1
20 19 18 17 16 15 14 13 12 11

Printed and bound in the United States of America

Contents

Acknowledgments vi

Introduction: Redefining the Role of Art and the 1
Artist at the Turn of the Century

Part I The Artist Avoids "Art for Life's Sake" 23

1 The Artist as Critic and Liar: The Unreal and Amoral 25
 as Art in Oscar Wilde
2 The Artist as Creative Receptor: The Subjective 41
 Impression as Art in José Asunción Silva

Part II The Artist Protests "Art for the Market's Sake" 57

3 The Artist as Elitist Taster: The Unprofaned and 63
 Unconsumed as Art in J.-K. Huysmans
4 The Artist as Creator Not Producer: The Unsold and 73
 Unappreciated as Art in Rubén Darío

Part III The Artist Promotes "Life for Art's Sake" 87

5 The Artist as Dandy-Aesthete: The Self as Art in 91
 Oscar Wilde and Thomas Mann
6 The Artist as Dandy-Flâneur: The World as Art in 115
 Manuel Gutiérrez Nájera and Julián del Casal

Conclusion: Reconsidering the Relationship between 136
Art and Life, Form and Content, Poetry and Prose

Notes 144

Bibliography 163

Index 172

Acknowledgments

To my husband, Diego, and my son, Adrian, I thank you for providing the perfect balance of support for and distraction from work. You make my life so joyous and complete, and no accomplishment would mean anything without the two of you to share it with. I also appreciate the constant encouragement from my parents, my brother and sister-in-law, as well as my entire family and dearest friends.

The comments and suggestions of Anthony Geist proved invaluable to the successful completion of this volume, and I am very grateful for his comprehensive feedback. Additionally, I wish to express my gratitude to Gene H. Bell-Villada, Liz Constable, Eric Downing, Gail Finney, and Ana Peluffo for providing insight and input into various stages of this project. I also want to thank my co-seminar participants from various ACLA conferences over the years, as your own papers and comments have helped shaped the development of this project. I am also very appreciative of Palgrave's editors for their diligent efforts and helpful guidance.

I greatly appreciate the faculty development funding I received from The Georgia Institute of Technology to help me finish this book. I thank my colleagues in the School of Modern Languages for their constant friendship, support, and collegiality.

Finally, the author and publishers wish to make various acknowledgments for permission to reproduce copyright material. Parts of the introduction to this book are based on the author's "Introduction" to the edited collection *Art and Life in Aestheticism: De-Humanizing and Re-Humanizing Art, the Artist and the Artistic Receptor* (Palgrave Macmillan, 2008) and are reproduced with permission of Palgrave Macmillan. Chapter 1 of this book is based on an article previously published in volume 32 (January 2008) of *The Wildean: A Journal of Oscar Wilde Studies* published by The Oscar Wilde Society: "The Critic as Artist and Liar: The Reuse and Abuse of Plato and Aristotle by Wilde" (pages 57–70), and is reprinted with permission. Chapter 2 of this book is based on an article accepted for publication in volume 38 of the *Revista de Estudios*

Colombianos: "The Artist as Impressionistic Critic in José Asunción Silva's *De sobremesa*: Transatlantic Borrowings from Walter Pater, Oscar Wilde, and British Aestheticism," and is reprinted with permission. Every effort has been made to trace rights holders, but if any have been inadvertently overlooked, the publishers would be pleased to make the necessary arrangements at the first opportunity.

Introduction: Redefining the Role of Art and the Artist at the Turn of the Century

In Charles Baudelaire's prose poem "Perte d'Auréole" ("Loss of a Halo," 1862), a poet loses his halo while "hastily" and "abruptly" crossing a busy, cosmopolitan street, which he describes as a "moving chaos in which death comes galloping toward you from all sides at once." Not having "the courage" to pick up the halo from the muddy road, the poet decides "that it would be less disagreeable to lose [his] insignia than to break [his] bones." Yet rather than lament the act of becoming a "simple mortal," the halo-less poet rejoices in the newfound freedom and anonymity associated with his inferior, humanly position in society. Freed from his fetters, he can now "walk about incognito, commit base actions, and give [himself] over to debauchery." And despite the interlocutor's surprise at finding the poet in "a place of ill-repute," we learn that the poet – whom "dignity bores" – feels "quite comfortable" in what is most certainly a brothel. This former "drinker of quintessences" and "eater of ambrosia" has no intention of placing a lost-and-found ad or filing a claim at the police station for the missing aureola. His former insignia, now simply lost property and an exchangeable commodity, will soon belong to someone else, yet the poet "can't help but feel joyful" contemplating the possibility that "some bad poet" will pick up the halo and "impudently set it on his head." In this way, the poet can delight in making someone else happy, especially if it were someone such as "X, or Z!" who could make him laugh and "be funny."

In Colombian author José Asunción Silva's short story "La protesta de la musa" ("The Muse's Protest," 1890), the poet-protagonist does not lose his halo, but rather his muse. "You weren't here ... I didn't

1

hear your voice when writing," the poet says reproachfully to the muse (70).[1] As a result of the muse's absence, the poet gains a new perspective on life and on art and goes on to publish a popular and lucrative book of satire in which he displays "the vileness and errors, the misery and weaknesses, the defects and vices of mankind" (69–70). The poet admits that he laughed while making others laugh and had fun writing his book of mockery. This was something he could not have done under the muse's guidance, since, as he explains: "Muse, you are serious and do not understand such amusement; you never laugh ... Muse, laugh with me ... Life is happy" (70). The muse responds to the contrary, insisting that "[l]ife is serious, verse is noble, art is sacred" (70). She repeats the phrase "oh, desecration!" and asks the poet why he has converted his insults into a work of art (70, 71). By the end of the tale, the poet's initial pride in his satirical work as well as his pleasure in contemplating "the money ... those brilliant gold coins that are the fruit of [his] labor," turn into shame and discontent, as he "glanced with disillusionment at the heap of gold and the pages of his satirical book, and, with his forehead supported by his hands, sobbed in despair" (70, 72). Despite the poet's frequent references to laughter and happiness, then, Silva's tale ends with the image of the sobbing poet who takes to heart the muse's protest of his art. In this way, Silva critiques the productive and profit-seeking artist figure who makes art in accordance with the demands of the market, instead of creating in accordance with his inner demand for high or pure art. Moreover, the Colombian author suggests that the sale of art is the equivalent of the sale of the artist and that both are akin to prostitution.

What interests me about these two representative works from late nineteenth-century Europe and Spanish America, respectively, is the shared concern with the humanization of the formerly deified poet and the profanation of previously sanctified art. Both texts suggest a change in the role of the artist and the character of the artwork, although the former is more celebratory in tone, while the latter is more somber and remorseful. Baudelaire's and Silva's unnamed poet protagonists serve to challenge established notions of art and the artist as sacred, aristocratic, elevated, high, apart, etc. They narrate the situation of the artist integrated into modern life, living among mortals, and participating in industrial capitalist society in a variety of ways: as a man of the crowd, a consumer of flesh, and an exchanger

of property and identities in Baudelaire's tale; as a voice of the masses, a producer of popular art, and a seller of profitable books in Silva's story. Both works register the demythologization of the poet who is emancipated from the tedium and dignity of his formerly poetic self and is now able to feel joyful and happy, if seen in a positive light, or who is declassed from his privileged position in society and turned into a member of the wage-laboring marketplace, if seen in a negative light. Karl Marx's famous contention in *The Communist Manifesto* regarding the change in the writer's role under capitalism is both illuminating and relevant here:

> The bourgeoisie *has stripped of its halo* every occupation hitherto honored and looked up to with reverent awe. It has converted the physician, the lawyer, the priest, *the poet*, the man of science, into its paid wage laborers. … Rank and station dissolve, *all that is holy is profaned*, and men are finally compelled to consider their position and mutual relations with sober eyes. (*Die Frühschriften* 528–9, translation mine, emphasis added).

With regard to Marx's observation, we might argue that Baudelaire clearly concerns himself with the poet's stripped halo, lost rank, and demoted station, while Silva plainly points out the conversion of the poet into a paid wage laborer – either out of economic necessity or because of the absence of a corresponding public for his formerly high or pure art. In "On Some Motifs in Baudelaire," Walter Benjamin interprets Baudelaire's "Loss of a Halo" as a prose piece that demonstrates that "the lyric poet with a halo is antiquated" and presents the poet as a "supernumerary," that is, as someone who is extra or unneeded and serves no particular function (192). Insofar as the text singles out "the decisive, unique experience" of the poet being "jostled by the crowd," it points to "the disintegration of the aura in the experience of shock" that occurs in the modern age ("On Some Motifs" 193–4). In Benjamin's estimation, the poet's loss of his aureole coincides with the total shattering of aura, and thus we might pause to reflect on what it means for art's "aura" to disintegrate at this moment. In his famous essay "The Work of Art in the Age of Mechanical Reproduction," Benjamin discusses the ways in which the aura of a work of art – its authenticity and uniqueness, on the one hand; its "cult of value" and rejection of utility, on the other hand – withers

away in industrial capitalist society as the democratizing and universalizing aspects of modern art replace the ritualistic basis of premodern art. "[F]or the first time in world history," Benjamin insists, "mechanical reproduction *emancipates* the work of art from its parasitical dependence on ritual," and from "the instant the criterion of authenticity ceases to be applicable to artistic production, the total *function of art* is reversed. Instead of being based on ritual, it begins to be based on another practice – *politics*" ("Work of Art" 224, emphasis added). Yet just before it becomes emancipated and adopts its new, political function, Benjamin observes that "art sensed the approaching crisis" and "reacted with the doctrine of *l'art pour l'art*, that is, with a theology of art in which "the idea of 'pure' art ... denied any social function of art" ("Work of Art" 224). The distinction between an asocial and social art, an auratic and non-auratic art, definitely appears to be of concern to Baudelaire, whose halo-less poet protagonist represents the "emancipated" artist living in the crowd and contemplating the changed relationship between art and the artist vis-à-vis modern society, although the ambiguous tone of the work makes it difficult for us to assess with confidence whether Baudelaire prefers the halo-less poet to his formerly crowned self. It is clear that both Baudelaire's and Silva's poet protagonists come to see their position "with sober eyes," and although Baudelaire's poet appears content while Silva's poet's initial joy turns to sorrow and despair, an alternative reading of both works would lead us to question Baudelaire's positive portrayal of the artist as "a man of the crowd" and Silva's privileging of the muse's "art for art's sake" ideal over the poet's "art for money's sake" opportunism. Moreover, both texts drag art and the artist into the realm of life, specifically into the life-world of industrial capitalism. In fact, these two works question the "art for art's sake" ideals that their protagonists seemingly held in a previous point in time before the narration begins. Whether we take these works at face value or intuit an ironic or subversive reading of them,[2] they undoubtedly suggest the emergence of new relationships between the poet and his artwork (i.e., a transition from the creator of art to the producer of commodities) and between the poet and his world (from the sacred and venerated artist to either a man of the crowd or an unhallowed and unappreciated working-class type).

In the transatlantic investigation of European aestheticism and Spanish American *modernismo* that follows, I explore the motivations behind each literary movement's philosophy of "art for art's sake"

and examine a variety of fictional works that address the changing role of art and the artist in turn-of-the-century society. By choosing literary texts that have artist protagonists and that address the question of the "for what" or "so what" of art, and by analyzing those works in terms of the multiple dichotomies of art and life, aesthetics and economics, production and consumption, center and periphery, this comparative study offers new insights into both transatlantic and modernist scholarship. More specifically, the ensuing analysis of the aims and attitudes of different types of artist protagonists in representative literary works from both movements considers the intersection between the artist figure and the impressionistic and creative critic (Chapters 1 and 2), the producers and consumers of art (Chapters 3 and 4), and the aesthete, the dandy, and the *flâneur* (Chapters 5 and 6). It also explores the ways in which the artist figures avoid "art for life's sake" (Part I), protest "art for the market's sake" (Part II), or promote "life for art's sake" (Part III).

In order to understand the implications of the proposed comparison between European aestheticism and Spanish American *modernismo*, it is helpful to begin by outlining the leading characteristics and tenets of both movements. I shall begin with a discussion of aestheticism for three reasons. First, whereas Spanish American *modernismo* is a strictly temporal movement ranging roughly from 1880 to 1910, European aestheticism begins several decades before and extends nearly a century later.[3] Second, as a result of these differences in chronology and extension, it is more plausible that European aestheticism influenced Spanish American *modernismo* than vice versa, although there were, of course, key moments of symbiosis and mutual influence between these two movements, as subsequent chapters will discuss. Finally, I wish to establish the fact that aestheticism's "art for art's sake" slogan also served as a driving force behind much of the *modernistas'* literary production in Spanish America, since both movements are equally intent on establishing and promoting the value and the autonomy of art.[4]

The Characteristics and Tenets of European Aestheticism[5]

Aestheticism – also termed "art for art's sake" or the French equivalent *l'art pour l'art* – is commonly viewed as an attempt to separate art from life, as many authors, artists, and aesthetes consciously elevated art to

a position of supreme importance and to an autonomous sphere of its own. To best understand the defining elements of aestheticism, it is helpful to follow the approach suggested by R. V. Johnson, who treats aestheticism in three different applications: (1) "as a view of art," which he calls art for art's sake; (2) "as a practical tendency in literature and the arts (and in literary and art criticism)" in which the artist does not feel "called upon to speak either for or to his age at all"; and (3) "as a view of life," which he terms "contemplative aestheticism – the idea of treating experience, 'in the spirit of art', as material for aesthetic enjoyment" (12). Let us consider each of these positions.

Beginning with the first classification of art for art's sake as a view of art, the most defining characteristic is the tendency to attach an unusually high value to the form of the artwork as opposed to its subject matter. Style is what matters; it alone determines the quality of a work of art. The particular stylistic proclivities that came to be recognized as distinctly aestheticist include the use of sketches (instead of drawings), suggestion (rather than statement), sensual imagery, symbol, synaesthesia, musicality, aphorisms, fragments, non-linear narratives, catalogs, lists, etc. All of these formal approaches contribute to the overall downplaying of the work's content. In aestheticism, authors and artists want to distance their subject matter from "real" and "everyday" life, and they do so by conjuring distant and exotic realms, fashioning fantastic and unreal spaces, and taking on forbidden and taboo themes.

The second categorization of aestheticism as the tendency toward artistic autonomy is best characterized by the call for complete artistic freedom – freedom from morality, from didacticism, from convention, and, as the previous paragraph suggests, from the responsibility of realistically representing reality. As Robert C. Olson accurately explains, aestheticism served as an alternative "to prevailing utilitarianism and moralism," since the aestheticist artist was protesting "against literature's being used to teach lessons, against art as political, religious, or social propaganda" (60). In contrast to the commonly accepted and long-standing view that literature (or any other art form) is meant to hold a mirror up to reality, aestheticism purports the contrary and argues either that reality as a subject matter should be avoided or that life ends up mirroring (i.e., copying) art, rather than the other way around. Moreover, aestheticism embraces the idea that literature should lack all extra-literary

purposes – be they moral or social – since its sole objectives are to be beautiful and to give pleasure. In this way, art for art's sake consciously avoids the alternative of "art for some other sake," especially the notion of "art for life's sake," since art and the artists should not be concerned with "life" insofar as realism, didacticism, morals, or ethics are concerned.

To understand aestheticism of the third kind, namely as a view of life instead of a view of art, or as what Johnson calls "contemplative aestheticism," it helps to consider the position adopted by many nineteenth-century aesthetes and dandies (and then revisited in a variety of ways by supporters of twentieth-century movements such as formalism, camp, and deconstruction). What emerges *in art* as the self-contained and self-sufficient artwork manifests itself *in life* in the figure of the solipsistic aesthete or dandy who creates himself in a similarly conceived form of artistic expression and chooses an equally unique and independent existence. Dandies and aesthetes likewise place great importance on formal features, on surfaces, and on appearances. They elevate art "to a position of supreme – or even exclusive – importance in the conduct of life" and willingly subsume all aspects of life into the sole criterion of artistic beauty and pleasure (Johnson 12). By consecrating life to the cultivation of art, beauty, and taste above all else, the aesthete's slogan is not so much "art for art's sake" as it is "life for art's sake" or "life for the sake of beauty." Because those who adopted aestheticism as a view of life insisted on placing the aesthetic at the forefront of life, art was promoted as a quasi-religion, as an alternative to the materialist ethic of industrial-capitalist society that undermined the place of art and the artist in the changing marketplace, and this alternative says much about the artist's tenuous relationship with society. Whereas I previously outlined the dominant artistic "styles" common in aestheticism, it is here worth mentioning the prevailing life "styles" common to the aesthete or dandy: elitism (and a critique of bourgeois culture and philistinism); orientalism (and a distaste for the common and ordinary); and, quite often, effeminacy or homosexuality (and a rejection of rigid gender norms and mainstream tastes and sexual orientations).

Because aestheticism emphasizes the formal aspects of art, promotes stylistic innovation, and demands freedom of artistic expression, it has long been interpreted as an attempt to isolate the aesthetic from the human, to divorce art from life. As such, aestheticism has been a

target of critique by those who find fault with its "dehumanizing"[6] tendencies and see it as an amoral, asocial, and apolitical artistic tradition, as "the *inhuman* deification of 'Art'" (Coomaraswamy 42, emphasis added). Yet, whereas the phrase "art for art's sake" is indeed provocative for its dehumanizing potential, so too are the alternatives of "art for some other sake" – art for money's sake, art for fame's sake, art for the nation's sake, art for the sake of politics, etc. I agree with Nicholas Shrimpton's contention that art for art's sake "is not a mark of triviality," since for both artists and critics "it is the guarantee of their professional and intellectual integrity" (15). If aestheticism is a form of "pure art," then its advocates insist that art for some other sake – art with an agenda – makes art "impure" (Guérard 178). I concur with the positions of Shrimpton and Guérard and focus throughout this study on the ways in which the "art for art's sake" motto of both European aestheticism and Spanish American *modernismo* is aimed at preserving "integrity" and "purity" in both art and the artist. I aim to demonstrate that the idea of the aesthetic as an autonomous sphere without relations or obligations to the domains of utility, morality, politics, religion, etc. does not necessarily preclude the possibility that aestheticist works of art and literature critique the societal status quo and undermine its norms of class, gender, sexuality, ethics – to name only its most salient targets.[7] As I will argue, the long-standing tension between art and life that fuels the aestheticist doctrine as well as the general privileging of art over life nonetheless come to constitute a critique of life.

It is worth considering here the fact that two differing critical assessments of aestheticism have long coexisted. On the one hand, there is the tendency to view aestheticism in a negative or at least very limited fashion. On the other hand, there is the possibility of seeing aestheticism in a more positive or more expansive way. The former view is espoused by Peter Bürger in *Theorie der Avantgarde* (*Theory of the Avant-Garde*, 1974); the latter view is argued by Theodor Adorno in *Ästhetische Theorie* (*Aesthetic Theory*, 1970). Let us review both sides of what I term the "Bürger–Adorno debate" on aestheticism's relationship to the avant-garde, so as to understand the extent of this movement's potential for social critique.

Bürger insists that in aestheticism art altogether detaches itself from the praxis of life in order to develop itself as purely aesthetic. For him art for art's sake's "break with society," "progressive

detachment ... from real life contexts," and "correlative crystalliza-
tion of a distinctive sphere of experience, i.e., the aesthetic" come to
constitute the center of aestheticist works of art and literature (Bürger
33, 23). As a result of art's desire "to be nothing other than art" and
to make art "the content of art," aestheticism loses its ability to make
a social impact, since "social ineffectuality" and the functionlessness
of the aestheticist artwork stand revealed as its essence (Bürger 27, 49).
Aestheticism interests Bürger, however, on account of its role as "the
logically necessary precondition of the historical avant-garde move-
ments" that protest and position themselves against nineteenth-
century aestheticism, and its call for the autonomy of art (96). Thus,
according to Bürger, the avant-garde, in contrast to aestheticism,
reintegrates art into the praxis of life and marks the beginning of
the self-criticism of art in bourgeois society, while art for art's sake
remains "unassociated with the praxis of men" (96).

In contrast to Bürger, Adorno praises aestheticism as a socially
significant art form in its own right. He celebrates art for art's sake
for its "opposition to society" and its position as "autonomous art"
(Adorno *Aesthetic Theory* 225). He hails aestheticism's ability to
criticize society "merely by existing," since for him what "is social
in art is its immanent movement against society" (225, 227). In
response to what he saw as the "united front," from Brecht to the
Youth Movement, that existed against *l'art pour l'art*, Adorno writes
in a letter dated March 18, 1936 to his colleague and friend Walter
Benjamin that aestheticism is "in need of a defense" and deserves
"a rescue" ("Letters" 122). He finally offers this defense of art for art's
sake in his posthumously published *Aesthetic Theory*, when he states
that "Art's asociality is the determinate negation of a determinate
society" (225). Here we see Adorno assign to aestheticism an impor-
tant function: that of negating the social status quo and imagining
alternative possibilities – not just for art, but for life as well. Because
the aestheticist work of art "posit[s] something spiritual as being
independent from the conditions of its material production," claims
Adorno, it "keeps itself alive through its social force of resistance;
unless it reifies itself, art becomes a commodity" (*Aesthetic Theory*
226). Another way he explains his position is by noting:

> Insofar as a social function can be predicated for artworks, it is
> their functionlessness. Through their difference from a bewitched

reality, they embody negatively a position in which what is would find its rightful place, its own. Their enchantment is disenchantment. Their social essence requires a double reflection on their being-for-themselves and on their relations to society. (Adorno, *Aesthetic Theory* 227)

It should not come as a surprise to learn that Bürger rejects Adorno's praise of aestheticism's break with society and critiques the latter's "repeated attempts to vindicate it" (Bürger 34). For Bürger, art for art's sake cannot engage in the "double reflection" that Adorno assigns to it, that is, it cannot reflect on its being-for-itself without precluding all reflection on the relation of aesthetics to society. For Adorno, however, the tension between art and life in aestheticism does not preclude the ability of *l'art pour l'art* to critique life, and thereby to have significant import and a viable social function.

One convincing attempt to solve this debate over aestheticism's social ineffectuality versus its social function comes from Jeffrey D. Todd, who defines aestheticism's "central tenet" as the conviction "that art occupies its own autonomous realm independent of other spheres of life" (127). Given this autonomy structure inherent in aestheticism, two types are conceivable to Todd: a "weak" and a "strong" aestheticism. Todd explains that "weak" aestheticism

is characterized by a reciprocal separation between spheres …. If an autonomous art conceives of the separation between spheres as reciprocal, that is to say, if it understands itself as being just as unable to encroach upon the domain of, say, morals as morals are to determine the content of art, its possibilities will be circumscribed by those boundaries, and consequently rather limited. In this case, the freedom from determination from other spheres won through autonomy exacts a rather high price: the separation of art from life. (127)

In "weak" aestheticism, art has a limited role on account of its limited domain. By contrast, "strong" aestheticism is the term Todd designates to encompass another attitude according to which "art, while maintaining the autonomy of its own sphere, oversteps the boundaries of the other spheres, trespasses on their terrain, and proceeds to determine their content. Here art is less well behaved,

less self-effacing, less observant of the boundaries between itself and the other domains" (127–8). In "strong" aestheticism, art can affect life because it has a more expansive domain, encroaches on other spheres, and asserts its power and influence over them. If we consider what Julia Prewitt Brown terms the "main contradiction" of aestheticism, namely "the paradoxical separation yet interdependence of art and life," we can conclude that according to Todd's categorization, "weak" aestheticism involves "separation," while "strong" aestheticism involves not so much the "interdependence of art and life," but rather the supremacy of art over life or the hegemony of art over life (72). Todd's distinction between "weak" and "strong" aestheticisms helps us to understand the seemingly antinomious positions regarding art for art's sake as asocial or social, life-evading or life-sustaining, dehumanizing or rehumanizing.

I introduce this last set of terms in my edited volume *Art and Life in Aestheticism: De-Humanizing and Re-Humanizing Art, the Artist, and the Artistic Receptor*. Drawing on and expanding the concept of "dehumanization" put forth by Ortega y Gasset in his 1925 essay *La deshumanización del arte* (*The Dehumanization of Art*), this collection sets out to determine whether or not the dehumanization of aestheticist works leads to rehumanization, to a reconsidered and deepened relationship between the aesthetic sphere and the world at large, or more modestly, between the artistic receptor and his or her human existence. The term "dehumanization" can be understood diversely as the process of eliminating the human from art's subject matter, the method of isolating art in its own autonomous sphere, the desire to free art from human utility or usefulness, the act of rejecting a universal, communal, or collective experience of art, or the reification and self-alienation that occur in art or for the artist as a given social fact under the capitalist mode of production. The term "rehumanization" can be defined variously as the process of re-engaging with the human through the creation of, exposure to, or appreciation of art, the act of affirming a unique, subjective experience of art that promotes individual humanity, the desire to make life meaningful and livable through the sublimation of the external world into the artistic mind or the aesthetic personality, the generative practice of aesthetic reception that leads to the creation of new art, or the ability to undermine reification, commodification, consumption, and self-alienation through exposure to and engagement

with specific types of art. The challenge posed by *Art and Life in Aestheticism* is to search for a corresponding process of rehumanization to match, counter, or accompany aestheticism's dehumanizing impulse. Establishing aestheticism's rehumanizing potential serves to dispute widespread and persistent interpretations of art for art's sake as having little or nothing to do with life and to contest the apparent severance between the aesthetic and the human in aestheticism which has so long been considered to constitute one of its central characteristics. I, along with many of the contributors to the volume, locate an important and undeniable social function in aestheticism: aestheticist works condemn the dominant social values that make such a redefinition of art and literature necessary to begin with. Despite the seeming solipsism of an "art for art's sake" stance, then, aestheticism can and should be examined in terms of the elements of "life" that art and the artist are avoiding, protesting, critiquing, rethinking, or redefining.

The Characteristics and Tenets of Spanish American *Modernismo*

Given the fact that the Spanish American *modernistas* wrote almost exclusively between 1880 and 1910 – "a time when the phrase as well as the idea *l'art pour l'art* had become commonplace in France and elsewhere" – the possibility of overlap between these two movements should not come as a surprise (Bell-Villada 107). Nevertheless, only a handful of scholars have argued the case that Spanish American *modernismo* "represents the arrival and implanting of the theory of Art for Art's Sake in Latin American literary life" (Bell-Villada 107). Gene H. Bell-Villada makes this important assertion in Chapter 4 of his book *Art for Art's Sake and Literary Life: How Politics and Markets Helped Shape the Ideology and Culture of Aestheticism 1790–1990*, where he suggests that the doctrine of "el arte por el arte" characterizes the spirit of the Spanish American *modernista* movement, since what these movements share in his estimation is "a 'pure' verse in which beauty was the sole relevant factor, to the exclusion of all moral, civic, or social content" (107). I too am interested in assessing what these movements have in common and how the "art for art's sake" slogan fuels them both, although I will insist that social content is not completely excluded from aestheticism and *modernismo*, given

my belief that representative texts from both movements reveal significant social critique.

Bell-Villada's claims regarding the shared emphasis on "pure verse" and the common "exclusion of moral, civil, or social content" in both aestheticism and *modernismo* can be traced back to what is generally considered to be one of the earliest manifestos of Spanish American *modernismo*, namely Manuel Gutiérrez Nájera's 1876 essay "El arte y el materialismo" ("Art and Materialism"), which outlines the tenets of the *modernista* movement in a remarkably clear and concise manner. Gutiérrez Nájera sets out to distinguish between "degraded art that ties and binds man to the earth" and "sublime art that purifies man and raises him to the heavens" (60, translation mine). Promoting the latter over the former, he argues that the creation of sublime art requires the following standards: (1) the "liberty of art" and freedom of the artist, who "should be left in complete liberty to express his ideas in the form that his inspiration dictates to him"; (2) the notion that "art has as its objective the achievement of the beautiful," since "just as industry has as its aim *the useful*, so does art have as its goal *the beautiful*," and the beautiful is useful simply by being beautiful; (3) the idea that beauty is to be found in the spiritual as opposed to the material; (4) the conviction that art is an act of creation, not imitation, and the related belief that realism – "this *materialization* of art, this disgusting and repugnant positivism … this prostitution of art, this deification of matter" – is a "crime" for "seizing from art everything spiritual that it has, making it a slave to everything material, reducing it to the narrow path of reality, imprisoning it, in sum, in the miserable cell of servile imitation"; and, finally, (5) the idea that "beauty is not something you define, but rather something you feel" (53–7, translations mine). The parallels between Gutiérrez Nájera's *modernista* manifesto and the leading "art for art's sake" ideals of aestheticism are obvious, especially with regard to the notion of artistic autonomy, the search for beauty, and the rejection of both realism and utilitarianism in art.

Other scholars, in addition to Bell-Villada, have also noted the *modernistas*' emphasis on the aesthetic over the social, on art over life, even if they have been less inclined to apply the term "art for art's sake" to Spanish American *modernismo*. Graciela Montaldo explains in her important study *La sensibilidad amenazada: Fin de siglo y modernismo* (*Threatened Sensibility: Fin de Siècle and Modernismo*)

that Spanish American *modernismo* emerged "in the moment in which artists began to see the aesthetic world as different from the world of experience, but also when the aesthetic becomes a term that encompasses ever greater meaning" (Montaldo 17, translation mine). Such aesthetic production is best characterized by "the abandonment of the principle of *mimesis* in favor of artificiality and anti-naturalism as the predominant aesthetic values" as well as by "the non-functionality ["la afuncionalidad"] of many practices linked to the aesthetic" (Montaldo 15–16, translations mine). Anti-mimetic and anti-natural, artificial and lacking in utility – these are the dominant features of *both* aestheticist and *modernista* works of art and literature. According to Carlos Blanco Aguinaga, the "dominant tendency" in *modernismo* is "the rebellious will to liberate artistic forms from the hindrances of reality and previous traditional forms" (*Sobre el modernismo* 20). Scholars of Spanish American *modernismo* have also noted "the movement's *escapist* or *evasive detachment*" as well as "the intentional separation of an aesthetic practice from the society that gave rise to it" (Aching 4). Spanish American *modernismo* has been described as "an aestheticized and evasive movement" and as "an overindulgent art for art's sake" in which "producers of high art" make "apolitical," "detached," and "distanced" literary works (Zuleta 30, translation mine; Aching 3, 22). As Gwen Kirkpatrick notes, "[p]erhaps the most common criticism of *modernismo* is the attack on its lack of social commitment ... Variously called *torremarfilismo* ["ivory-towerism"], *cosmopolitismo*, or *decadentismo*, the movement of *modernismo* has been criticized as an aberrant faction of escapist writers who would not accept their immediate environment nor reflect it in their poetry" (Kirkpatrick 21, 23). As these comments serve to demonstrate, there are important parallels between aestheticism's call for pure art and artistic autonomy and the literary and artistic project of the Spanish American *modernistas*.

Nevertheless, in the same way that aestheticism should, in my view, be seen simultaneously as escapist *and* engaged, so too have scholars of Spanish American *modernismo* noted another side to this movement, which voices the "concerns ["inquietudes"] and ideals" of the Spanish American continent and thus serves as a "destabilizing force" and a "political gesture" (Molloy, "La política de la pose" 129, translation mine). As Gerard Aching points out, the "inner realm" ["reino interior"] of so many *modernista* texts "signifies beyond its

representations of internal spaces to say something about the social circumstances that gave rise to its literary creation and refinement" (23). Aching examines the *modernistas'* "detachment" as a form of "assertive engagement," much in the same way Adorno attributes to aestheticism's autonomy a form of societal opposition (Aching 3). This dual character of *modernismo* is also noted by Kirkpatrick, who locates "a striving toward a pure form of art combined with more utilitarian goals" (37). "Though these ideals seem to be contradictory," Kirkpatrick elaborates, "they represent the social amalgam that *modernismo* formed from its European sources. Despite their insistence on being enemies of utilitarianism and other manifestations of positivist thought, the manifesto clearly shows a dialectic between the ideals of an art striving towards pure form and an awareness of the role of the artist in society" (37). Perhaps the clearest articulation of *modernismo's* tension between pure art and socially engaged art comes from Aníbal González, who writes in *A Companion to Spanish American Modernismo*:

> Critics have usually divided *modernismo* into two periods or stages, separated by the Spanish-Cuba-American War of 1898. In one commonly held view, the writings of the *modernistas* before 1898 (with the notable exception of Martí) are considered more aestheticist, frivolous, and less overtly political than after the war, when there arose a renewed sense of nationalism and Pan-Hispanic solidarity with Spain against "the Colossus of the North" (the United States). This presumed divide between an "Art for Art's Sake" *modernismo* before 1898 and a politically committed one afterwards has recently been called into question by critics who point out the existence of significant political and social concerns in the works of the early *modernistas* besides Martí, particularly when their crónicas and other prose writings[8] are taken into account. (13)

Of course, González goes on to clarify that this temporal divide between an early and later *modernismo* corresponds to "a real divide of another sort between the first *modernistas* and subsequent members of the movement, and it arises from the coincidences that the four major 'founding fathers' of *modernismo*, Martí, Nájera, Casal, and Silva all died before 1898" (*Companion* 14). Still, I agree with González that many significant early works of Spanish American

modernismo – such as those by Darío, Silva, Gutiérrez Nájera, and Casal examined in subsequent chapters – voice "political and social concerns" at the same time as they espouse an "art for art's sake" ideal. In fact, this is the argument I wish to make with regard to both movements: their "art for art's sake" ideals are part and parcel of their social concern, commitment, and commentary.[9] Interestingly enough, then, the same dichotomous possibilities that I explained with regard to aestheticism have long been attributed to Spanish American *modernismo* as well – and it is precisely this similarity that has motivated my comparative study of these two movements.

Transatlantic Comparisons of the Portrayal of Art and the Artist in Aestheticist and *Modernista* Fictions

My investigation of the motives behind and the consequences of the "art for art's sake" slogan of *both* European aestheticism and Spanish American *modernismo* continues in subsequent chapters through a comparative study of the aims and attitudes of different types of artist protagonists in representative literary works from both movements. Each of this volume's three sections pairs texts from both sides of the Atlantic in which the protagonists are artist figures with a view to exploring the role of art and the artist in turn-of-the-century European and Spanish American society.

In Part I, "The Artist Avoids 'Art for Life's Sake,'" I examine literary heroes whose "art for art's sake" philosophy is aimed at rejecting the "art for life's sake" expectations that limit the turn-of-the-century artist figure. By addressing the tension between art and life in both movements, this opening section asks what it is about "life" that aestheticist and *modernista* authors and their artist protagonists so desperately want to avoid. In Chapter 1 – "The Artist as Critic and Liar: The Unreal and Amoral as Art in Oscar Wilde" – I examine Wilde's literary-philosophical essays "The Decay of Lying" (1889) and "The Critic as Artist" (1890). In Chapter 2, "The Artist as Creative Receptor: The Subjective Impression as Art in José Asunción Silva," I analyze Silva's novel *De sobremesa* (*After-Dinner Conversation*, written in 1896, first published posthumously in 1925). The first chapter considers the ways in which Wilde's protagonists endorse the notion of art for art's sake in an effort to advocate a total aestheticization of the life sphere. They promote the artist as an impressionistic critic

primarily in an effort to eschew imitation and mimesis, reject realism in form and content, shun morality and public opinion, and uphold the creation and appreciation of an autonomous sphere for a particular type of art and the artist. The second chapter addresses the ways in which Silva's artist hero uses Wilde's concept of the artist as impressionistic critic in order to avoid the conversion of the artist into a producer and of the artwork into a commodity. Silva's protagonist reorients the aims of the creative critic so as to ensure that the relationship between artist–art object–artistic receptor is *not* akin to that between producer–commodity–consumer. Both authors insist that the sources for artistic creation should be found neither in life nor in nature, but rather in the aesthetic sphere as the artist intentionally distances himself from the social realm of reality and from bourgeois society altogether. Additionally, both Wilde and Silva desire that their protagonists find a way to exist in the realm of art, rather than the realm of life. Because they convert previous artwork into something new and different via an ongoing process of aesthetic evolution and artistic recycling, Wilde's and Silva's artist heroes redefine the turn-of-the-century artist figure and promote the philosophy of "art for art's sake" over the undesirable alternative of "art for life's sake."

In Part II, "The Artist Protests 'Art for the Market's Sake,'" I consider how the aestheticist and *modernista* ideals of "art for art's sake" emerge as a response to pressures to produce or consume art in accordance with the dictates of the market. In this section, "art for art's sake" is pitted against a very precise and pervasive part of life: the capitalist marketplace. As market values increasingly come to determine artistic value in the nineteenth century, both movements emerge as a way of contesting the changes that made "artistic worth" seem to be something "worthless." Artists from both movements struggled with the disparity between their own aesthetic standards and the market's economic criteria for the production and sale of art. Once the concept of profitability and the laws of supply and demand were applied to artistic production, aestheticist and *modernista* artists became aware of the unmarketability of their artistic gifts and the various ways in which their art, especially their poetic production, was marginal to the dominant literary discourses of the period. These artists had to decide whether they would succumb to an "art for the market's sake" mentality in which they *accommodated* their art to

the changes brought about by the emergence of a literary market-place during the nineteenth century, or whether they would uphold an "art for art's sake" philosophy that *worked against or in spite of* such changes. By examining a more specific relationship, namely that between art and capital and between aesthetics and econom-ics, this section addresses the responses of representative European and Spanish American artists to the advances of modernity, further explores the changing role of art and the artist, and discusses the fate of aesthetic values in the face of market values. Both chapters in Part II assess how the selected fictional characters react to and deal with two related problems that escalate in this precise *fin de siècle* moment, the devaluation of the artist and the commodification of the artwork, and they do so through a consideration of the dual vantage points of production and consumption. Chapter 3 – "The Artist as Elitist Taster: The Unprofaned and Unconsumed as Art in J.-K. Huysmans" – examines the difficulties of (not) "consuming" art in industrial capitalist society through a consideration of Joris-Karl Huysmans's novel *À Rebours* (*Against Nature*, 1884). Chapter 4, "The Artist as Creator Not Producer: The Unsold and Unappreciated as Art in Rubén Darío," explores the problems of (not) "producing" art in the burgeoning Spanish American literary marketplace in three of Rubén Darío's short stories: "El Rey Burgués" ("The Bourgeois King," 1887), "El velo de la reina Mab" ("Queen Mab's Veil," 1887), and "El pájaro azul" ("The Blue Bird," 1886). The French author reveals his preoccupations with artistic consumption, while the Nicaraguan writer addresses his concerns regarding artistic production. Huysmans levies a staunch criticism of the bourgeois act of capitalist accumula-tion and the prison-like hold the market has on its members, and Darío portrays an ongoing critique of bourgeois society as hostile to artistic creation and inimical to the appreciation of aesthetic value. In addition to portraying negatively the art object as a commodity, both authors attempt to narrate alternative albeit unsuccessful solu-tions to the mass consumption and capitalist production of art in *fin de siècle* Europe and Spanish America. Huysmans promotes his protagonist, Duke Jean des Esseintes, as an elitist taster who appreci-ates the unprofaned and the unconsumed as art. Darío presents his artist heroes as creators, not producers, whose unsold and unap-preciated art nonetheless retains its artistic value. Both authors fail to offer plausible solutions to the crisis in aesthetic value that they

observe in the 1880s. Despite the escapism that is temporarily narrated, Huysmans's and Darío's fictions underscore the impossibility of preserving elitist standards of artistic consumption and production in the modern period. They also communicate their lamentable belief that aesthetic activity fails to provide a long-term solution for those who reject dominant market values and bourgeois taste and seek instead to preserve an elitist or purist element in art. Still, I locate in Huysmans's and Darío's texts an important and undeniable social function: by trying to separate aesthetics from production and consumption practices and by attempting to avoid the fate of "art for the market's sake," these authors and their selected texts critique the dominant social and economic values that made such a redefinition of art and the artist necessary in the first place.

In Part III, "The Artist Promotes 'Life for Art's Sake,'" I analyze the figures of the aesthete, dandy, and flâneur in terms of their attempts to treat experience in the spirit of art, to elevate art to a position of supreme importance in the conduct of life, and to make themselves or their worlds more artistic (Johnson 12). Chapter 5, "The Artist as Dandy-Aesthete: The Self as Art in Oscar Wilde and Thomas Mann," considers how three European protagonists – Wilde's Lord Henry and Dorian Gray from *The Picture of Dorian Gray* (1890) and Thomas Mann's Felix Krull from *Berkenntnisse des Hochstaplers Felix Krull: Der Memoiren erster Teil* (*Confessions of Felix Krull: Confidence Man (The Early Years)*, 1954) – emerge as dandy-aesthetes whose only creation is their own stylized selves and aestheticized beings. These men exist as alternatives to the traditional artist figure, since they turn themselves into art while avoiding the production of an external art object. I argue in this chapter that Lord Henry successfully constructs for himself an artistic life in which he is simultaneously artist, art object, and artistic receptor, while Dorian Gray is presented as a copy of someone else's artistic masterpiece (in the case of Basil's portrait) and as an imitation of someone else's self-doctrine (in the case of Lord Henry's aesthetic philosophy). For these reasons, Dorian is a false or failed dandy who lacks the originality and creativity, the individualism and independence, needed to carry out a true or successful process of self-aestheticization. Felix Krull, however, proves to be a very successful dandy-aesthete on account of his ability to use "art" to improve his "life." He draws on his performative skills successfully to raise his social status, attain his desired ends, and prove

his own merit as an artist of the self. The sixth and final chapter, "The Artist as Dandy-Flâneur: The World as Art in Manuel Gutiérrez Nájera and Julián del Casal," examines the Spanish American chronicle as a genre wherein we find examples of dandies and flâneurs in the subject matter as well as instances of the flâneur in the narrative personas employed by both authors. Although it was indeed challenging to find Spanish American literary protagonists that resemble the fictional dandies and flâneurs frequently found in European aestheticism at the turn of the century and who adopt a philosophy of "life for art's sake" in their attempts to turn themselves into artworks or to make their worlds more artistic, this chapter explores the repercussions of adopting in the Spanish American periphery the social and aesthetic models of the dandy and flâneur which were taken from the European center. By examining the complex portrayal and simultaneous disavowal of these two late nineteenth-century figures in various chronicles by Casal and Gutiérrez Nájera, I discuss what is lacking in Spanish America – modernization, cosmopolitanism, a long-established aristocratic class, an educated and cultured readership – since this helps to explain the scarcity of dandy and flâneur figures in Spanish American *modernismo*, on the one hand, and the altered or alternative portrayal of them, on the other hand. I also consider how these two authors' journalistic careers serve to align them with the wage laborer or the salaried scribe, which is a figure antithetical to the elitist and refined dandy or the free and idle flâneur. Thus, even when Manuel Gutiérrez Nájera and Julián de Casal describe dandies and adopt the identity of flâneurs in their chronicles, they simultaneously point out the gulf that separates their Spanish American versions from the European originals.

As this chapter-by-chapter outline suggests, my investigation aims to illuminate the numerous crossovers and the reciprocal influences between these two literary and artistic movements and to offer new insights into transatlantic modernist scholarship by exploring texts from seven national (France, Germany, the United Kingdom, Nicaragua, Colombia, Cuba, and Mexico) and four linguistic (French, English, Spanish, and German) traditions in which the main unifying traits are that: (1) the works' protagonists are all artist figures (broadly conceived), (2) the works share a concern with the role of art and the artist, and (3) the texts emerge during the turn-of-the-century period and fall into the category of European aestheticism or

Spanish American *modernismo*. More specifically, I shed light on the tensions between the ideal of art for art's sake and the alternatives of art for some other sake, be it that of life in general or the market in particular. I also locate an important and undeniable social function in both European aestheticism and Spanish American *modernismo*. Widening the distance between art and life, separating aesthetics from production and consumption practices, and trying to make life more artistic allows the chosen authors and their selected texts to critique the dominant social and economic values that made it necessary for them to redefine art and the artist in their selected literary works to begin with.

This book's structure stakes out the stance of the different artists vis-à-vis the role of art and the artist in society: against social engagement, for an art free of commercial entanglements, in favor of the artist living life for art's sake. If we return to the two prose pieces that we analyzed at the outset of this introductory chapter, we see that these works touch on all three subsections of this study. Baudelaire and Silva examine the tensions between art and life both in terms of the art to be created and in terms of the life to be lived. These works also examine the particular intersection of art and the marketplace as the writers consider their changing role in industrial capitalist society. Baudelaire's poet protagonist suggests that life – with its busy streets, bustling urban environment, and chaotic nature – has gotten in the way of art and has caused the artist to lose his profession, but he also believes that one can live life more freely and enjoyably when not fettered to an artistic vocation. Silva's poet hero argues that art ought to take on all of life's subjects, especially its most human ones, and to be able to sustain the artist's life in economic terms, but the muse's overpowering message is to the contrary, as she insists that both art and the artist ought to remain sacred, pure, artistic, and separated from the realms of life and the marketplace.

Part I
The Artist Avoids "Art for Life's Sake"

Introduction

Part I of this study considers artist protagonists from both European aestheticism and Spanish American *modernismo* who promote an "art for art's sake" philosophy as part of their staunch refusal of any and all "art for life's sake" expectations that would hinder the turn-of-the-century artist figure. This initial section thus explores the tension between art and life in both movements and strives to answer the following questions: Why is "art for art's sake" so uneasy with the idea of "art for life's sake"? What is it about "life" that aestheticist and *modernista* authors as well as their artist protagonists want to avoid? What is it about "life" that threatens both art and the artist? Chapter 1 examines Oscar Wilde's literary-philosophical essays "The Decay of Lying" (1889) and "The Critic as Artist" (1890) and discusses the ways in which Wilde's protagonists endorse the notion of art for art's sake in an effort to advocate a total aestheticization of the social and natural world; to free art from societal dictates, pressures, and expectations; to reject imitation, mimesis, and realism in art; and to shun any ethical or moral considerations on the part of the artist. Chapter 2 analyzes Colombian writer José Asunción Silva's only novel *De sobremesa* (*After-Dinner Conversation*, written in 1896, first published posthumously in 1925) and shows how Silva's artist hero employs Wilde's concept of the artist as impressionistic critic to differing ends. José Fernández is less concerned with overcoming the moral or ethical limitations that society places on art or with avoiding imitation and realism in art; instead, his art for art's sake

philosophy targets distinct elements of the life sphere that he deems equally pernicious to the artist, namely the tendency to convert the artist into a producer and the artwork into a commodity as well as the unartistic public that lacks the ability to understand and appreciate true art. By refusing to publish his work in the literary marketplace, by rejecting the labels of artist or poet, and by redefining the artist as a creative receptor whose artistic work simply registers the subjective impressions of previous artworks, Fernández tries to ensure that the relationship between writer, text, and reader is *not* akin to that between producer, commodity, and consumer. If the artist and the artistic receptor are equally creative and if their artwork is based on impressions from art, not life, Silva's protagonist can save or sever art from the mercantile, capitalistic, bourgeois, and unartistic life sphere that he so despises. Both authors insist that the sources for artistic creation should be found neither in life nor in nature, but rather in the aesthetic sphere as the artist intentionally distances himself from the social realm of reality and from bourgeois society altogether. Additionally, both Wilde and Silva desire that their protagonists find a way to exist in the realm of art, rather than the realm of life. Wilde's and Silva's artist heroes convert previous artwork into something new and different via an ongoing process of aesthetic evolution and artistic recycling, and, as a result, they redefine the artist figure and promote the philosophy of art for art's sake.[1]

1

The Artist as Critic and Liar: The Unreal and Amoral as Art in Oscar Wilde[1]

Oscar Wilde, the leading figure of late nineteenth-century British aestheticism, redefines the artist as a type of artistic or impressionistic critic and places great importance on the powerful effect of art on the receptor. A close analysis of "The Critic as Artist" and "The Decay of Lying" reveals the ways in which Wilde lives up to the titles of his essays as well as their proposed methodology: he, or each of his main characters, is the critic who becomes an artist creating in the spirit of the "cultured and fascinating liar" ("Decay" 305). In the two essays under consideration, Wilde posits ancient Greece as a lost ideal, which *his* Socratic personages – Gilbert and Vivian – aim to recover, albeit in distorted form, for modern England. Both literary-philosophical dialogues reveal a curious *fin de siècle* rereading of antiquity, particularly of Plato's *Republic* and Aristotle's *Poetics*. Whereas philhellenism played a major role in nineteenth-century British culture in general,[2] Wilde's particular appropriation of this already dominant discourse proves tactically useful for establishing his own anti-establishment poetics and overtly aestheticist doctrine. My examination of the reuse and abuse of Plato and Aristotle by Wilde uncovers the way in which Wilde's promotion of art for art's sake advocates a total aestheticization of the social and natural world, and thereby frees art from societal dictates in a way that contrasts starkly with the social mediation of aesthetics in antiquity. In Plato, Wilde encounters the praise of beauty, the promotion of lying, and the notion that Life imitates Art. In addition to these central ideas, he locates Plato as the founder of the critical spirit, and thereby positions him at the origin of aesthetic theory. From Aristotle's writings on poetics, Wilde

inherits the powerful and celebratory aspect of aesthetic reception, a form of catharsis that attests to art's powerful effect on the contemplative spectator, as well as a privileging of aesthetics over ethics.[3] In both essays, Wilde's protagonists repeatedly evoke the ideals of antiquity so as to create a genealogical justification for what otherwise might appear as outlandish or ungrounded claims with regard to their goal of creating a "new aesthetics." In so doing, the authenticity of the original ideas of Plato and Aristotle is transformed into the basis for a new aesthetic work.

Beginning with an examination of Wilde's borrowings from Plato, it is important to note that in both essays Wilde adopts Plato's chosen form, the dialogue, even if it is a medium already saturated with cultural heritage and tradition by the time Wilde inherits it. Vivian and Cyril discuss the notion of lying in art, whereas Gilbert and Ernest debate the role and function of the art critic. In both texts, one of the two interlocutors takes on – in an ironic adaptation of Plato's genre of choice – the overtly Socratic position of never being wrong: Vivian and Gilbert "convincingly" persuade Cyril and Ernest, respectively, of a number of points regarding aesthetics.[4]

Yet Wilde not only evokes Plato in form, but also in content. Let us turn first to "The Decay of Lying" in order to compare Plato's discussion of the "noble lie" and his connection between lying and art to Wilde's own interest in – as the title of his essay suggests – the decay of lying. To justify his thesis that "Lying, the telling of beautiful untrue things, is the proper aim of Art," Vivian reminds Cyril that the advantages of "Lying for the sake of the improvement of the young are so admirably set forth in the early books of Plato's *Republic* that it is unnecessary to dwell upon them here" ("Decay" 320, 318). Thus, in a manipulative way, Wilde redirects Plato's call for the "noble lie" to the aesthetic sphere, thereby ignoring its original social and political intent, regardless of the fact that, if understood correctly, such intent would be wholly at odds with Wilde's own aesthetic project. Despite Socrates' previous contentions that "[e]ssential falsehood … is hated not only by gods but by men" and that it is right to condemn "anyone [who] imagines badly in his speech the true nature of gods and heroes, like a painter whose portraits bear no resemblance to his models," Plato's protagonist goes on to advocate one opportune falsehood (629, 624). This lie, a sort of Phoenician tale, is permitted, although lying in art is impermissible, on account

of Socrates' contention that "[t]he rulers ... of the city may ... fitly lie ... for the benefit of the state," although, as he again reminds us, "no others may have anything to do with" lying (634). Wilde distorts Socrates' sanctioning of falsity in the name of improving the state, when he transports the promotion of lying from the social to the aesthetic sphere, from the realm of life to the realm of art. In Wilde's essay, lying to improve the arts depends on one's belief in art's separation from society, a separation wholly inconceivable to Plato.[5]

Furthermore, Vivian, when "pleading for ... Lying in art," insists that art has nothing to do with the social sphere insofar as it becomes sullied when it involves an imitation of Life or Nature ("Decay" 292–3). He locates a "struggle between Orientalism, with its frank rejection of imitation, its love of artistic convention, its dislike to the actual representation of any object in Nature, and our own imitative spirit" ("Decay" 303). Vivian continues his tirade on strictly mimetic art with the warning: "if something cannot be done to check, or at least to modify, our monstrous worship of facts, Art will become sterile, and Beauty will pass away from the land" ("Decay" 295). Consequently, Wilde's protagonist advocates that society ought to "return to its lost leader, the cultured and fascinating liar" whose aim is simply "to charm, to delight, to give pleasure" ("Decay" 305). Lying in art, thus, would allow the artist to escape the confines of realism in form and to discard all moral and social obligations in content. It would also serve to rejuvenate art and to make art more enjoyable. In a similar reading of "The Decay of Lying," Matthew Sturgis argues that Wilde views art as "entirely free from the moral and social duties that many Victorians considered part of art's sphere, but even from an obligation to objective reality" (119). Curiously enough, Vivian turns to Plato for further support in this argument; he explains: "Lying and poetry are arts – arts, as Plato saw, not unconnected with each other – and they require the most careful study, the most disinterested devotion" ("Decay" 294). The problem with this move for careful readers of the *Republic* is that, in stark contrast to Wilde's celebration of art's distance from truth, Plato criticizes the fact that art can never be anything but a copy of a copy. With truth as his aim, Socrates distinguishes between three levels of creators: God, the creator of nature; the workman, who copies nature; and the artist, who makes a copy of a copy. The artist is most abhorrent to Socrates because he lacks all knowledge of the truth, being thrice removed

from it, and yet "he will nonetheless imitate, though in every case he does not know in what way the thing is good or bad. But, as it seems, the thing he will imitate will be the thing that appears beautiful to the ignorant multitude" (827).[6] Although Wilde too warns against imitation of the public's expectations, he nonetheless celebrates the possibility of art to exist in a sphere of her own, as indeed this is the ideal he promotes. Yet, as we shall see later, Wilde rejects the idea that art is a "copy of a copy," since he goes to great lengths to sever art from any imitative relationship to life. Once again boldly ignoring the context in which Socrates links art and lying, Wilde nonetheless uses the *Republic* as a foundational text on which to base his own aesthetic (and aestheticist) manifesto.

By rejecting imitation in favor of lying, Wilde promotes art over life and artifice over nature. This reversal of our general understanding of mimesis again involves a return to antiquity. In his protest against realism in art, Vivian asserts that the Greeks, "with their quick artistic instinct," understood that Life imitates Art. Thus, explains Vivian, the Greeks:

> set in the bride's chamber the statue of Hermes or of Apollo, that she might bear children as lovely as the works of art that she looked at in her rapture or her pain. They knew that Life gains from Art not merely spirituality, depth of thought and feeling, soul-turmoil and soul-peace, but that she can form herself on the very lines and colours of art, and can reproduce the dignity of Pheidias as well as the grace of Praxiteles. ("Decay" 307–8)

Vivian continues by arguing that the Greeks objected to realism because they "disliked it on purely social grounds. They felt that it inevitably makes people ugly, and they were perfectly right" ("Decay" 308). In these passages a specific reference to Plato or Aristotle is avoided, as the whole ancient world is conflated into a general spirit or tendency, one that evokes Aristophanes' *Frogs* and Aeschylus's critique of Euripides as well. Wilde's argument that "Life imitates Art far more than Art imitates Life" inverts the common notion that Art holds a mirror up to reality and reproduces it ("Decay" 320); instead, Wilde purports that "Life holds the mirror up to Art, and either reproduces some strange type imagined by [a] painter or sculptor, or realizes in fact what has been dreamed in fiction" ("Decay" 311).

He insists that "Art finds her own perfection within, not outside of herself. She is not to be judged by any external standard of resemblance. She is a veil, rather than a mirror. She has flowers that no forests know of, birds that no woodland possesses" ("Decay" 306). In short, the artistic sphere is both separate from and more desirable than the social world of "reality," and if any connection between these realms exists, it is the social sphere which imitates the artistic one.

Again such a notion of art both resembles and contradicts Plato's own criticism of art as being that which is thrice removed from the forms. With regard to the distance between Art and Life, Plato bemoans what Wilde hails. Plato's *Republic* is fueled by a fear of the very fact that Life imitates Art. It is because of Life's imitative tendency that the arts are subordinated to the needs of the polis, and censorship is promoted to eliminate from the state all poetic works that stray from the accepted formula of offering "hymns to the gods and the praises of good men" (832). Fearing that "from the imitation they imbibe the reality," Socrates argues against all forms of imitation save those of good men (640). And although he admits that the imitative poets whom he wants to banish are certainly more "pleasing" than "the more austere and less delightful poet and taleteller" that he promotes, Socrates nonetheless insists that the former are "ill suited to our polity," whereas the latter, in imitating the diction of only good men, are alone fit to educate the soldiers of the imagined polis (642–3). For Socrates mimesis is not productively or therapeutically cathartic, as it will become for Aristotle; instead, it brings about a dangerous act of contagion in which the fictional infects the real as a result of the acts of narrating, spectating, reading, or listening. Wilde seems to recognize that for Plato it is not only the distance between imitation and truth that makes the mimetic arts so disdainful, but also the fact that these arts appeal to the emotions (the "inferior part of the soul" or "the irrational and idle part of us") and not to reason (the "better part of the soul" or the higher principle), something which lends art the power of harming even the good (830). Owing to his belief that "poetic imitation … waters and fosters these feelings when what we ought to do is to dry them up, and it establishes them as our rulers when they ought to be ruled," Socrates locates the cathartic moment as socially or morally dangerous, because there is an element of contagion in which one acts out that which is thrice removed from both the real, the true, and the good (832). Socrates'

condemning discussion of art nonetheless attests to the power of art, a power far less granted or acknowledged by Wilde's contemporaries, which explains the latter's interest in recuperating such power for his own theoretical ends. In this regard, Wilde partly ascribes to a similar rejection of art's vulgar appeal in favor of promoting its service to a higher quality, a quality that is largely intellectual. Strangely enough, then, Plato and Wilde both ascribe simultaneously to the power and the sterility of art.

Thus recognizing the powerful force Plato attributes to art as a shaping element in society, Wilde's Vivian goes on to argue that "wherever we have returned to Life and Nature, our work has always become vulgar, common, and uninteresting" ("Decay" 303). Taking on not only the social sphere, but so too the natural world, Vivian insists that both interpretations of nature, either as "natural simple instinct" or as "the collection of phenomena external to man," are problematic: the first because it is "opposed to self-conscious culture" and "the work produced under this influence is always old-fashioned, antiquated, and out of date"; the second because "people only discover in her what they bring to her. She has no suggestions of her own" ("Decay" 301). His critique of nature thus rejects the debasement of Art on account of being a copy of nature and elevates culture and artifice over nature and the natural world. Moreover, his claim that "Nature, no less than Life, is an imitator of Art" introduces a second thesis to the dialogue's overall argument ("Decay" 311). Not only is art free from limitations of imitation, but Life and Nature are bound to her. In her two-volume study *Aestheticism and Oscar Wilde*, Aatos Ojala makes an important distinction between aestheticism as that which "remains only an intellectual attitude, revealing itself only in the sphere of art but not in that of life" and an aesthetic movement which goes even further by claiming "the hegemony of art over life" (13–14). Ojala claims that Wilde's "The Decay of Lying" "is not contented with the autonomy of art, as Art for Art's sake would have it, but claims the supremacy of Art over Life and Nature" (111). This idea correctly suggests that Wilde wants more than the mere separation of art from life, since he advocates the aestheticization of life, the supremacy or hegemony of the aesthetic over the social – in a clear example of what Jeffrey D. Todd terms "strong aestheticism."[7] In "The Portrait of Mr. W. H.," Wilde makes a similar argument that "Art ... can never really show us the external world.

All that it shows us is our own soul, the one world of which we have any real cognizance. ... It is Art, and Art only, that reveals us to ourselves ... and leaves us different" (209–10). Only art can affect life – not by revealing or mirroring the external world, but by revealing us to ourselves in the face of powerful and self-altering moments of aesthetic reception or appreciation.

Another motivation behind Wilde's separation of Art from both Life and Nature is his ability to free Art from its ethical fetters and to establish the belief that "[a]ll imitation in morals and in life is wrong" ("Soul" 266). The relationship between aesthetics and ethics is addressed in greater detail in "The Critic as Artist" via recourse to Aristotle's *Poetics*. According to Gilbert, Aristotle's treatise on poetry is "one perfect little work of aesthetic criticism" insofar as "here we have art treated, not from the moral, but from the purely aesthetic point of view" ("Critic" 352). Curiously enough, despite the fact that the concept of the "aesthetic" is a purely eighteenth-century category, and not a classical one, Wilde manages to trace its origins to antiquity. Here Gilbert contrasts Aristotle's laudable privileging of aesthetics over ethics with Plato's condemnable interest in the "ethical effect of art, its importance to culture, and its place in the formation of culture" ("Critic" 352). In this second essay, then, it is Aristotle and not Plato who warrants Wilde's attention, namely because of the former's consideration that poetry is "essentially aesthetic, and is not moral" ("Critic" 352–3).

By privileging Aristotle over Plato in this instance, Wilde's protagonist can argue for an additional separation between Art and Life, since this division between ethics and aesthetics serves to sever the artistic world from the social sphere in yet another way. Although Gilbert does not cite particular passages from the *Poetics*, we can certainly imagine which arguments he would highlight in an attempt to demonstrate Aristotle's rejection of the ethical dimension of artistic production. Aristotle's contention that the poet should create characters who are "either above our own level of goodness, or beneath it, or just such as we are; in the same way as, with the painters, the personages of Polygnotus are better than we are, those of Pauson worse, and those of Dionysus just like ourselves" implies an all-inclusive realm of ethical possibilities (1448a4–7). In other words, despite mentioning ethical terms such as "better" and "worse" and purporting that "the line between virtue and vice is one dividing

the whole of mankind," Aristotle nonetheless grants the artist the freedom to represent any aspect on the spectrum of good and evil, although arguably such liberty depends on the genre chosen, and, as will be discussed shortly, the socially determined rules of the probable and necessary (1456).

In addition to positing a supposed separation of Art and Ethics, Gilbert further asserts that Aristotle, being primarily concerned with the effect that the work of art produces, "sets himself to analyze that *impression*, to investigate its source, to see how it is engendered" ("Critic" 353, emphasis added). This emphasis on the impression of the work of art is crucial to our understanding of Wilde's proposed method of "impressionistic" or "creative" criticism, something which has its origin in Walter Pater's notion that the fundamental step in aesthetic criticism is to know "one's *impression* as it really is" (*Three Major Texts* 71). Thus, once Art has been separated from the ethical sphere and stripped of its prescriptive formula for the artist, Wilde can begin to elaborate his theories regarding the reception of art. In "The Critic as Artist," Gilbert's praise of the effect of art on the receptor is marked by a celebration of the "transference of emotion" from the spectacle to the spectator: "We sicken with the same maladies as the poets, and the singer lends us his pain. ... There is no passion that we cannot feel, no pleasure that we may not gratify" (379). Yet Gilbert insists, in an important refutation of Plato's views on the subject, that despite such intensity of emotion, "Art does not hurt us. ... We weep, but we are not wounded. We grieve, but our grief is not bitter. ... the sorrow with which Art fills us both purifies and initiates us, if I may quote once more from the great art-critic of the Greeks. It is through Art, and through Art only, that we can shield ourselves from the sordid perils of actual existence" ("Critic" 380). Art is a remedy for life; it is a pleasurable, sweet, yet harmless alternative to reality. With regard to Wilde's comments regarding art's power and function, it is important to recognize that Aristotle – this great art critic of the Greeks whom Gilbert praises – is certainly interested in the effect of tragedy on the spectator, namely in our natural delight in "works of imitation" (1457). In the *Poetics*, Aristotle's discussion of drama's ability to arouse pity and fear, to involve either *peripeteia* ("a change from one state of things to its opposite") or recognition ("a change from ignorance to knowledge") attests to his belief that an imitation ought to be valued for, and judged by, its teleological

effect of catharsis, that is, the act of "learning – gathering the meaning of things, e.g. that the man here is so-and-so" (1465, 1457). In this regard, Aristotle shares Gilbert's sentiments when contending that "though the objects themselves may be painful to see, we delight to view the most realistic representations of them in art, the forms for example of the lowest animals and of dead bodies" (1457). It is the desire to see and to experience painful and base things that urges us to escape into the artistic realm and to enjoy that which we would normally detest, thereby purging ourselves of these qualities or negative desires.

Nonetheless, this link between Gilbert's new aesthetics and Aristotle's treatise on poetics fails to acknowledge that the cathartic effect, if understood correctly, is wholly dependent on public opinion. Aristotle insists that "the poet's function is to describe, not the thing that has happened, but a kind of thing that might happen, i.e. what is possible as being probable or necessary" (1463). "A likely impossibility is always preferable to an unconvincing possibility," he contends, since the story "should never be made up of improbable incidents" (1482). For Aristotle, all artists are "maker[s] of likenesses," and thus they "must necessarily in all instances represent things in one or other of the three aspects, either as they were or are, or as they are said or thought to be or to have been, or as they ought to be" (1483). Moreover, if the artistic object is neither true nor as it ought to be, then it must be "in accordance with popular opinion" (1484). This emphasis on popular opinion attests to the union between art and society in Aristotle's worldview, a union that Wilde once again consciously negates. Wilde shuns both "likenesses" and "popular opinion" as concerns for art or the artist, since they lead to realist and mimetic art and they open the door to ethical concerns.

The fact that Aristotle advocates the construction of plays based on the rules of the probable and necessary suggests that mimesis, for him, is a semi-autonomous system whose success is based on a largely internal and logical consistency. In Aristotle, everything ought to be done based on the rules of doxa, that is, according to the dictates of the public imaginary. The cathartic moment, or tragic effect, is the result of something unexpected – a surprise – and it involves an irrational, illogical or paradoxical conclusion. Aristotle thus wants tragedy to depict how the logical and doxical, logically and doxically, lead to the illogical and paradoxical. Then, in seeking

to understand how this works, the spectator understands the "logic of the illogical" and enjoys witnessing how a cultural logic fails or turns on itself.

Nonetheless, when Wilde's protagonist laudably employs Aristotle's phrase – "a convincing impossibility is preferable to an unconvincing possibility" – he does so with a drastically different intent (1485–1486). Gilbert's slightly modified claim that "[m]an can believe the impossible, but man can never believe the improbable" bases his understanding of the probable on something other than socially determined notions of acceptable plots and characters in art ("Critic" 317). Gilbert's call for the impossible parallels Vivian's promotion of lying, because for both of Wilde's fictional characters, unlike Aristotle, what the public expects or anticipates is never – and ought never to be – taken into account; rather, artistic convention shall replace the actual representation of the social world as art is further distanced from life.

Upon discussing this distinction between aesthetics and ethics, the improbable and the impossible with regard to the cathartic effect of the work of art, Gilbert and Ernest go on to compare the role and function of the artist and the critic. Ernest proposes a series of provocative questions:

> what is the use of art-criticism? Why cannot the artist be left alone, to create a new world if he wishes it, or, if not, to shadow forth the world which we already know, and of which, I fancy, we would each one of us be wearied if Art, with her fine spirit of choice and delicate instinct of selection, did not, as it were, purify it for us, and give to it a momentary perfection. ... Why should those who cannot create take upon themselves to estimate the value of creative work? ("Critic" 344)

Ernest idealizes the past of Ancient Greece in which, as he insists, there were no "art-critics" and "the artist was free" ("Critic" 348, 347). Ernest's comments here resemble those made by the French author and critic Théophile Gautier in his famous Preface to *Mademoiselle de Maupin*. Gautier launches what he terms a "criticism of the critics," a caustic critique of their consumption of art (50). Gautier attacks the moral, utilitarian, and hardened journalists on account of the fact that they "have produced no work and can only feed on and destroy other people's" (50). Likening the critic to the "person who does

nothing for the person who does something – of the drone for the bee, of the gelding for the stallion," Gautier points to the parasitic nature of what to him is a truly lamentable and disdainful profession (28). He believes that art should be valued for its "spiritual use" and should serve no other function, since "a book does not make jellied soup; a novel is not a pair of seamless boots; a sonnet, a syringe with a continuous spurt; a drama is not a railway; though all these things are essentially civilizing, and they advance humanity along the path of progress" (36–7). He insists, in a truly aestheticist fashion, that "[n]othing beautiful is indispensable to life. If you suppressed the roses, the world would not materially suffer; yet who would wish there were an end of flowers? I would rather give up potatoes than roses, and I believe that there is only one utilitarian who could tear up a bed of tulips to plant cabbages" (39). "Nothing is really beautiful," he explains, "unless it is useless; everything useful is ugly, for it expresses a need, and the needs of man are ignoble and disgusting, like his poor weak nature" (39). According to Gautier, then, "the only useful thing in the world" is that which provides pleasure and enjoyment (40). Thus, he argues in favor of the sovereignty of art, its independence of moral and social conditions, and its freedom from the critiques and judgments of the critics. Despite sharing Wilde's affinity for aestheticism, Gautier, like Ernest, fails to see the possibility of a creative type of criticism.

Gilbert, however, takes on the Socratic role of successfully rebuffing his interlocutor and corrects Ernest when he contends that "the Greeks were a nation of art-critics" ("Critic" 349). He goes on to explain that "our primary debt to the Greeks" was the "critical spirit" ("Critic" 350). In fact, Wilde's protagonist insists that with regard to "the two supreme and highest arts," namely Life and Literature, the Greeks have bequeathed "the most flawless system of criticism that the world has ever seen" ("Critic" 350). After discussing the ancient Greeks collectively, Gilbert goes on to name the two most influential critics of that age: Plato, "with his passion for wisdom," and Aristotle, "with his passion for knowledge," for whom contemplation – the heart and soul of criticism – was "the noblest form of energy" ("Critic" 381).[8] To further support his claim, Gilbert reminds Ernest of the content of Plato's *Republic*, particularly of

that lovely passage in which Plato describes how a young Greek should be educated, and with what insistence he dwells upon the

importance of his surroundings, telling us how the lad is to be brought up in the midst of fair sights and sounds, *so that the beauty of material things may prepare his soul for the reception of beauty that is spiritual.* Insensibly, and without knowing the reason why, he is to develop that real love of beauty which, as Plato is never weary of reminding us, is the true aim of education. ("Critic" 395, emphasis added)

Although Gilbert goes on to lament the fact that "we in England have fallen short of this ideal," he nonetheless musters hope for the return to the aesthetic model of ancient Greece, to an epoch in which "the true aim of education was the love of beauty, and that the methods by which education should work were the development of temperament, the cultivation of taste, and the creation of a critical spirit" ("Critic" 395). Consequently, he insists that the Greeks have left their legacy to modern thought: "the conception of the contemplative life as well as the critical method by which alone that life can be realized" ("Critic" 387). Without this critical faculty, explains Gilbert, "there is no artistic creation at all, worthy of a name" ("Critic" 355). Here Plato's ideas for raising the guardians or philosopher kings have been stripped of their useful, societal function. Wilde values the emphasis on temperament, taste, and the critical spirit not for its import on Life, but solely for its influence on Art.

With its origin in antiquity, the so-called "criticism of the highest kind" finds an echo in the work of Wilde's contemporary, mentor, and friend, Walter Pater, another Oxford student of Classics and another well-known promoter of aestheticism (367). In *The Renaissance: Studies in Art and Poetry* (1873), Pater famously rejects the concept of universal beauty and insists that beauty is relative, that the fundamental step in aesthetic criticism becomes, in a significant twist to the famous Arnoldian dictum, knowing "one's *impression* as it really is" (*Three Major Texts* 71, emphasis added).[9] It is no longer the concrete art object, but only one's impression of it, that can truly be known. Pater advocates that one should strive to answer the questions: "What is this song or picture, this engaging personality presented in life or in a book, *to me*? What effect does it really produce *on me*?" (*Three Major Texts* 71, emphasis added). Rejecting universal interpretations of art, Pater promotes a subjective, individual, and personal reception of art that is to be carried out by the sensitive and

artistically oriented critic. He insists that art affects life, since for him the aesthetic critic seeks to know how his "nature" is "modified" by the "presence" or "influence" of the art object, which brings about "a special, a unique, impression of pleasure" (*Three Major Texts* 72). He argues that the aesthetic critic must possess "a certain kind of temperament, the power of being deeply moved by the presence of beautiful objects," in order to experience "the elevation and adorning of our spirits" that art affords (*Three Major Texts* 72, 91). It is "the love of things of the intellect and the imagination for their own sake" that leads to "new subjects" of poetry and "new forms" of art, and, more importantly, to "new experiences" for both the artist and the artistic receptor (76–7). In short, Pater suggests that the effect of an art object on the receptor of art can turn the receptor (i.e., the critic) into an artist of new artworks, and it is indeed this notion that Wilde takes up in the essays under examination here.

In "The Critic as Artist," Wilde promotes Pater's mode of artistic criticism, calling his method "right" and deeming it "criticism of the highest kind" (367). Wilde summarizes Pater's process of treating

> the work of art simply as a starting-point for a new creation. It does not confine itself … to discovering the real intention of the artist and accepting that as final. And in this it is right, for the meaning of any beautiful created thing is, at least, as much as the soul of him who looks at it, as it was in his soul who wrought it. Nay, it is rather the eye of the beholder who lends to the beautiful thing its myriad meanings, and makes it marvellous for us. ("Critic" 367)

Wilde agrees with Pater that art's beauty as well as art's meaning depend in large part on having an artistically attuned receptor. In strikingly Paterian language, Wilde too purports that a beautiful artwork can cultivate "a beauty-sense," an "artistic temperament," and a "creative instinct" in the receptor as it prepares humans for the experience of "new desires and appetites," a "larger vision and … nobler moods" ("Critic" 394, 386, 400). He too revises Arnold's famous dictum, when he writes: "it has been said … that the proper aim of Criticism is to see the object as in itself it really is. But this is a very serious error, and takes no cognizance of Criticism's most perfect form, which is in its essence *purely subjective*, and seeks to reveal

its *own secret* and not the secret of another. For the Highest Criticism deals with art *not as expressive but as impressive purely"* ("Critic" 366, emphasis added). By defining criticism as a subjective and impressive experience of art, Wilde has moved very far away from the ideas outlined in Gautier's "criticism of the critics." Accepting wholeheartedly Pater's own interpretive inaccuracies of various creative artists, Wilde's mouthpiece, Gilbert, asks rhetorically: who "cares whether Mr. Pater has put into the portrait of Monna Lisa something that Lionardo never dreamed of?" ("Critic" 366). Obviously Wilde does not "care" about art's relationship to anything original or real, as he celebrates the possibility of the critic as an artist of newly refashioned artworks.

In "The Preface" to *The Picture of Dorian Gray*, Wilde similarly declares that "[t]he critic is he who can translate into another manner or a new material his *impression* of beautiful things" (xi, emphasis added). Wilde expands on this notion in "The Critic as Artist," where he contends that for the highest critic, "the work of art is simply a suggestion for a new work of his own, that need not necessarily bear any obvious resemblance to the thing it criticizes," since the artist's creation "may be merely of value in so far as it gives to the critic a suggestion for some new mood of thought and feeling which he can realize with equal, or perhaps greater, distinction of form, and, through the use of a fresh medium of expression, make differently beautiful and more perfect" (388). The "highest Criticism" thus proves to be more creative than creation as the critical and cultured spirits "grow less and less interested in actual life, and ... seek to gain their *impressions* almost entirely from" art ("Critic" 375, emphasis added). If one accepts this argument, then it follows that "Criticism is no more to be judged by any low standard of imitation or resemblance than is the work of poet or sculptor. The critic occupies the same relation to the work of art that he criticizes as the artist does to the visible world of form and colour, or the unseen world of passion and of thought" and the critic's work "has least reference to any standard external to itself, and is, in fact, its own reason for existing, and, as the Greeks would put it, in itself, and to itself, an end" ("Critic" 364–5).[10] If this type of impressionistic art is an end in itself, then it follows that it does not exist for any other sake – hence the underlying philosophy of "art for art's sake." Moreover, art is not "for life's sake" insofar as life is not the starting point for art, rather art is

the starting point for additional art. It does seem plausible, however, that this type of art helps to make life more enjoyable and more livable, simply because it makes life more beautiful and more artistic.

With regard to this mode of impressionistic criticism, Wilde's simultaneous references to the Greeks and to Pater prove illuminating given the fact that just one year after the publication of "The Critic as Artist," Pater delivered a series of lectures on "Plato and Platonism" in which he devoted the last lecture to a consideration of Plato's aesthetics. Pater begins this final lecture with the contention:

> When we remember Plato as the great lover, what the visible world was to him, what a large place the idea of Beauty, with its almost adequate realisation in that visible world, holds in his most abstract speculations as the clearest instance of the relation of the human mind to reality and truth, we might think that art also, the fine arts, would have been much for him; that the aesthetic element would be a significant one in his theory of morals and education. (267)

In establishing Plato as "the earliest critic of fine arts," the origin of artistic theory, and the first to theorize "about the beautiful, its place in life, and the like," Pater, in a manner wholly reflective of Wilde's, reveals a marked interest in establishing a genealogy that begins with Plato and leads to his own generation's aestheticist doctrine (268). As Pater boldly claims, it is Plato who "anticipates the modern notion that art as such has no end but its own perfection, – 'art for art's sake'" (268). Thus, Pater and Wilde are both engaged in a manipulative yet very strategic rereading of the ancient ideals of art, and indeed, this is the cornerstone that legitimizes their respective aestheticist philosophies.[11]

In "The Critic as Artist" and "The Decay of Lying," Wilde willfully misinterprets antiquity and eagerly severs the artistic sphere from the social realm, so that he can re-employ Plato and Aristotle's ideas in his own aesthetic philosophy. In a revealing moment in "The Critic as Artist," Gilbert, observing Plato's constant connection between art and society, aesthetics and morality, Beauty and Truth, goes on to argue that Plato is useful only when we transfer his ideas from the "metaphysical sphere of abstract being" to "the sphere of art" (353).

Hence, in spite of the fact that Plato "dealt with many definitely artistic subjects, such as the importance of unity in a work of art, the necessity of tone and harmony, the aesthetic value of appearances, the relation of the visible art to the external world," he is, to use Gilbert's phrase, "destined to live" as a critic of Beauty only "by altering the name of the sphere of his speculation" ("Critic" 353). By removing "life" from Plato, the Greek philosopher's ideas on art can lead to an affirmation of an aestheticist doctrine. In *Oscar Wilde: Art and Egotism*, Rodney Shewan lends credence to this idea when he notes that Wilde sees the possibility "of turning Plato from a moral philosopher into an aesthetician" by considering Plato's findings "in a new context" (22, 104). As Wilde told André Gide, everything Plato ever said about metaphysics could "be transferred immediately into the sphere of art, and there find its complete fulfilment" (*Letters* 476). The same can be said of Wilde's use of Aristotle as well. Only by himself becoming either a higher critic, who makes of someone else's creation something newer and better, or a liar, who distorts and even ignores the truth, can Wilde employ Plato and Aristotle to his advantage, that is, turn them against themselves in order to reject the social, natural, and ethical in favor of the aesthetic. Wilde's attempt in these essays to sever art from life, artifice from nature, the aesthetic from the ethical, thus involves a creative rereading of Plato and Aristotle. The works of these two classical authors are transformed into a new aesthetic creation, and, as a result, Wilde engages in a process of cultural recycling as well. He takes his "impression" of Plato and Aristotle and reworks it into two artistic works that eschew imitation and mimesis, reject realism in form and content, shun morality and public opinion, promote lying or the telling of beautiful untrue things, and call for the creation and appreciation of an autonomous sphere for a particular type of art and the artist. And to what end does Wilde do all of this? His desire to promote art for art's sake in terms of form, content, and method allows him to retain the beauty, the pleasure, and simply the "art" that he finds to be lacking in "life."

2
The Artist as Creative Receptor: The Subjective Impression as Art in José Asunción Silva[1]

José Fernández, the protagonist of Colombian author José Asunción Silva's only novel, *De sobremesa*, resembles the type of impressionistic or artistic critic promoted by Oscar Wilde and discussed in the previous chapter.[2] Through comparisons with the ideas of Wilde, I locate a similar rejection of the role of the traditional artist and an analogous celebration of the creative aspects of the critical faculty on the part of José Fernández. In this instance, however, the promotion of the artist as an impressionistic critic serves not so much to critique the moral or ethical limitations that society places on art or to criticize imitation or realism in art; instead, the endorsement of art for art's sake comes in response to different "life" targets: contemporary society's bourgeois mediocrity, mercantile spirit, and utter lack of artistic appreciation. Silva's definition of the artist as a creative receptor who turns the subjective impression of art into new art aims to undermine and undo the commodification and consumption of art. José Fernández protests *the commodification of art* by refusing to publish his work or introduce it into the literary marketplace, since he shares his private writing only with a limited group of intimate friends who are among the few capable of appreciating aesthetic beauty, and thereby prevents art from becoming a commodity and the artist a producer of commodities. He also protests *the consumption of art* because the method of producing new art based on and inspired by previous art cancels out the definition of "consumer goods" and ensures that art remains a "raw material" to be used in further and ongoing creation processes.

In *De sobremesa*, the dandified and decadent Spanish American protagonist reads aloud from his European travelogue to a group

of intimate friends. The written diary records José Fernández's experiences in France, Switzerland, and England over a two-year-and-seven-month period in the early 1890s. During the four months that Silva's artist hero resides in London, he becomes immersed in the study of various local and contemporary art movements, particularly British Romanticism, the Pre-Raphaelite Brotherhood, and the English Arts and Crafts Movement. Fernández reads poetry by Shelley and Keats; he embarks on "the incessant contemplation of Rossetti's paintings and the reading of his verses" (142),[3] views artworks by Holman Hunt, commissions a painting from Burne-Jones, and acquires a portrait by the fictive but nonetheless significantly named artist J. F. Siddal[4]; he makes references to leading figures from the decorative arts such as Walter Crane and William Morris. Interestingly enough, however, it may be the one figure from the late nineteenth-century London scene that is conspicuously *not* mentioned in the novel, namely Oscar Wilde, who has the greatest influence on José Fernández's artistic temperament.[5] Similarly, it may be the artistic movement of British Aestheticism, which again is curiously *unnamed* in this novel overflowing with literary and artistic references, that corresponds most closely with Silva's position regarding the desired role of art and the artist. It is to these two possibilities that I now turn in this chapter, which sets out to (1) examine how Silva employs Wilde's notion of the impressionistic critic in the construction of his own protagonist, (2) assess the aspects of "life" that José Fernández's "art for art's sake" philosophy is opposed to, and (3) account for the divergences between Wilde's and Silva's call for "art for art's sake" in terms of geographic, cultural, and personal differences.

The opening dialogue of the novel's titular scene sets the tone for the protagonist's ideas regarding artistic production. Having let the last two years pass without writing a single line, José Fernández, the once-famous Spanish American poet, staunchly declares: "I'll never write another verse ... I'm not a poet" (54). Fernández's most intimate friends, those with whom he engages in after-dinner conversation, deem it "a crime" that he is willing to waste his writing talents and artistic abilities "and to let the days, months, and entire years go by without writing a line!" (52). They believe that "the best" of their friend consists in his "deep-rooted calling" ("vocación íntima") and his "soul of a poet" (54). Despite their

complaints, the former poet insists: "No, I'm not a poet. ... That's ridiculous. I a poet! To call me by the same name men have called Aeschylus, Homer, Dante, Shakespeare, Shelley ... What a profanation, what a blunder!" (54). Unwilling to equate himself with his artistic heroes, Fernández adamantly rejects the classification of poet.

Yet part of José's abdication of the role of poet stems from his fear of not being understood by the public, since this accounts for much of his reluctance to publish. "The fact is I don't want to *say* but rather suggest," insists Fernández, "and for the suggestion to work, the reader needs to be an artist" (60). This notion of the reader as an artist significant and clearly recalls the ideas of Pater and Wilde discussed in Chapter 1. By being himself an artist, the reader becomes a creative critic who has "a certain kind of temperament, the power of being deeply moved by the presence of beautiful objects" and who possesses "an artistic temperament," a "beauty sense" and a "creative instinct" (Pater *Three Major Texts* 72; Wilde "Critic" 386, 394, 400). Convinced that the modern public is not, however, a group of artists, he laments: "what effect would the work of art produce? None" (60). The former poet believes that half of art "lies in the verse, in the statue, in the painting," whereas the other half is in "the brain of the one hearing, seeing, or dreaming" (60). In José Fernández's estimation, however, "the public is nearly always a table and not a piano" insofar as the masses want to consume poetry as one would food (60); they are not capable of counteracting the forces of consumption by turning one creation into another.[6] The public does not possess the critical and artistic faculty which Wilde, and now Silva's protagonist too, endorse. Silva further expresses his distrust of the traditional art critic in his poem entitled "Un poema." After devoting the first 38 of 40 lines to the process of shaping ("forja[ndo]") a poem, Silva ends with the deceptive reality of the proud poet vis-à-vis an inept and clueless critic:

Pleased with my verses, with the pride of an artist,
I gave them the scent of heliotropes and the color of amethyst ...

I showed my poem to a marvelous critic ...
And he read it six times and said to me ... I don't understand it!
<div align="right">(translation mine)</div>

[Complacido en mis versos, con orgullo de artista,
Les di olor de heliotropos y color de amatista ...

Le mostré mi poema a un crítico estupendo ...
Y lo leyó seis veces y me dijo ... ¡No entiendo! (49)]

Here we see clearly the artist's fear of not being understood or appreciated by the traditional critic (one similar to the critics so famously critiqued by Gautier in the "Preface" to his 1834 novel *Mademoiselle de Maupin*), and this points to the necessity of rethinking the role and function of both the artist and the critic.

Silva's protagonist admittedly recognizes that "[i]n the public's mind you have to be something," and thus the label "poet" reflects how they have chosen to classify him, however erroneous such an appellation may seem to its possessor (233). Curiously enough, the omniscient narrator of the frame story also uses this "label" to refer to Silva's protagonist – calling him poet ("poeta") once and writer ("escritor") twice in the four pages which precede the commencement of the journal excerpts (i.e., the novel's embedded narrative) – even though he knows of, indeed narrates, the character's repudiation of such a role (55). Silva's decision to underscore this professional label in spite of his protagonist's disavowal of it is an intriguing yet puzzling move. *De sobremesa* presents an ambivalent attitude toward artistic production as well as a curious commentary on the role and place of the artist figure in turn-of-the-century Spanish American society. It is our task to establish the extent to which José is in fact an artist, and also to decide what type of "artist" he might be.

Whereas I will argue that José Fernández is an artistic and impressionistic critic, others have deemed him a failed artist who "seems incapable of carrying out any project," since his fixation on Helen serves as "a displacement for his abortive artistic ideal" and "a substitute for his frustrated creativity" (Hazera 75, 79, 72). I disagree with this analysis and suggest instead that José Fernández manages to create three artistic works throughout the scope of the novel, and these include: (1) the written European travelogue which becomes the novel's embedded story, (2) the fictionalized image of Helen that occupies so much of the journal's subject matter, and (3) the highly decorated and adorned Spanish American home of the protagonist, his so-called "Villa Helena." I will demonstrate that José Fernández

creates in accordance with Wilde's method of impressionistic and creative criticism in each of these creations.

Evidence of José Fernández's Wildean approach to aesthetic production can be seen throughout his *first* artistic creation within the scope of the novel: the European travel journal that constitutes the embedded narrative. The writing of the journal begins with a reference to reading, as the first words José Fernández writes of his Parisian experience are "[t]he reading" ("la lectura") (64). The protagonist thus underscores the notion that one work of art can serve as a catalyst for the creation of another, and he establishes himself as a reader who is also an artist. Moreover, he himself attributes his previous literary production to the fact that "reading the great poets stirred such profound emotions" in him (54).[7] In this instance, Fernández has been reading two texts which together form "a perfect antithesis of intuitive comprehension and systematic incomprehension of Art and life" ("del Arte y de la vida") (64).[8] Wholly ignorant of both art and life is Max Nordau – whom José terms the "grotesque German doctor" – in his *Degeneration*; keenly aware of both the social and aesthetic spheres is María Bashkirtsteff – whom Fernández calls "one of the most vibrant, most burning souls of the present day" – in the two volumes that comprise her diary (65). Part of the praise of the Russian memoirist undoubtedly stems from the fact that she shares Silva's hero's artistic method and sets off to create art only after engaging with other artistic works, in sharp contrast to Nordau whose only reaction to the artists he names is to classify their supposed manias and to undermine their aesthetic achievements. Thus, in a manner identical to Silva's protagonist, María Bashkirtsteff uses aesthetic reception as a catalyst for artistic production. As a result of "several hours of reading Balzac," she brings to fruition the painting of which she had dreamed and realizes "the miracle of translating [it] to oil" (66). Likewise, María turns a recent reading of Hamlet into a symphony – thereby proving quite literally to be more like a piano than a table, since according to José Fernández, "[a]s she sat there at the piano, the ivory keyboard quivering under her nervous fingers, the music of Beethoven stretching out into the dormant air, and in the semidarkness, evoked by the pained notes of the nocturne and by a reading of Hamlet, floated the corpse of Ophelia, Ophelia, pale and blonde, crowned with flowers …" (68). Additionally, José notes the frenzy in which the

Russian artist wrote in her own diary upon discovering Kant, much as he himself has done upon reading Bashkirtsteff. In each of these instances, we see evidence of José's belief that one work of art may serve as a suggestion for a new aesthetic creation, as the artist figure turns to art, not life, in search of sources and inspiration already far removed from reality.

The *second* phase in José's mode of artistic production involves the fictionalized image of Helen that occupies the subject of so much of the diary. Moving now to a detailed analysis of Helen's function in the novel, I find it pertinent to review the previous scholarship regarding her role: some deem her the artist's muse (Schanzer 47), while others see her as either a symbol of the artist's soul (Díaz Rinks 35) or a substitute for the artist's frustrated creativity (Hazera 72). Finally, other scholars deem her "a 'phantom,' an 'auto-suggestion'" ("un 'fantasma', una 'autosugestión'") on the part of José Fernández (Hinterhäuser 102, translation mine). As my analysis aims to demonstrate, Helen is neither José's muse nor the product of his artistic impotence or *abulia*; rather, she is a consciously fashioned art object, and as such she cannot be the source of her own inspiration or a sign for José's lack of creative force. I intend to demonstrate the ways in which Helen represents one phase in José's mode of artistic production, one which clearly involves the artistic refashioning of the creative critic.

From the moment José first sees Helen in the private dining room of his Geneva hotel, he continually likens her to women in the visual and literary arts. In her admirer's estimation, Helen parallels a multitude of literary heroines. Numerous references to Dante's Beatrice abound in José's ruminations of Helen. The importance of Beatrice as Dante's spiritual guide in *La vita nuova* and the *Divine Comedy* is very familiar to José, who imagines himself in a conversation with the Italian poet's beloved. Perhaps believing in Dante's contention that the person "[w]ho speaks with her can never come to ill," Silva's protagonist reflects: "When I think of you, Beatrice, you who make me ascend from the depths of my hell to the heights of your glory, Alighieri's verses sound in my soul like a song of hope and of comforting certainty" (139). More importantly, in the only words he imagines Helen directing to him, she insists: "do not stray from my path, poor, dark, sick soul, I will be your guide toward the light, your Diotima and your Beatrice" (108). José thus considers himself on

a journey from the depths of hell to the height of heaven, a spiritual quest that leaves reality in favor of the divine.[9] Likewise, Diotima, the Greek priestess who educates Socrates on the nature and role of love in Plato's *Symposium* (a work whose title clearly parallels that of Silva's novel insofar as "de sobremesa" or "after-dinner conversation" invokes the classical definition of a symposium as a party, usually following a dinner, for drinking and conversation),[10] serves a similar purpose to Beatrice in that she relates a theory of love in which one progresses from first loving the beauty of the young body to later coming to see the beauty in all bodies, from then noticing the beauty of the soul to being able to identify the beauty in all souls, from finally appreciating the beauty in the laws and the structure of all things to lastly discovering the beauty of the forms or divine ideas. Love is thus important because it starts and continues one on the path to the divine. In addition to naming Beatrice and Diotima and evoking the spiritualized ideas of love associated with them, José also recalls the divine soul addressed in "Fray Luis de León's sweet, sweet stanzas" in relation to Helen (109). He thinks of "the princess Helen from Tennyson's idyll," given the similarity of their names (110). His friend, Camilo Monteverde, rightly accuses José of "dreaming always of some Dulcinea (210). What these female literary figures – Beatrice, Diotima, Elaine, Dulcinea – share is their ability to love in an incorporeal and sacred manner that does not require direct manifestation in the social or physical sphere. Helen is thus a phantom of various women who themselves are already disembodied and etherealized personages, not to mention literary constructs.

Such references to fictive women are coupled with connections between Helen and female images in the pictorial arts. As José Fernández notes, Helen resembles "the portrait of a young princess painted by Van Dyck" (106). Her long, pale hands recall those of Anne of Austria in Rubens's portrait (106). She appears "naïf and pure as that of a Fra Angelico virgin" (106). Owing to these comparisons, most critics agree that Helen is an evasive figure – one "seen more in paintings than in reality" (Loveluck 24, translation mine). She is "little more than a picture, a living painting, and Fernández always contemplates her as framed in various ways" (Elmore 207, translation mine). From her first appearance, explains Peter Elmore, "Helen is woman and painting at the same time" (204, translation mine); she is "the echo of an image, the phantom of a representation"

(Elmore 208, translation mine). Nonetheless, José does more than turn to the art of past ages in his search for models on which to base or with which to compare his beloved. He soon becomes aware of the fact that his image of Helen – both in dream and waking reality – is curiously intertwined with a portrait of her own mother, on the one hand, and the image of his own grandmother, on the other. Within the fictional world of the novel, then, Helen is a trace of formerly painted women from the two generations that precede her.

Additionally, José's interest in these two portraits in particular is linked to his overall obsession with a "real" artistic movement outside the fiction, namely the Pre-Raphaelite Brotherhood. This new artistic interest conveniently overlaps with José's decision to reside in London, where he embarks on "the incessant contemplation of Rossetti's paintings and the reading of his verses" (142). José's research into Helen's whereabouts leads him not to her present location (at least not to her living location, but only to her grave); rather, he acquires only "a few new perceptions on beauty" that emerged from his investigation into "the noble artists that made the Brotherhood famous" (140). Given his piqued interest in this particular mid- to late-nineteenth-century British art movement, José enters "with mad verve ["con loco entusiasmo"] into the study of the origins and development of the Pre-Raphaelite school, the lives and works of its leaders" (140). In particular, he seeks to know the causes that determined the apparition of Helen's mother in the world of art (140). Silva's hero attributes the painting of Helen's mother to J. F. Siddal, a Pre-Raphaelite artist whom "[t]he critics that have written on the Pre-Raphaelite Brotherhood fail to even mention" and whose name is not "included in any gallery or museum catalogue" (162). In this way, Silva merges the protagonist's own initials with the last name of the real-life woman, Elizabeth Eleanor Siddal. He seems to suggest that his own protagonist is partially responsible for the creation of the painting, which would indeed explain why no one has heard of this particular artist, but would also underscore José Fernández's later role as "artist" of Helen and as "creator" of his beloved. Yet the simultaneous reference to Siddal points not only to the wife of the painter and poet Dante Rossetti, but also the favorite model of the most renowned British painters of the Pre-Raphaelite tradition: Holman Hunt, Millais, and Rossetti himself. It is important to note that Siddal sat as the model for John Millais's drowned Ophelia; she also posed

for the figure of Beatrice in three of Rossetti's paintings: *Beatrice Denying Dante Her Salutation* (1851–2), *Dante Drawing an Angel on the Anniversary of Beatrice's Death* (1853), and *Dante's Dream at the Time of the Death of Beatrice* (1856). Thus, the connections between Helen and both fictive and real women become blurred as "life" within the novel comes to look more and more like "art." As a result of all of his research into the Pre-Raphaelite movement, José admits: "I tried to find out about Helen and I have found out details of the life of Fra Angelico, read letters from Rossetti and Homan Hunt, *canzone*s by Guido Cavalcanti and by Guido Guinicelli, verses by William Morris and by Swinburne, seen canvases by Rossetti and Sir Edward Burne-Jones" (140). He finally recognizes the extent to which his detour into the world of Pre-Raphaelite art and poetry has prevented him from actually finding Helen: "God knows how long I would have gone without looking for her, dreaming of Her, with my imagination spinning around her radiant image and my eyes searching poems and paintings for phrases and lineaments that evoke her" (140–1). Yet what interests me is how this seeming delay further underscores the validity of my interpretation of Helen as an artistic creation that results from José Fernández's impressionistic method of criticism.

Helen is an art object that results from and leads to the discovery of other art objects, since her image is constantly reworked in an ongoing process of artistic recycling. Given her origin in beatified female characters from the literary and pictorial arts, it comes as no surprise that she functions as an ideal creature (or ideal creation), as the asexual, unearthly, and saintly alternative to the other seven female characters in the novel, the so-called "horizontals" ("horizontales") whom José consumes, exchanges, discards, and even, on two occasions, treats violently. Consummating a relationship with a woman causes suffering rather than joy, disgust as opposed to pleasure, in Silva's protagonist, who longs desperately to return to the time when, as he explains, loving "without satiating love, and immortalizing Her name in songs or in statues … was a man's undertaking" ("fue empresa de hombres") (196–7). He laments the misery and decrepitude of his contemporary society "in which adultery is simple, indulged in out of harm's way, like a sport; in which the life of the woman is in its entirety a slow and gradual preparation for the fall, and in which the husbands come to visit the fortunate one to ask favors of him" (197). José thus contrasts this love in past ages

with that of the present, in which love (or the beloved) becomes a commodity to be bought, sold, and exchanged. The resistance on the part of José to consummate – that is, to profane – the relationship with Helen is significant. His desire to maintain the beloved as an ideal can be seen clearly when he symbolically imagines Helen moving without "*touching the carpet* … uncontaminated by the earth's atmosphere" (115). Similarly, when José's British psychiatrist, Dr. Rivington, asks his patient: "Do you intend to marry this beautiful young lady if you find her, and to start a family?" (124), José's response is one of shock, as indeed such bourgeois notions as marriage, family, and parenthood had never occurred to him despite all of his searching for Helen. "Good God," he reflects, "I, Helen's husband! Helen, my wife! The intimacy of daily dealings with her, the details of married life, that vision deformed by maternity … All the dreams in the universe had passed through my imagination except the one suggestion in the specialist's words" (125).

And just as he cannot imagine Helen in an intimate husband–wife relationship or as the mother of a child, so too does he fail to conceive of her death in terms of a decomposing physical body. This becomes poignantly clear in the diary's closing scene, when, upon discovering Helen's tomb in a Parisian cemetery, José begins to doubt whether she ever really lived:

> Her tomb? Dead, you? … No, you have not died; you are alive and will live always, Helen …
>
> You, dead, Helen? … No, you cannot die. Perhaps you never have existed and you are but a luminous dream of my spirit; but *you are a dream more real than what men call Reality.* What they call thus is but a dark mask behind which the eyes of mystery loom up and look out, and *you are Mystery itself.* (216–17, emphasis added)

As this poetic reflection suggests, there can be no wasting away or deterioration of Helen's body. She is an intangible creature – more spiritual than material, more art than life. Helen is, for the Spanish American poet protagonist, a dream more real than that which we call reality.[11] Given José Fernández's previous critique of reality as "all things mediocre, all things trivial, insignificant, and worthless" and of real life as "the emotionless bourgeois life … void of curiosity," it is revealing that at the close of his diary, he redefines Helen as

that which lies behind this reality (141, 56). As the previously cited passages suggest, Helen as "art" allows José Fernández to escape the mediocrity, triviality, insignificance, worthlessness, and emotionlessness of "life." The spiritual alternative that loving or – perhaps more accurately phrased – creating Helen promises is linked to her role as art object: just as the love for Helen remains unconsummated, so is art unconsumed; just as there is no end to this eternal and immortal love, so is the art object refashioned over and over again.

As the examples of the diary and of Helen show, the creation of one work of art stems from reading, viewing, and recreating or refashioning other artworks. Just as Helen is the product of other fictions both from within and without the novel, so too can she can be treated as an artwork used to stimulate the creation of a *third* and final creation, namely the "Villa Helena." If we recall Wilde's notion that "the work of art is simply a suggestion for a new work of his own, that need not necessarily bear any obvious resemblance to the thing it criticizes," since the artist's creation "may be merely of value in so far as it gives to the critic a suggestion for some new mood of thought and feeling which he can realize with equal, or perhaps greater, distinction of form, and, through the use of a fresh medium of expression, make differently beautiful and more perfect" (as well as Pater's argument that "the love of things of the intellect and the imagination for their own sake" leads to "new subjects" of poetry, "new forms" of art, and "new experiences" for both the artist and the artistic receptor), then we can make sense of the change in form and medium as José goes from creating Helen to constructing and adorning his "Villa Helena" (Wilde, "Critic" 388; Pater *Three Major Texts* 76–7). *De sobremesa* begins and ends with a description of the room in which the titular after-dinner conversation takes place. Even before the protagonists are described or their conversation begins, the decoration and adornment of the setting are highlighted, as if the passing light of a camera or the movement of an artist's brush were focusing on various objects, decorations, or props on the staged scene of another artistic creation – the performative recitation of the written journal. The fact that almost the exact same language is used in the opening and closing scenes to describe the adorned space warrants attention and consideration. The narrator chooses to repeat almost word for word the description of various concrete art objects ("[t]he tenuous smoke from the Oriental cigarette," "the blood-red velvet of

the rug," "the cut-crystal bottle," "[t]he fragile china cups," etc.), and such conscious and conspicuous repetition serves to remind us of the artistically constructed space in which the narration takes place (217).[12] It also reminds us of aestheticism's application in the fields of interior design and the decorative arts by figures such as Walter Crane and William Morris. Finally, it underscores the fact that for the Spanish American artist aesthete living in the periphery, most of the desired luxury items had to be imported (or collected) from abroad, namely from Europe or the Orient.[13]

Interestingly enough, José is criticized by his friends on account of the collection of art objects that adorn his villa. They accuse him of living an isolated existence "among the treasures of art" in an effort to "isolate" himself "from real life" (56). José's friends suggest that he ought to get rid of his riches, move out to the country, and live a simple life, so as to save himself from himself and be able once again to produce poetry. The invited guests believe that "hard work" will cure Fernández, and at one point the protagonist himself is convinced, stating: "I am going to ask of common and commercial operations and of the incessant employment of my material activities *that neither love nor art could give me*: the secret of enduring life" ("el secreto para soportar a la vida") (208, 214, emphasis added). Here it is suggested that in order to tolerate life, Silva's protagonist must avoid both love and art, and instead embrace work. This is a surprising and puzzling resolution, since work is clearly antithetical to the ideals the novel has promoted all along. As Evelyn Picon Garfield correctly notes, José Fernández "looks toward art and love as life-preservers" ("mira hacia el arte y el amor como salvavidas") (268, translation mine). It is in this light that we can understand José's final declaration – "I have not left [for New York]!" – as evidence of his belief that hard work and North American industriousness are not viable solutions (208). Moreover, this passage underscores the notion that "artistic production" – the creative work he *has* demonstrated throughout the novel – differs from "capitalistic production." The ideal the novel posits is precisely that José find a way to exist in the realm of art, rather than the realm of life – and it is in this regard that the overlap between Wilde's aestheticism and Silva's *modernismo* becomes evident.

By transforming the artist into an impressionistic critic who turns previous art and literature into sources for *new* literary creations and creates for a private audience outside the literary marketplace, Silva

redefines the role of the artist, protests the commodification and consumption of art, and promotes the philosophy of art for art's sake so as to critique specific aspects of industrial capitalist life. It is important to note that one of the main artistic creations in the novel, namely the journal itself, is neither published nor presented to a public readership; rather, José Fernández reads excerpts from his private diary to "el grupo," a select assembly of chosen receptors, i.e., his closest and most intimate friends. He insists on several occasions that he writes only for himself, as his notes serve to calm him and distract him from his moments of anguish. On the other hand, he also admits that he takes up the pen because he is possessed – as a true impressionistic critic should be – by the "eternal mania of turning [his] *impressions* into literary works" (149, emphasis added). Like Wilde's creative critic, José Fernández's "sole aim is to chronicle his own impressions" (Wilde, "Critic" 366). In this regard, we should reconsider the incorrect assertion of Fernández's friend, Máximo Pérez, who tells José: "the critic in you kills off the poet" (55). It is precisely the opposite, I would argue, insofar as the critical faculty allows Fernández to be creative and artistic. Whether the journal was meant only for José or whether he intended to turn it into a work of literature with a corresponding public, the truth remains that he shares his verses only with his friends, and it is through this structure that Silva presents his novel to us. José Fernández's guests need to hear something unedited in order to disinfect their soul (61). We see here evidence of the notion that art, when kept out of the public and mercantile sphere, can serve a spiritual role with regard to its receptor. Confining art to the private sphere seems to be one way of preventing it from becoming a commodity or object of exchange, which is what would happen if it were introduced into the literary marketplace.[14] As Domna C. Stanton rightly notes in *The Aristocrat as Art: A Study of the Honnête Homme and the Dandy in Seventeenth- and Nineteenth-Century French Literature*, "[i]n its extreme form, the commitment to uselessness went so far as to preclude the production of a literary text. ... This refusal to produce a tangible work of art, an object of consumption to be sold in the marketplace to vulgarians, becomes proof of uncompromising artistry" (96). Keeping his art out of circulation allows Fernández's writing to retain its artistic qualities. Sheltering art from life seems to be a conscious goal of Silva's protagonist.

Moreover, given his private audience and unpublished work, Fernández can also distance himself from the occupational qualities typically associated with the artist figure in Spanish America's bourgeoning market economy, and this is something Silva clearly aims to do.[15] Lamenting the wasted existence of those who die having lived "locked into a profession, to a field of expertise, to a belief, as in a prison that has only a single window open always onto the same horizon," José Fernández praises ephemerality and insists on the need to vary one's endeavors and roles (56). It is important to recognize that even when he does follow his passions into the artistic realm, it is never permanently, and certainly not in the vulgar bourgeois sense of having an occupation. José is proud to confess: "just as poetry fascinates and attracts me, so too does everything fascinate and attract me, irresistibly" (55). As a result, he cannot conform his actions to any single sphere simply in order to chisel sonnets ("ponerse a cincelar sonetos") (56). Yet the problem for him does not seem to be as much with the sonnets themselves, as it is with the act of *setting out* to chisel them, that is, with consciously aiming to create them, rather than being inspired to create them as a result of the reception of some other aesthetic object.[16] As he explains elsewhere in the novel, one should not actively seek to produce art, since "[v]erses make themselves inside one, one does not make them, one simply writes them down" (60). Stimulated by one aesthetic creation to make another, the artist has to be moved and inspired by art in order to create art. In this way, José Fernández lays "down a double challenge – to the bourgeois perception of the literary work as a commodity for consumption [... and] to the archbourgeois notion of 'work' itself" (Stanton 98).

This leads us to a consideration of the final way in which *De sobremesa* redefines the role of the artistic producer and rejects the consumption of the art object by promoting a form of artistic recycling. The recycled or refashioned artwork, that is, the critic's conversion of one artwork into another, refuses to be a consumer good, owing to the fact that its production process is never-ending. The term "consumer good" refers to products that are ready for consumption in satisfaction of human wants and are not utilized in any further production. In light of this definition, we see that the production of new art based on, or inspired by, previous art cancels out the definition of consumer goods, since such aesthetic recycling

ensures that art remain a raw material to be used in further creation processes. The recycled material, then, is this impression of beauty, the aesthetic value of the work of art – not something tangible, sellable, marketable, or exchangeable. As a result of such recycling, Silva's appropriation of Wilde's impressionistic or artistic critic for his protagonist serves to protest the commodification and consumption of art and transplant the philosophy of art for art's sake to the Spanish American subcontinent – creating a viable link between British aestheticism and Spanish American *modernismo*.

It is important to note, of course, that my use of the verb "to recycle" differs from the general conception of the term. As it is commonly understood, to recycle means to reuse or make something new out of the container, medium, or outer shell of a product in which the content has already been consumed and used up, whereas I consider the ways in which one's impression of art is altered and reused. Silva's protagonist recycles the impression caused by the artwork, as opposed to its concrete aesthetic form or specific artistic content, and this key difference ensures that art's substance is not copied, consumed, or commodified. Nonetheless, the emphasis still remains – in a clearly aestheticist fashion – on the form, the surface, the appearance of the art object as that which is made anew. If consumption is defined as the act of using up, taking away, wasting, or eating, and as a process that "involves the destruction of matter" and is "equivalent to destruction, waste, decay – in short, to a death-directed process," then it comes as no surprise that consumption has traditionally been viewed as "the end of the road for goods and services, a terminus for their social life, a conclusion to some sort of material cycle" (Williams 5–6; Appadurai 66). Thus, the difference between a mode of production (artistic or otherwise) based on recycling versus one based on consumption is a significant one: the former leads to creation and rebirth; the latter leads to destruction and death.

Given these considerations of the artist as creative receptor and of art as the subjective impression in *De sobremesa*, it becomes clear that such a characterization of the artist and art object proves to be a useful strategy for Silva insofar as it allows him to ensure that the relationship between writer–text–reader (or, more broadly conceived, artist–art object–receptor) is *not* akin to that between producer–commodity–consumer. In the ideal promoted by Silva's

protagonist, the reader does not simply consume the text as one would a commodity; on the contrary, the reader acts as an artist in an ongoing creative process that rejects consumptive reading. Yet in contrast to Rubén Darío, for example, whose artist protagonists in short stories such as "El Rey Burgués" or "El pájaro azul" either die or commit suicide as a result of the ways in which modern capitalist society is hostile to the success of the artist figure and inimical to the appreciation of aesthetic value, Silva allows his protagonist – although regrettably not himself – to overcome the difficulties faced by the Spanish American artist,[17] and this involves aligning his character with the type of artistic critic of which Wilde writes. We can therefore conclude that José Fernández *does* become involved with artistic creation, even if he rejects the label of "poet," namely because he redefines what it means to be a poet as someone who is moved and influenced by, for example, "the tender ingenuousness of the Pre-Raphaelite painters, the subtleties of Japanese art, the grandiose symphonies of Wagner, the pitiable characters that cross the gray shadows of Dostoyevsky's novels, the otherworldly creations of Poe" (102). Yet, in spite of this and other lengthy lists of authors, artists, and artistic movements named in *De sobremesa*, it appears to be the *unnamed* influences of Wilde and British Aestheticism[18] that best account for José Fernández's artistic method, since he clearly agrees with Wilde's contention that "[i]t is through Art, and through Art only, that we can shield ourselves from the sordid perils of actual existence" ("Critic" 380). According to Silva's novel, "Art" encapsulates the spiritual, sacred, elevated, sublime and pure, whereas "life" represents the profane, material, mundane, base, and deplorable. Art must be separated from life in order to maintain its desirable qualities, and the artist must turn himself into a creative or impressionistic critic in order to put into practice the "art for art's sake" methodology needed to safeguard art from life.[19] Thus, whether critiquing mimesis and morality in art, as does Wilde, or criticizing the commodification and consumption of art, as does Silva, the notion of the artist as impressionistic critic allows the artist figure to find solace in an artistic realm where art is for art's sake and life is too far and too distant to intrude.

Part II
The Artist Protests "Art for the Market's Sake"

Introduction

Part II of this study considers how the aestheticist and *modernista* ideals of "art for art's sake" emerge as a response to pressures to produce or consume art in accordance with the dictates of turn-of-the-century industrial capitalist society. In this instance, then, "art for art's sake" is not pitted against "life" in general, but rather against a specific (yet very pervasive) part of life: the capitalist marketplace. Given that market values come to determine artistic worth in the nineteenth century, both movements emerged as a way of contesting the changes in the broad political economy of literary life that have made "artistic worth" seem to be something "worthless."[1] I wish now to explore the tension between literary works and literary protagonists that *accommodate themselves to* the changes brought about by the emergence of a literary marketplace during the nineteenth century ("art for the market's sake" or "art for capital's sake"), in contrast to those that *work against or in spite of* such changes ("art for art's sake). Speaking of what we might term "pure artists," the true aestheticist and *modernista* authors (and artist protagonists) did not alter their work to please editors or buyers or to ensure marketability or profit. Yet despite the resistance on the part of these artists – both real and fictional – to succumbing to market demands, we cannot deny the fact that there are both surprising similarities and marked differences between aesthetic interests and market tendencies in both literary traditions.

Many of the dominant characteristics of European aestheticism and Spanish American *modernismo* find parallels in the nineteenth-century

market economy. The shared emphasis on newness, originality, and autonomy overlaps to a significant extent with the similar interests of industrial-capitalist society. Constant technical advancements infused bourgeois society with an ardent desire to be up to date, and the same desire is also manifest in the literary and artistic realms as a driving force behind aestheticism and *modernismo*. Literary practitioners replicate on the aesthetic plane what was already occurring on the material plane: the goal of innovating, improving, renewing, and upgrading the technique or the so-called "means of production." Interestingly enough, both movements appear here to be copying – rather than distancing themselves from or critiquing – the life-world. The literary quest for new structures, forms, and materials replicates the liberal-capital ethos of bourgeois life in which one tries to go beyond existing frontiers; likewise, the aesthetic utopia of total artistic freedom is analogous to the market utopia of total business freedom (Bell-Villada 145). Thus, the desire for artistic innovation suggests that these movements' "art for art's sake" tendencies may indeed be following, albeit despite themselves, the logic of commodity culture.[2]

Even though art for art's sake's call for newness, originality, and renovation of style parallels market tendencies, one cannot deny that aestheticism and *modernismo* defy the market in other, significant ways as well, namely because of the unmarketability of their artistic gifts and the various ways in which their art was marginal to the dominant literary discourses of the period. Upon citing Karl Marx's famous statement in *Theories of Surplus Value* that "capitalist production is hostile to certain aspects of intellectual production, such as art and poetry," Gene Bell-Villada explains that *"l'art pour l'art* was the position adopted by certain authors whose specific mode of discourse and personal rhythms of production conflicted with demands of the newly industrialized literary market" (*Literature and Art* 28, 50). Whereas under the *ancien régime* art had existed almost exclusively under the sway of princely patronage, great changes had been taking place in the institutional machinery of Europe since 1789, changes which meant that "sources of support that had been available under hegemonic feudalism or modified monarchy were comparatively diminished or even negligible in scale" (Bell-Villada 41, 138). The role of former patrons of the arts declined under the industrial-capitalist system, leaving fewer aesthetic works to be commissioned.

Having lost their royal, ecclesiastical, noble, or academic support-
ers, artists – particularly poets – began to recognize that they were
at odds with the new system of literary production, one in which
"the pressure to produce more goods for expanding markets, at even
faster speeds, relegates traditional crafts to the margins of society
and renders complex skills obsolete" (Bell-Villada 45). The economic
motive of producing as much as could be sold – so as to satisfy the
reading demands of the growing middle classes and also to pay for
the technical machinery that made increased production possible in
the first place – meant that art forms that could not sell to mass audi-
ences lost their privileged place in a cultural sphere determined by
market rules of output and genre. Poetry as a literary art, with its lim-
ited audience and unquantifiable character, becomes marginalized
by new technologies on account of the fact that selling art in high
quantities was necessary to pay for the machinery that made printing
in high quantities possible in the first place. The carefully and slowly
crafted verse of aestheticist and *modernista* poets lacked function and
salability in the mass print culture of the bourgeois marketplace. The
overarching concern with form in aestheticist and *modernista* works
of art demands intense labor and prolonged periods of production,
not to mention that such "pure" verse generally fails to please the
aesthetic demands of the masses. As a result, the application of the
concepts of profitability, marketability, and the laws of supply and
demand to these specific artistic creations threatened their survival,
as artists from both movements struggled with differing standards for
aesthetic versus economic criteria.

By examining the multifaceted relationship between art and capi-
tal, aesthetics and economics from the dual vantage points of pro-
duction and consumption,[3] I consider in the next two chapters the
responses of representative European and Spanish American artists to
the advances of modernity, explore the changing role of art and the
artist, and discuss the fate of aesthetic values in the face of market
values. Both chapters in Part II assess how the selected fictional char-
acters react to and deal with two related problems that escalate in
this precise *fin de siècle* moment: the devaluation of the artist and the
commodification of the artwork. Chapter 3 examines the difficulties
of "consuming" art in industrial capitalist society through a con-
sideration of Joris-Karl Huysmans's novel *À Rebours* (*Against Nature*,
1884), while Chapter 4 explores the problems of "producing" art in

the burgeoning Spanish American literary marketplace in three of Rubén Darío's short stories: "El Rey Burgués" ("The Bourgeois King," 1887), "El velo de la reina Mab" ("Queen Mab's Veil," 1887), and "El pájaro azul" ("The Blue Bird," 1886). Among the queries that underlie this analysis of Huysmans and Darío are the following: What is the role of the artistic producer or consumer in the turn-of-the-century period? How is the artistic producer or consumer *re*defined – both by society for these real-life authors and by these authors for their fictional characters? How can the artist avoid being contaminated or compromised by the socioeconomic forces of industrial capitalism? How does the *fin de siècle* artist deal with the conversion of aesthetic value into the commodity form of value? Whereas Huysmans levies a staunch criticism of the bourgeois act of capitalist accumulation and the prison-like hold the market has on its members, Darío portrays an ongoing critique of bourgeois society as hostile to artistic creation and inimical to the appreciation of aesthetic value. The French author reveals the preoccupations of artistic consumption, while the Nicaraguan writer addresses the concerns of artistic production. In addition to portraying negatively the art object as a commodity, both authors attempt to narrate alternative, albeit unsuccessful, solutions to the mass consumption and capitalist production of art in *fin de siècle* Europe and Spanish America, respectively. Huysmans promotes his protagonist, Duke Jean des Esseintes, as an elitist taster who appreciates the unprofaned and the unconsumed as art. Darío presents his artist heroes as creators, not producers, whose unsold and unappreciated art nonetheless retains its artistic value. What these two authors from opposite sides of the Atlantic share is a common interest in contrasting real art, real artists, and real art lovers with those who accumulate for accumulation's sake, who only appreciate products with a practical purpose, and who are bound by a materialistic worldview that makes them blind to the spiritual side of existence that art aspires to reveal. Nonetheless, both authors fail to offer plausible solutions to the crisis in aesthetic value that they observe in the 1880s. Despite the escapism that is temporarily narrated, Huysmans's and Darío's fictions underscore the impossibility of preserving elitist standards of artistic consumption and production in the modern period. They also communicate the lamentable belief that aesthetic activity fails to provide a long-term solution for those who reject dominant market values and bourgeois taste and seek

instead to preserve an elitist element in art, even as class categories are being reconfigured and equality as an ideal is being everywhere promoted. Still, by trying to separate aesthetics from production and consumption practices and by attempting to avoid the fate of "art for the market's sake," the chosen authors and their selected texts critique the dominant social and economic values that made such a redefinition of art and the artist necessary in the first place.

3

The Artist as Elitist Taster: The Unprofaned and Unconsumed as Art in J.-K. Huysmans

In Huysmans's *À Rebours*, Duke Jean des Esseintes, the novel's non-conformist and contestatory protagonist, opposes consumption in its modern commercial form, that is, in its mass-reproduced form in which formerly elitist goods are now available to all regions and classes as a result of the rise in production efficiency, the boom in mass marketing, and the decline in prices that accompany high-volume sales; instead, he chooses an alternative path of elitist tasting and savoring and moves even further away from mass consumption toward refusal of consumption, as a way to access an idealist "reality" of unprofaned and unconsumed art, which he deems more real than the social realities of consumer society. In this way, Huysmans's novel reveals a general critique of capitalist consumerism as its decadent protagonist[1] seeks a way to appreciate art that is free from the capitalist marketplace in which he feels trapped and with which he is dissatisfied.

Fed up with the "bourgeois optics" of his contemporaries, Des Esseintes's "distaste for accepted ideas had hardened to disgust" (29, 96). We see evidence of this when he rejects Oriental rugs and fabrics as "commonplace and vulgar now that upstart tradesmen could buy them in the bargain basement of any department-store," and also when he finds diamonds to be "terribly vulgar" once "every business-man wears one on his little finger" (30, 51). Revealingly, he prefers the sapphire among jewels on account of its "inviolate" and "unsullied" quality (55). Des Esseintes further advocates such exclusionary and elitist taste when discussing his belief that "just as the loveliest melody in the world becomes unbearably vulgar once the public start

humming it and the barrel-organs playing it, so the work of art that appeals to charlatans, endears itself to fools, and is not content to arouse the enthusiasm of a few connoisseurs, is thereby polluted in the eyes of the initiate and becomes commonplace, almost repulsive" (108–9). Given his refined artistic taste and desire for the unpopular and unprofaned, Des Esseintes fears the equalizing threat posed by mass consumerism, and thus he tries single-handedly to resist "an unauthentic market and to create his own ideal of consumption," an ideal based on the search for the unsullied and the inviolate (Williams 129).

Des Esseintes withdraws from the world in an effort to preserve his vision of the ideal form of artistic consumption or aesthetic appreciation. Tempted by the idea "of hiding away far from human society," he removes himself from "the tidal wave of Parisian life" in order to fashion for himself a fresh existence in the peaceful silence of his new residence at Fontenay-aux-Roses (24–5). It is in this exclusionary setting that he hopes to escape the dominant spirit of the age, "this terrifying world of commerce" (134). Des Esseintes spares no group or class from his all-pervasive social critique: he attacks "the decaying nobility," which "had sunk into imbecility or depravity [... and] was dying from the degeneracy of its scions" (213–14); he derides the clergy for its "passion for profits" and "love of lucre," which has caused monasteries to turn into factories or distilleries as "commercialism invaded the cloisters" (214); he criticizes the bourgeoisie's rise to power, which has brought about "the suppression of all intelligence, the negation of all honesty, the destruction of all art," as faith is now put "in the power of ... money" (218); and, finally, he disparages "the common herd," which is characterized as those "waves of human mediocrity" and "the base and servile riff-raff of the age" (56, 219). Des Esseintes deplores commercialism in general and aims to demonstrate the ways in which it affects negatively all levels of society. In his estimation, nothing remains sacred; commerce has profaned everything.

Huysmans makes it strikingly clear that his protagonist's dislike of capitalist society "had inevitably affected his literary and artistic tastes, so that he shunned as far as possible pictures and books whose subjects were confined to modern life," choosing instead either to "return to past ages, to vanished civilizations, to dead centuries" or to pursue "dream and fantasy, a more or less vivid version of a future

whose image reproduces, unconsciously and as a result of atavism, that of past epochs" (180–2). Feeling estranged in a commercially oriented market economy of bourgeois mediocrity and philistine materialism, Des Esseintes unmistakably supports an "art for art's sake" position in the face of the pressure to conform to an "art for capital's sake" approach. He critiques his society's mistreatment of art and the artist in the changing literary marketplace and launches a caustic if reactionary critique of the ways in which industrial-capitalist society had undermined all that had been glorious and desirable in previous epochs. Unsatisfied with the work of his contemporaries, Des Esseintes defines his aesthetic philosophy and refines his artistic taste via recourse to the past and a nostalgically driven contemplation of the future. Simply put, he wants to rise above both mass reproduction and the resulting call for mass consumption by taking flight into a realm of fantasy and fiction or retreating to far-off places. Having first removed himself physically from the society he loathes, Des Esseintes now severs himself – intellectually, spiritually, aesthetically – from the age of industrial capitalism.[2] And he does this, as Rosalind Williams rightly notes, by seeking aesthetic works that "transcend the supposed vulgarity of ordinary consumption through a uniquely individual arrangement of commodities serving lofty spiritual and aesthetic ideals" (13). In other words, he isolates himself in a realm of carefully selected art objects and attempts to redefine beauty and aesthetic value based on the promptings of his own artistic tastes. To prevent the market from determining artistic worth, Des Esseintes must isolate himself from the commercial world altogether so as to shun products with a pragmatic and practical purpose as well as those directed toward crass and materialistic ends. His act of "investing objects with aesthetic value" has the potential, then, to reconfigure the accepted hierarchy of goods by turning commodities into art, by converting exchange-value into use-value (Swenson 52).

In his new home, which is designed solely "for his own personal pleasure," Huysmans's protagonist aspires "towards an ideal, towards an unknown universe, towards a distant beatitude" (28, 89). He lives the life suggested to him by Mallarmé, who "in an age of universal suffrage and a time of commercial greed, lived outside the world of letters, sheltered from the raging folly all around him by his lofty scorn; taking pleasure, far from society, in the caprices of the mind and the visions of his brain" (196). He also strives to achieve the

ideal presented to him in the works of Flaubert, namely "the fever-
ish desire for the unknown, the unsatisfied longing for an ideal, the
craving to escape from the horrible realities of life ... in the misty
upper regions of art" (115). Simply put, Huysmans's hero meditates
on artistic themes, pursues a literary diet, and gorges himself with
literature and art. His retreat from the external world leads him to
the internal confines of not just the home, but also the mind – the
mind of a unique and original artist.

Though he may not be an artist in the producing sense, Des
Esseintes continually showcases his artistic sensibilities as a way to
distinguish himself from his inferior and loathsome contemporaries.
Thus, in spite of the fact that many critics insist that he "was not a
creative type" or that he was "[u]nable to create," it is possible to see
Des Esseintes's commitment to "cultivating the exotic, prenatural,
and involuted world of his fantasies" as well as "sensual highs" as
a creative and artistic endeavor (Knapp 204, 205, 203). He indeed
proves to be a connoisseur of various art forms: from colors to
tastes, from horticulture to perfume making, from art and literature
to music and precious stones, and he manages, in this way, to turn
consumption into a creative act. In "Consumption as the Vanguard
of History," Daniel Miller attempts to vindicate consumerism and
to dispel its pejorative connotations by promoting it as a form of
"empowerment" with "positive" or "even transgressive" conse-
quences for the consumer, who engages in "creative labour" and
becomes a "paragon of creative individualism" (41, 27–9). According
to Miller:

> To be a "consumer" as opposed to being a producer implies that
> we have only a secondary relationship to goods. This secondary
> relationship occurs when people have to live with and through
> services and goods that they did not themselves create. The con-
> sumer society exists when, as in industrialized societies today,
> most people have a minimum relationship to production and
> distribution such that consumption provides the only arena left to
> us through which we might potentially forge a relationship with
> the world. (17)

It is undoubtedly true that Des Esseintes's method of "forg[ing] a
relationship with the world" involves consumption. The notion

that consumers can autonomously "employ their resources for the self-construction of their individual and social identity" and "extract their own humanity through the use of consumption as the creation of a specificity, which is held to negate the generality and alienatory scale of the institutions from which they receive goods and services" is based on Miller's belief that "[t]here is no single or proper way to consume" (42, 31, 41). Clearly, for Des Esseintes, consuming becomes a mode of self-formation – even if his individual identity is opposed to some larger or collective social identity; we might even agree that consuming is empowering and transgressive for him. Yet Huysmans's protagonist nonetheless refuses to accept a plurality of consuming behaviors. For him, there is clearly a right and a wrong way to consume. It is because he views everyone else as consuming in a unified way – a way dictated to them by what the capitalist economy produces for them and then persuades them to buy; a way that simply equates consuming with buying – that he attempts to overcome consumption as a mass practice and engages in an exclusionary and elitist form of consumption. In short, Des Esseintes believes that mass consumption has destroyed essential and significant differences between people and between objects. In response to the homogenization and cultural erosion that results, he aims to recover authenticity and superior aesthetic standards.

In order to do this, he must keep art away from both the social and the natural world and develop his own personal aesthetic philosophy, one characterized by his "penchant for artificiality and his love of eccentricity" (88). As the narrator explains: "artifice was considered by Des Esseintes to be the distinctive mark of human genius," namely because "anyone who dreams of the ideal, prefers illusion to reality, and calls for veils to clothe the naked truth" (36, 29). According to Des Esseintes, the time has surely come for artifice to take Nature's place, since Nature merely "supplies the raw materials," while it is man who "rears, shapes, paints, and carves [it] afterwards to suit his fancy" (102). Vilifying nature as being "like a tradesman … like a shopkeeper," Des Esseintes insists that there is not a single invention of nature that human ingenuity cannot manufacture, reproduce, imitate, counterfeit, or match to perfection (36–7). Des Esseintes's freedom from work and his isolation from the marketplace allow him to engage in an ongoing process of aesthetic experimentation in which he aims to acquire artistic works or invent aesthetic pleasures

untainted by the unacceptable aesthetic standards of his contemporaries. His preference for the imitation over the real (e.g., the ability to imitate natural smells by mixing artificial ones, the chance to substitute oral intake of real food with rectal injection of liquid food, the opportunity to improve upon nature by having a tortoise's "buckler glazed with gold [… and] encrusted with precious stones") reflects his overall desire to distance himself from the social and natural world and to embrace the artistic – or simply the artificial – realm (54). Yet on other occasions, Des Esseintes seeks out the real, but only if it gives the appearance of the unreal, as seen when he desires "natural flowers that would look like fakes" or wants "magnificent materials to give the impression of old age" in the decoration of his bedroom as a monastic cell (97, 75). In either instance, "his inborn taste for the artificial" remains the dominant aesthetic principle as he withdraws from both the natural and social spheres (97). As Robert Ziegler accurately explains, for Des Esseintes "[w]hat is real in art is what unrealises nature, subverts the monolithic crudeness of commercial bourgeois values" (367).

As an extension of his preference for artifice over nature, Des Esseintes also privileges the mental over the material, as he gives new meaning to the phrase "mind over matter." Let us consider, for example, his comments regarding the stationary "sea-voyage" in which "one can enjoy, just as easily as on the material plane, imaginary pleasures similar in all respects to the pleasures of reality" (35). Thus, as a result of his own contemplative capacities, Des Esseintes is able "to enjoy quickly, almost simultaneously, all the sensations of a long sea-voyage, without ever leaving home" (35). The inert and stationary existence reinforces his belief that "the imagination could provide a more-than-adequate substitute for the vulgar reality of actual experience" (35). Owing thus to his contemplative power, he continually fashions something new out of his otherwise limited surroundings, while still managing to avoid contact with the outside world. As the narrator explains: "He had to live on himself, to feed on his own substance," since he had "no fresh food for thought, no exchange of impressions from the outside world, from mixing with other people and sharing in their life" (84, 87). Not only is he consumptive, but so too is he self-consumptive – and this is the consequence of trying to eliminate life from his mode of art.

It is important to recognize, however, that despite Des Esseintes's attempts to do for artistic consumption what he claims Edmond de Goncourt did for literary production, that is, to create "new acceptations, new uses, new forms," his search for the new leaves him forever disappointed (183). As the example of the digester suggests, his enthusiasm dies down just as suddenly as it is initially aroused (201). In so many instances throughout the novel, boredom grows "to infinite proportions" as the novelty of new aesthetic experiments wanes (108). And although this boredom is frequently a catalyst for new aesthetic experiments, the overarching message is that the protagonist's ideal is rarely attained and never sustained. The narrator continually reminds us that "nowhere in the world had he found the fairyland of which he had dreamt" (141); "he found it impossible to discover a book that satisfied his secret longings" (179); he suffered from "the irremediable conflict between his ideals and those of the world into which chance had ordained that he should be born" (179). Domna C. Stanton rightly explains that Des Esseintes "creates sensations never before experienced, and yet, not even his most imaginative experiments, whether with perfumes, foods, jewels, flowers, lights, furniture, or sex, can remedy his incurable ennui" (104). This is in part because Des Esseintes's mode of consumption is clearly based on what Arjun Appadurai terms "the aesthetic of ephemerality" (84). In his chapter "Consumption, Duration, and History" from the book *Modernity at Large: Cultural Dimensions of Globalization*, Appadurai argues that "not all consumption need be repetitive or habitual, but any consumption system that strives for freedom from habit is pushed towards an aesthetic of the ephemeral," namely because the search for novelty fuels the method (68). Despite the striving for freedom, then, Des Esseintes is a slave to his quest for newness and change, which are also, let us not forget, the aims of the marketplace. Whereas Paul Fox, in "Dickens À La Carte: Aesthetic Victualism and the Invigoration of the Artist in Huysmans's *Against Nature*," attempts to demonstrate that "Des Esseintes rejects only that which has already been corrupted, aesthetically polluted for him by consumerist tastes," the truth of the matter is that everything becomes corrupted and polluted for him over time, even that which was previously pleasing to his own rarified taste (68).

In *Dream Worlds: Mass Consumption in Late Nineteenth-Century France*, Rosalind Williams offers an illuminating interpretation of

Des Esseintes's flawed or failed mode of consumption. Upon labeling him "the most memorable consumer in French literature," she goes on to insist that he is a "heroic" consumer on account of his "lonely and agonized attempt to salvage the elitist ideal in an age of mass consumption" (Williams 127). In response to the equalizing threat posed by greatly expanding mass consumerism in late nineteenth-century France, Des Esseintes refuses "to accept any object that has become a popular item of consumption," Williams explains, yet as a result, he "is unable to evaluate objects independently of their market value" (137). Consequently, he "must keep buying and discarding, picking up and dropping items, perpetually on the move to keep one jump ahead of the common herd" (Williams 139). Thus, in a reverse way "his mode of consumption is just as dependent on the mass market" with its cult of novelty similar to that which propels the logic of capitalistic consumerism (Williams 137). We begin to wonder whether Des Esseintes can escape the logic of consumer culture, since market production and distribution determine what is considered refined or elitist, on the one hand, and popular or mundane, on the other hand. Despite the originality of his method, then, his experiment ultimately fails. He is fettered by the logic of consumer culture insofar as he identifies strongly with the objects he consumes and defines his status or worth according to those products. Des Esseintes is likewise trapped by the wisdom of commodity fetishism in that he continually describes what he sees as "material relations between persons and social relationships between things" and imbues objects with "a life of their own" (Marx, *Capital* 165). As Bettina L. Knapp rightly notes, "[u]nbeknownst to des Esseintes, exile was really a strategy: the elimination of the world of people and its replacement by a world of things" (205). And precisely because he "replaces relationships with nature or with people by relationships with *things* – specifically, with market items," he cannot escape "the grip of the market, for it continues to dictate its values on him" (Williams 149). Hence, Williams rightly notes a parallel between Des Esseintes's "private hell" and "the social hell he desperately wants to escape" in that commodity fetishism fuels them both (148). In other words, in spite of his attempts to escape life and embrace art, the market is too pervasive and its forces are too ubiquitous or too omnipresent to be avoided.

Ultimately, Huysmans's text offers no solutions to the problems it acutely addresses. Des Esseintes's experiment is continually

undermined by the return of repressed natural urges and social reali-
ties, which force him to choose "between death and deportation"
(211). His doctor explains that the recluse "would have to abandon
his solitary existence, to go back to Paris, to lead a normal life again,
above all to try and enjoy the same pleasures as other people" in
order to ensure his good recovery (211). The narrator recounts the
protagonist's thoughts regarding the horror of having to return to
Parisian society:

> Had he not outlawed himself from society? Had he heard of any-
> one else who was trying to organize a life like this, a life of dreamy
> contemplation? Did he know a single individual who was capable
> of appreciating the delicacy of a phrase, the subtlety of a painting,
> the quintessence of an idea, or whose soul was sensitive enough
> to understand Mallarmé and love Verlaine? (213)

Des Esseintes's inevitable decline in health, which mandates his
return to society, is primarily a result of his staunch refusal to "leave
the shelter of this haven of his," that is, of his persistent and self-
imposed alienation (213). Although Des Esseintes may have pre-
tended to invert nature, nature sooner or later gets the better of him.
His solipsistic and cloistered existence brings about the disintegration
of his own ability to nourish himself, and this leads to a depletion
of his vital energy. His world has "become fungal and parasitic, feed-
ing exclusively on itself," which serves to suggest that Huysmans's
depleted and solipsistic protagonist had not been "liberating, but
destroying himself" with his method (Knapp 211; Lloyd 99). Should
Des Esseintes fail to reintegrate himself into the society he loathes,
"insanity speedily followed by tuberculosis" would be his fate as he
goes "either mad or consumptive" (212, 211). Ironically then, this
avid yet elitist consumer runs the risk of dying from "consumption."
Considering the term "consumption" with regard to both its medi-
cal and economic definitions, we realize that Des Esseintes must give
up his method of consuming or else become consumptive, since on
account of its derivation from the Latin root *consumere*, consump-
tion "refer[s] not only to the use of commodities but also to the
wasting away of the body (specifically, in tuberculosis), for in both
cases the process involves the destruction of matter" (Williams 5).
Consumption can thus be considered the "equivalent to destruction,

waste, decay – in short, to a death-directed process" (Williams 6). Des Esseintes's seemingly creative form of "consuming" fails to save him from consumer culture. Huysmans's artist turned elitist taster cannot help but find commodities rather than the unprofaned or unconsumed art that he seeks, as indeed the novel ends up sounding very much like the pages of a consumer catalogue and its protagonists comes to resemble the "collector" who "idealizes objects in order to camouflage their status as commodities" and tries, unsuccessfully, to use the interior of his home "as a rampart against the city and the encroachments of the market" (Parkhurst Ferguson 37). His "art for art's sake" approach is finally overpowered by the "art for the market's sake" tendencies of his contemporary society, despite his valiant efforts to the contrary.

4

The Artist as Creator Not Producer: The Unsold and Unappreciated as Art in Rubén Darío

Central to Rubén Darío's literary corpus is a preoccupation with the ways in which the socioeconomic sphere protrudes into the artistic realm. It is important to establish from the outset that whereas Rubén Darío has been seen, in general, as Ricardo Szmetan rightly notes, "as a poet little attuned to man's problems in his social environment," the truth of the matter is that his short stories, especially those from *Azul*, "are evidence of the courage of the writer" insofar as they show "real societal problems through the suffering characters" and demonstrate "some of the principal concerns regarding the poet's condition" (415, 423, translation mine). Darío incorporates "latent rebelliousness and real social protest" into these stories, which underscore the fact that "the situation created for the artist requires the artist to invent artificial worlds outside of daily reality, expressing in this way his discontent with a social system little interested in the products of pure creation ["en los frutos de la creación pura"]" (Szmetan 415, 417, translation mine). Darío's societal concerns are best captured in three of his most famous short stories from the collection *Azul* (*Blue*): "El Rey Burgués," "El pájaro azul," and "El velo de la reina Mab." Given that the artist figures in these tales die (the nameless poet in "El Rey Burgués"), commit suicide (Garcín, the poet in "El pájaro azul"), or else fantastically escape bourgeois reality altogether (the four bohemian artists in "El velo de la reina Mab"), we can begin to locate in Darío's work a desire to protect his artist protagonists from the negative repercussions of turn-of-the-century society and to keep art away from the tasteless and consumptive masses. "Art for art's sake" is clearly pitted against

"art for capital's sake" or "art for the market's sake" in each of these literary works.

In contrast to Chapter 2's consideration of the ways in which Silva aligned his character with the type of artistic and impressionistic critic of which Oscar Wilde writes in order to allow Fernández to exist in a realm of art and thereby avoid the world of life, Chapter 4 examines a series of artist protagonists who are less successful in separating the two spheres. In the end, Darío cannot help but demonstrate the futility of his characters' wishes, as the artists' "art for art's sake" ideals are ultimately thwarted within each of the aforementioned stories. Darío wants to establish the artist as a creator, and not a producer, but in order to do so he must limit the artist's work to that which remains unsold and unappreciated. The discontentment with capitalist society and bourgeois culture evident in Huysmans's novel parallels the lamentations of Darío's artist protagonists, although now the criticism comes from a different vantage point as it is viewed from the perspective not of the consumer but rather the producer of art. The artist's inability to find a corresponding public for his creations in the Spanish American context corresponds to the art consumer's inability to find corresponding art objects for his elitist taste in the European context.[1] Such refined standards in consumption find echoes in the aristocratic ideals for artistic production among the Spanish American *modernista* writers, even if their social position does not allow them the same luxuries as consumers, as Darío's starving and struggling artist protagonists serve to remind us.[2]

Darío's characters feel bitterly the decline of artistic value and aesthetic taste that was to characterize their life-world in general and their corresponding audience in particular. It is the contrast between the bourgeois king and the revolutionary poet in "El Rey Burgués" that sets the stage for a consideration of art's role in capitalist society. By transforming the elite monarch into a bourgeois consumer and collector, whose name, King "Mecenas," which translates to "patron or sponsor," paradoxically symbolizes the end of the patronage system, Darío launches a criticism of the reduction of art into an exchangeable and valueless commodity. In response to the interlocutor's question – "Was he a poet king?" – the narrator insists: "No, my friend: he was the Bourgeois King" (3). In "La ideología de la clase dominante en la obra de Rubén Darío" ("Ideology of the Dominant Class in the Work of Rubén Darío"), Carlos Blanco Aguinaga notes

the ironic and contradictory nature of this story's title and of the king's label as "bourgeois": "king and bourgeois are terms that oppose one another … king refers us to precapitalist social structures, while bourgeois, obviously, is one of the key terms of the capitalist mode of production" (520–1, translation mine). The king's decline into bourgeois status, claims Blanco Aguinaga, stems from the fact that "this king (as rich, elegant, and powerful as the best of them) is not himself a poet. Consequently, he is a bourgeois king" (525, translation mine). I would go further in this assertion to state that not only is the king himself not a poet, but he lacks all appreciation of poetry as an art form, and it is this decline in aesthetic taste that binds him to the capitalist mode. Simply put, the monarch, with his "amassed riches and marvelous art objects," represents the spirit of capitalism and the death of aesthetic value (5). Despite his "Good taste" and "Refinement" – terms used by the narrator in an ironic fashion to mock rather than praise the monarch – he has never before seen anything as "new and strange" as a poet (5, 7). Upon noticing this "rare breed of man," the king asks the members of his court: "What is this?" (5). His choice of the word "What" instead of the term "Who" foreshadows the treatment of the artist figure, who is transformed from a person to a thing, from a subject to an object, from a creator to a worker. Moreover, the king's lack of familiarity with poets in general reflects the market economy's rejection of poetry on the grounds that it is an unsalable genre that does not accommodate itself to the laws of supply and demand. Darío further explains that although the bourgeois king "was very fond of the arts," his collection of art objects has been chosen for "luxury, and that's all," which explains why he silences the poet's verses and treats him as if he were another adornment or commodity at his disposal, one that he can place in the garden – symbolically "near the swans," the emblem of Spanish American *modernismo* – to entertain passersby (3, 5, 9).

The poet's own need for sustenance proves to be his downfall, since on account of his hunger, he can neither resist nor survive as a poet in the world of capitalistic consumption. His first words to the king, "Highness, I haven't eaten," serve to set up a relationship of exchange, in which words will be traded for food (7). Yet the king's command – "Speak and you'll eat" – soon becomes altered, as the poet must make music rather than poetry (7). "You'll turn a crank. You'll shut your mouth," insists the monarch, "No gibberish, no

talk of ideals" (9). The new bargain – "A piece of music for a chunk of bread" – clearly underscores the king's position as a bourgeois employer who exploits the working class and transforms intellectual labor into wage labor and artistic creation into piecework (9). Moreover, given the privileging of musicality in Spanish American *modernismo*, it is very significant that the making of melodies is here confined to the repetitive action of turning the crank of a barrel organ; art has become sterile, unoriginal, mechanical, and anti-aesthetic: it is only the recurrent sound "deedle-deedle-dum, deedle-deedle dum …" (9). Were it not for the precarious economic situation of this artist protagonist, one which clearly resembles Darío's own financial woes, he might retain his artistic dignity and remain true to himself. Unfortunately, however, he does not have the elevated social status that allowed José Fernández and Des Esseintes, for instance, to remain apart from society in their respective homes and to be relatively free from the demands of the marketplace.

By reinforcing the notion that the hungry poet "had to fill his belly," Darío's text raises several provocative questions: How can one *not* "sell" art in capitalist society? How does one uphold aesthetic value, when one has to exchange it daily for a piece of bread, that is, use it in order to earn a wage, a living, a meal? (9). If the artist's poverty and hunger constantly remind him of his human and bodily needs, he will surely find it difficult to escape into what Des Esseintes called "the misty upper regions of art," since life is always dragging him back down (115). In part because of this fact, the tension examined here is no longer simply that between art and life, but rather between the specific aspects of life that seem so opposed to art and to an aesthetic enjoyment of life, namely the economic and market forces that limit the artist's success. Forced to neglect his artistic vocation, "the poor man," Darío's neglected poet, "felt the cold in his body and his soul. And his brain seemed to have turned to stone, and the great hymns were forgotten" (9). This sentimentalized account of the deadening, hardening, or numbing of the poet's mind reflects his loss of intellect as he becomes a dehumanized worker and then a corpse. Producing for production's sake, the poet becomes a visual emblem of what Darío portrays as the bourgeois public's overall distaste for *modernist* art, which is underscored quite overtly by the bourgeois king's inability to appreciate poetry in general and new or revolutionary art forms in particular, in spite of his immense

collection of art objects. In *Historia de mis libros* (*History of My Books*), Darío explains that "El rey burgués" voices the protest "of the artist against the practical and dry man, of the dreamer against the tyranny of ignorant wealth" (qtd. in Oviedo 251, translation mine). The unnamed poet protagonist "finally died, thinking that the sun of the coming day would rise, and with it the Ideal" (11). Yet with the poet's death expires the ideal "in which art would no longer wear trousers but a mantle of flames or of gold" (11). Art's attire has come to resemble that of a worker more than that of an aristocrat, just as the artist loses his privileged position as a god of antiquity or a valued member of the pre-capitalist mode or patronage system and changes into a wage laborer. All that the bourgeois king stands for – "academic correctness in literature," "an excessively fastidious style in the arts," "proper spelling," "bourgeois vocabulary" – replaces the poet's ideal (5, 7). In the present, anti-artistic times, the poet reflects: "Rhythms are being prostituted, people write about women's moles, and poetic syrups are being manufactured. What's more ... the cobbler criticizes my hendecasyllables, and the professor of pharmacy adds periods and commas to my inspiration" (7, 9). And it is the bourgeois king who "authorize[s] them to do all that," that is, to prostitute, debase, and manufacture art (9). He represents all that exists to thwart the artist's success and to hinder his happiness.

Curiously enough, however, this short story is subtitled "A Merry Tale" ("Cuento alegre"), and it is supposedly told to "dispel foggy, gray melancholy" (3). The storyteller of the frame narrative goes so far as to exclaim: "how an opportune phrase ... warms the soul" (11). Yet this closing celebratory remark contrasts starkly with the embedded story's content, as the "poor devil" grows cold rather than warm, becomes sad rather than happy (9). The ideal effect of art, then, is lost to all but a discerning few. The subtitle is clearly meant to be ironic and to reinforce just how far Darío's protagonist is from existing in a world in which art and literature warm souls (rather than freeze poets) and distract one from melancholy (rather than lead one to it). The basic idea behind art for art's sake, which is that art should exist because it is beautiful and gives pleasure, proves impossible on two accounts: first, because art is accumulated for accumulation's sake by the symbolic bourgeois king, who lacks any and all spiritual appreciation for art; second, because the *modernista* artist cannot fend off his need for food, shelter, and even patronage, and thus

alters his ideal of art so as to create in accordance with the demands and dictates of the market.

Darío continues his criticism of the bourgeois public's inability to appreciate artistic creations for their aesthetic value in the story "El pájaro azul." The central figure in this tale, "poor Garcín," is a poet who is "almost always sad" (45). He insists that he has "a blue bird" in his brain, which suggests that Garcín's artistic vision is symbolically trapped inside, because either there is no one with whom he can share it or nothing to inspire him to create to his full potential (45). Garcín's own aesthetic taste, which privileges "[a]mong flowers, pretty bluebells. / Among precious stones, sapphires. / Among infinite things, the sky and love," has an aristocratic and elitist element, at the same time as the poet himself rejects the material world of upper-class or bourgeois society (47). When walking down the boulevard, Garcín saw "*with indifference* ... luxurious carriages, elegant men, and beautiful women go by," but the poet "admitted he was really *envious*" whenever he "came near a bookstore ... and when he saw luxury editions" (47, emphasis added). Although frustrated with his inability to gain access to these luxury editions, something his social position precludes, Garcín is indifferent to other signs of wealth and luxury. Here Darío distinguishes between intellectual and material elitism, lauding the former and disdaining the latter. In a society interested primarily in market values, Darío promotes aesthetic values over such things as money, industry, commerce, and social mobility.[3] Darío echoes this notion in the preface to *Cantos de vida y esperanza* (*Songs of Life and Hope*), when he explains that his "respect for the aristocracy of the intellect, for the nobility of Art, remains always the same," while his "old abhorrence for mediocrity, for intellectual mongrelism, for aesthetic flatness" has scarcely been reduced to rational indifference (333, translation mine).

To further underscore the selective and elitist taste of Garcín and his bohemian friends, which is at odds with and criticized by the unappreciative bourgeoisie, Darío incorporates a letter from Garcín's father, "an old provincial from Normandy in the 'rag' trade" ("comerciante en trapos"), who threatens to cut off his son financially (47). "I know about your wild doings in Paris," writes Garcín's bourgeois dad, "[a]s long as you keep it up that way, you won't get a single sou from me. Come home and be the bookkeeper in my shop, and when you've burned your foolish manuscripts, good-for-nothing,

you'll get my money" (47). Rather than finding a buyer or public for his work, Garcín is offered money to stop making poetry and to burn his books. Moreover, he is asked to go from "writing" books to "keeping" books, a symbolic shift from creating to recording and calculating, from aesthetic acts to market tasks. The clash between Garcín's high or pure art and society's base tastes is further highlighted when the narrator explains that Garcín's "poetry was for us," meaning for his other artistic friends, and when Garcín himself admits: "Publishers don't even deign to read my verse" (47, 49). The beauty of Garcín's poetry is reserved for a few chosen receptors or initiates; it is not available to the masses for blind consumption, as indeed they would neither appreciate nor understand it. Despite the fact that Garcín was seeking "that old green laurel," he does not achieve public recognition or praise (45). His inability to publish his work causes his poetic potential to remain trapped in his brain, something visibly evident each time "he'd wrinkle his brow ... he'd turn his face skyward and sigh," because "[w]hen the bird wants to fly, [it] spreads its wings, and dashes itself against the walls of his skull," causing Garcín much pain and frustration (47, 49). Unlike Silva's José Fernández, whose wealth and elite status allow him the luxury of not needing to publish his writings if he does not want to, Darío's bohemian characters do indeed desire to share their work with a broader public and to be recognized for their talents, but those desires are not fulfilled.

Despite his caustic critique of the marketplace, Darío does not let his protagonist succeed apart from the bourgeois world. Yes, it is true that Garcín does not sacrifice his artistic ideals or sublime verse so as to "measure out cloth" for his father, and he is not, as his friends mistakenly think, "the prodigal son" (51). Nor does Garcín alter the form or content of his art so as to attract the praise and approval of the editors or the masses. In these ways, he remains true to himself and his artistic ideals, unlike the unnamed poets in "El Rey Burgués" or in Silva's "La protesta de la musa." Nevertheless, Garcín's only chance for liberation from the all-pervasive capitalist system comes in the form of his sacrificial suicide. By freeing his muse, metaphorically represented by the blue bird, Garcín ends his verse and his life simultaneously. On the one hand, there is something tragically romantic and even celebratory in Garcín's death – which occurs "while springtime is in full force," at the height of flowering and growth, furthest

from the decadence and decay of winter – because it symbolizes a resistance on the part of the artist to conform to bourgeois standards of aesthetic value (51). On the other hand, Darío inserts into the story the notion that Garcín both arrived and departed too soon. The narrator reflects: "He had a talent that would surely shine forth. His day would come ["vendría"]. Oh, the blue bird was going to fly ["volaría"] very high!" (47). The use of the conditional tense, combined with the narrator's closing lamentation – "Ah, Garcín, how many people there are with the same sickness as yours in their minds!" – injects into the narrative a bitter taste of melancholy (51). Garcín's death results in part from the poet's refusal (but also his inability) to insert himself into the economic structure of the burgeoning capitalist system. The poet's ideal, his inspiration, his masterpiece, and his symbolic "blue bird" fail to have the desired effect on the turn-of-the-century Spanish American public. As a result, Darío's protagonist can escape from the marketplace and preserve his artistic integrity only by ending his life and leaving "the cage door open for the blue bird" (51). Yet the ideal, the symbolic blue bird, is sacrificed – not liberated – along with the poet's life. Had Garcín been able to achieve the full breadth of his artistic goals, the cerebral blue bird would have been able to take flight in an acceptable way, but Garcín ends his life because he cannot find the way to express the "pájaro azul." Finding only uninterested editors, a father who would pay his son to stop writing, and just a few bohemian friends as supporters, Garcín knows that the public would not appreciate his work regardless.

Finally, we see that the four complaining artists in Darío's "El velo de la reina Mab"[4] also address the theme of a glorious art form with no corresponding public, although here the bohemians are saved from death by the illusory veil of a fairy queen. When "the fairies had distributed their gifts among mortals," the others received "desirable" professions as men of commerce (33). In contrast, the four starving artists whose lot it was to identify with "a stone quarry" (the sculptor), "rainbow" (the painter), "rhythm" (the musician), and "the blue sky" (the poet), curse their artistic fates and ironically point out the privileged position of their working contemporaries (181). The first artist to voice his complaint is the sculptor who, with the spirit of Greece in his brain and his dreams of marble, confesses: "I wish to give the mass line and sculptural beauty" (35). Nonetheless, trembling before "the gaze of today's people," that is,

the unappreciative aesthetic standards of the modern age, the sculptor retreats into reveries of past artistic glory (35). Joining his friend's tirade, the painter similarly critiques bourgeois taste, when he suggests that current society will cause him to break his brushes (35). He reveals that his art is neither accepted nor sanctioned by society, and thus laments: "Why do I wish for the rainbow and this extensive palette like a flowering field, if in the end my picture won't be accepted in the Salon?" (35). In addition to his failure to find a public venue for his work, the painter further bemoans his economic necessity: "always the same terrible disenchantment! The future! To sell a Cleopatra for two pesetas in order to eat lunch!" (35). Just as the poet in Darío's "El Rey Burgués" must produce art for a wage, so too does this artist figure offer his work in exchange for sustenance. The market economy prevents, however, the emergence of the painter's "great picture," since his masterpiece remains trapped inside him much like Garcín's "pájaro azul" (35). Adding to this list of complaints, the musician, the third of the four artist figures, reveals that he has lost his soul in the grand illusion of his symphonies (183). While aware of the numerous musical possibilities – "All sounds can be captured, all echoes are susceptible of being combined" – he too fails to convey his inner masterpiece to his contemporaries (37). Finally, the poet sums up the overall discontent of the modernist artist: "I would write something immortal, but I am overwhelmed by a future full of poverty and hunger" (37). His artistic ideal likewise remains floating "in the blue," as evidence of what Darío will later characterize, in his famous poem "Nocturno" ("Nocturne"), as "the false nighttime blue of an unloved bohemia" (37, *Cantos de vida* 399, translation mine). Given these artists' recurring complaints, we note an important connection between the artist's inability to sell his art and the insensitivity or lack of appreciation of that art on the part of the public. Darío's protagonists clearly realize that without a public that is sensitive to art, they cannot make a living from their (high, elitist, or *modernista*) art.

Interestingly enough, this story does not have the somber ending we have seen in the previous tales, namely because

Queen Mab took a blue veil [… that] was the veil of dreams, of sweet dreams that make you see life as rose-colored. And with it she enveloped the four thin, bearded, and impertinent men, who

> ceased being sad because hope had entered their hearts and merry
> sunshine entered their heads, along with the little imp of vanity,
> who consoles poor artists in their deep disappointments. (37)

Here the veil functions as a drug that alters the characters' perspective on life. It is only when they are separated from the world of capitalism that they are happy and find consolation. Queen Mab provides the "art for art's sake" situation that Spanish American *modernismo* arguably seeks to create, although the comparative analysis of these three stories suggests that such a separation between not only Art and Life, but so too aesthetics and economics, is, regrettably for Darío and the majority of his artist protagonists, not a viable possibility. Given the fact that he devotes the majority of the narration in this short story to the reality from which these artists so desperately seek to escape, Darío's *deus ex machina* ending seems just that – an artificial and improbable way of resolving the inescapable entanglements of the plot. Before Queen Mab's intervention, Darío's four artists resemble the sad and solitary artist, rather than the happy man, as described by fellow *modernista* poet Julián del Casal in the passage that follows:

> Happy the man that can, on such a night, sit at the table in his
> home, covered by a clean table cloth ["mantel"], whose immacu-
> late whiteness is broken only by the piping hot delicacies, while
> his loved ones are gathered around him below the amber light
> of the lamp that dispels shadows and revives expressions with
> happy brightness! Sad the solitary artist who, frightened by the
> gibberish on the streets and persecuted by his drove of memories,
> takes early shelter in his dismantled ["desmantelada"] little room,
> where the roar of the swarming crowd does not let him silently
> leaf through the pages of his favorite books, conclude the poem
> that he had begun, or shed his bitter tears. (*Poesía completa* 306,
> translation mine)

The unhappy artist cannot create or appreciate art on account of his solitude and hunger, which serves to remind us that outside the attic and beyond the veiled space, the life-world of industrial capitalism and bourgeois taste clearly remains – and it is not a world these artist figures thrive in.

Ultimately, Darío's protagonists from each of the texts examined are left with two equally unappealing options: they can refuse to materialize their thoughts by escaping from their respective societies, in the hope that their artistic visions will retain their artistic and intellectual value and remain distinct from the commodity form of value, that is, the monetary exchange value contained in a "price"; or they can enter into the marketplace where, in a moment of capitalistic peripeteia, art for art's sake becomes art for money's sake or simply art for sale. The former option leads to isolation and potential starvation, save in those fantastical situations in which fairy queens can shelter the artist from the outside, "real" world. The latter choice, however, leads to the petrification or death of the artist or the commodification of the artist's work. Darío's famous declaration in "Palabras liminares" ("Preliminary Words") – "I hate the life and times into which I had to be born" ("yo detesto la vida y el tiempo en que me tocó nacer") – reveals his dissatisfaction with the rise of material concerns at the expense of aesthetic concerns (48, translation mine). It was precisely his society's value system that ensured that the artist who wished to remain faithful to aesthetic value minus exchange value would have to keep his creations out of circulation and isolated from the economic sphere. This notion is perhaps best described by Casal, who asserts in 1890 that "modern artists" can be divided into "two large groups":

> The first is made up of those who cultivate their faculties, as the farmers do their fields, in order to speculate on their products, always selling them to the highest bidder. These are the false artists, servants ["cortesanos"] of the multitude, hypocritical merchants, whom Posterity – the new Jesus – will throw out of the temple of Art with lashings. The second is composed of those who deliver their productions to the public, not in order to obtain applause, but rather the money that results, so as to take refuge from the miseries of existence and to preserve a bit of the wild independence that they need to live and create. Far from adapting themselves to the demands of the majority, these artists try instead to make the public adapt itself to them. (*Crónicas habaneras* 148, translation mine)

By contrasting the so-called "false artists" of the former category with what we might term the "true artists" of the latter group, Casal

distinguishes between the artist as producer of commodified art and the artist as creator of ideal art, on the one hand, and between the artist as a victim of "art for the market's sake" or the artist as a faithful follower of "art for art's sake," on the other hand.

These same two problematics are taken up in the selected tales of Darío, since the Nicaraguan author explores the possibility, as articulated by Ángel Rama in *Rubén Darío y el Modernismo (circunstancia socioeconómica de un arte americano)* (*Rubén Darío and Modernismo: Socioeconomic Circumstances of an American Art*), that the division of labor and the installation of the market economy in Spanish America caused the poet to consider himself "condemned to disappear" (50, translation mine). As a way of concluding this chapter, I wish to consider Rama's delineation of three different tendencies of real-life *modernista* poets: (1) some steer toward "self-negation, destroying the artist within"; (2) others maintain a "dual posture: splitting themselves into an embarrassed and closeted poet and an individual equipped in the intellectual professions that society recognizes as legitimate or as commercial and productive"; and (3) others "affirm, as if committing suicide, their poetic vocations and persist in the job. ... But their action is definitely in vain" (58–9, translations mine). Whereas the poet in "El Rey Burgués" falls into the first category, Garcín clearly belongs in the last group. The artists in "El velo de la reina Mab" initially want to trade in their artistic vocations for more productive and commercial jobs, and would therefore belong in the second category, although Mab is able to convince them to remain artists in a fantastic world of her creation. In either case, it is because of the loss of artistic values in the new market economy, "in this world governed by the manufacture of and desire for things, the principles of competition, profit, and productivity," that the poet no longer appeared to be a necessity (Rama 56, translation mine). The poet's difficulty – or inability – to insert himself into the new capitalist system stems primarily from the fact that "he did not have a foreseeable place in the economic structure that was being transplanted from Europe to the Americas" (Rama 55, translation mine). And not only was there no particular niche for the poet, but, given the growing emphasis on fulfilling one's societal duties in this period of growth and industrialization, being a poet came to constitute an embarrassment insofar as the artist became symbolic of a lack of productivity (Rama 57). Alberto Acereda, in his book *Rubén Darío,*

poeta trágico (una nueva visión) (*Rubén Darío, Tragic Poet: A New View*), agrees with Rama when he argues that the *modernista* poet "will be seen as a socially pernicious element and his image will be that of a socially maladjusted person, that of a bohemian, and, finally, that of an unproductive individual" (13, translation mine). According to Acereda, "[p]oet and society will gradually separate from each other, and the poet will assume the philosophy of art for art's sake and will experience the public's indifference and the bourgeois atmosphere because there will not be much room for poetry in the market economy" (13, translation mine). Rafael Gutiérrez Giradot likewise insists that nearly all of the leading figures of Spanish American *modernismo* share the same attitude vis-à-vis their society: "they react against it, against its pressures, against its morals, against its anti-poetic values, and they do it in an obstinate manner, that is to say, underscoring energetically the value of that which society has relegated in different ways: art and the artist" (35, translation mine).[5] As the examples of Darío's protagonists suggest, the *modernista* artist within fiction also feels bitterly the decline of artistic value in this new market economy that makes art a commodity and the artist a producer of commodities. Such meditation on the role of the artist and his art, when taken to its furthest extreme, has led many Spanish American authors and their characters to liken the approaching *fin de siglo* with a symbolic *fin del arte*. In order to be creators and not producers, their art had to remain unsold and uncommodified. The paradox is that the art also remained unappreciated and the poet could not sustain himself as an artist.

Part III
The Artist Promotes "Life for Art's Sake"

Introduction

This final section will focus on what R. V. Johnson calls "contemplative aestheticism," which is the term he uses to designate aestheticism "as a view of life," as a way "of treating experience, 'in the spirit of art,' as material for aesthetic enjoyment" (12). By consecrating life to the cultivation of art, beauty, and taste above all else, the slogan to be explored in Part III is not so much "art for art's sake" as it is "life for art's sake" or "life for the sake of beauty." The change from a philosophy of "art for art's sake" to one of "life for art's sake" is embodied in the mid- to late-nineteenth-century figures of the aesthete, the dandy, and the flâneur. All three figures try to make themselves or their worlds more artistic, and they do so by elevating art "to a position of supreme – or even exclusive – importance in the conduct of life" and willingly subsuming all aspects of life into the sole criterion of artistic beauty and pleasure (Johnson 12).

In Chapter 5, "The Artist as Dandy-Aesthete: The Self as Art in Oscar Wilde and Thomas Mann," I examine how three European dandy-aesthete protagonists (Wilde's Lord Henry and Dorian Gray and Thomas Mann's Felix Krull) are artistic producers in a unique way insofar as they adopt the attributes of the artist, but construct only their own stylized selves and aestheticized beings. The dandy-aesthete parallels the aestheticist artwork insofar as he too strives for aesthetic autonomy and artistic freedom in the construction of his own artistic self. Let us consider Barbey d'Aurevilly's comments regarding the most famous living dandy, George Bryan

Brummell: "He was in his own manner a great artist; but his art was not esoteric, nor exercised in a given time. It was his very life, the perpetual glitter of faculties which do not dwell in man, a being created to live with his fellow-men. Brummell gave pleasure by his person as others do by their achievements" (32). A "great artist" of "his very life" who "gave pleasure by his person" – this is what the dandy-aesthete figure does, and precisely for this reason he warrants consideration in this investigation of the various turn-of-the-century definitions of the artist and his art. Additionally, this non-traditional artist of the self embraces the "art for art's sake" idea that artistic creations should lack all extrinsic purposes, be they moral or social, since their sole objectives should be to be beautiful and to give pleasure. One must be free from morality, from utilitarianism, and from convention in order to fashion oneself as a dandy-aesthete figure. Thus, what emerges *in art* as the self-contained and self-sufficient artwork manifests itself *in life* in the figure of the solipsistic aesthete or dandy who creates himself in a similarly conceived form of artistic expression and chooses an equally unique and independent existence. Owing to the fact that the figure of the dandy-aesthete exists as an alternative to the artist insofar as he turns himself into an artwork and thereby avoids the production of an external art object, we must assess whether the "self" as artwork manages to exist in an autonomous realm of ideal beauty or whether it becomes – as do other turn-of-the-century artworks – an object of exchange, commodification, or reification.

In Chapter 6, "The Artist as Dandy-Flâneur: The World as Art in Manuel Gutiérrez Nájera and Julián del Casal," I examine the philosophy of "life for art's sake" in the Spanish American context by altering the focus slightly from the "dandy-aesthete" to the "dandy-flâneur," since the flâneur also treats life artistically and sees his urban surroundings through the eyes of an artist. I find examples of the dandy and flâneur not in traditional literary texts from Spanish American *modernismo*, but rather in the hybrid genre of the Spanish American chronicle or "crónica," which came to constitute the bulk of both Gutiérrez Nájera's and Casal's publications. It is worth noting that the urban chronicler in general parallels the flâneur insofar as both are "'reader[s]' of urban life," whose strolling and idling throughout the city involves "a poetic – and a poet's – vision of the public places and spaces" (Burton 2; Tester 1). If, as Baudelaire contends,

the modern artist is at once "observer, philosopher, flâneur" and the painter of the "passing moment," then the same applies to the "cronista" as understood by the Spanish American *modernistas* insofar as they too underscore the creative and artistic side of their otherwise journalistic work (Baudelaire, *Painter* 5). Thus, even though the figures of the dandy and the flâneur did not – perhaps, could not – emerge on Spanish American soil at the turn of the century in the same way that they did in the metropolitan centers of Western Europe in the same period, I nonetheless explore the possibility of Spanish American dandy and flâneur figures, figures that appear as the narrative voices and the narrative subjects of many late nineteenth-century chronicles by these two *modernista* authors. Gutiérrez Nájera and Casal portray the dandy's elitism, discerning taste, and elegance while also embodying the flâneur's role as a "gentleman stroller of city streets" and "a botanist of the sidewalk," to use Baudelaire's phrasing. In fact, the same thing that David Harvey says of Baudelaire, that he "would be torn the rest of his life between the stances of *flâneur* and dandy, a disengaged and cynical voyeur on the one hand, and man of the people who enters into the life of his subjects with passion on the other hand," might be said of these two "cronistas" as well (14). The ensuing analysis of the adoption in the Spanish American periphery of the European figures of the dandy and flâneur points to both the complex portrayal and simultaneous disavowal of these late nineteenth-century types. I argue that the relative lack of modernization and cosmopolitanism, combined with the absence of a long-established aristocratic class and an educated and cultured readership, partially explains the scarcity of dandy and flâneur figures in Spanish American *modernismo*, on the one hand, and the altered or alternative portrayal of them, on the other. Additionally, I note the ways in which Gutiérrez Nájera's and Casal's journalistic careers serve to align them with the wage laborer or the salaried scribe, figures antithetical to the elitist and refined dandy and to the free and idle flâneur. Thus, even when these authors describe dandies and adopt the identity of flâneurs, they simultaneously point out the necessary or inevitable differences between the Spanish American copy and the European original in their respective efforts to treat life as art.

5
The Artist as Dandy-Aesthete: The Self as Art in Oscar Wilde and Thomas Mann

The dandy-aesthete protagonists in Oscar Wilde's *The Picture of Dorian Gray* (1890) and Thomas Mann's *Bekenntnisse des Hochstaplers Felix Krull: Der Memoiren erster Teil (Confessions of Felix Krull: Confidence Man (The Early Years)*, 1954)[1] differ from the previous artist protagonists examined in Parts I and II in the following ways: (1) they establish new relationships between art and life and between the aesthetic and the social, that is, instead of pitting an "art for art's sake" attitude against the alternatives of "art for life's sake" or "art for the market's sake," they promote a new or modified philosophy of "life for art's sake"; (2) they avoid the production of an external art object and concentrate instead on turning themselves into works of art, which allows them to exist simultaneously as artist and artwork; and (3) they use their dandy-aesthete identities as a means of securing an elite and aristocratic status at a time of changing class categories and social restructuring, which permits them to enjoy many of the luxuries (artistic and otherwise) that are not commonly afforded to other turn-of-the-century authors and artists who struggle with the lack of salability and marketability of their artistic creations. Despite these significant differences between the artist as dandy-aesthete and more traditional artist types, we will still consider many of the same questions in this chapter as we have in previous ones. This examination of Wilde's Lord Henry and Dorian Gray and Mann's Felix Krull as three fictional variations of the dandy-aesthete aims to answer the following questions: Does the dandy-aesthete – in promoting only the "self as art" and failing to produce any other external art object – avoid the commodification, reification, or reproduction of himself,

of his "self" as art? Does the dandy-aesthete manage to keep art out of the marketplace as a result of his solipsistic self-construction or does he participate in industrial-capitalist society in new and different ways? Does the role of artist become confused and confounded with the position of art object in each instance? Does the dandy-aesthete protagonist succumb to the problems that typically plague the turn-of-the-century artist, that is, do Lord Henry, Dorian Gray, and Felix Krull become wage laborers and producers of commodities or do their "selves" as artworks become commodities or objects of exchange? Does the dandy-aesthete's "life for art's sake" attitude allow him to merge the realms of art and life in laudable ways and to exist fruitfully as an artist figure in modern society? As a way of providing provisional answers to these questions, I would argue that Lord Henry successfully constructs for himself an artistic life in which he is simultaneously artist, art object, and artistic receptor; that Dorian Gray becomes a copy of both Lord Henry's and Basil Hallward's creative efforts and thus suffers on account of the fact that his aestheticized self is neither original nor of his own making; and that Felix Krull uses the dandy-aesthete's "art" to improve his "life" in socioeconomic terms and to prove his own merit as an artist of the self.

The True Dandy versus the False Dandy: Self-Aestheticization or the Loss of Self in Wilde's *The Picture of Dorian Gray*

Our analysis of the dandy-aesthete as literary protagonist will begin with a consideration of Wilde's *The Picture of Dorian Gray*, a novel in which the reader encounters four different artist types: Basil Hallward, the artist who puts everything into his art and thus has nothing left for life (63); Lord Henry, the aesthete who is content with philosophic contemplation and wishes to remain a spectator of his own artistic life (45, 124); Dorian Gray, the young dandy who has "never done anything, never carved a statue, or painted a picture, or produced anything outside of" himself, since his Life has been his art (247); and Sibyl Vane, the "born" actress who is nothing without her art and knows nothing of life (86, 98, 60). It is obvious that with this cast of characters Wilde sets out to explore the variegated relationships between art and life, between the artist and his or her

world. Whereas the painter and actress choose the world of art over the realm of life, Lord Henry and Dorian Gray attempt to combine the two realms by taking on the traits of the late nineteenth-century dandy-aesthete and embodying a "life for art's sake" philosophy. Given the negative portrayals of Basil and Sibyl as too engrossed in art to live life properly, one could rightly argue that Wilde prefers the "life for art's sake" position of Lord Henry and Dorian Gray and promotes the dandy-aesthete over the actual artist figures – the painter and the actress – in the novel. Lord Henry criticizes Basil for putting too much of himself into his art, for putting "everything that is charming in him into his work" and thus having "nothing left for life but his prejudices, his principles, and his common-sense" (3, 63). Basil is among the "good artists" who "exist simply in what they make, and consequently are perfectly uninteresting in what they are" (63). Despite his "wonderful genius for painting," Lord Henry notes that "a man can paint like Velasquez and yet be as dull as possible. Basil was really rather dull" (242). Charming, good, and wonderful in art; uninteresting, boring, and dull in life: Basil belongs in the former sphere as opposed to the latter. Similarly, Sibyl Vane, while not artistically on par with Basil in terms of her abilities, nonetheless shares certain traits with him. She is only fascinating to Dorian as an actress, that is, as someone who "knows nothing of life" and is "Never" Sibyl Vane (60, 61). Once she comes to prefer reality to art, once she stops regarding Dorian "merely as a person in a play" and tells him: "[y]ou taught me what reality really is. ... You are more to me than all art can ever be," she creates "simply bad art," is "a complete failure," and loses her appeal as an artist and a lover (60, 97, 94). Both Basil and Sibyl are meant to stay in the realm of art; they cannot exist successfully in the life-world, as their tragic deaths suggest, occurring as they do when both characters catch a glimpse of the life beyond their art.

On the other hand, Lord Henry and Dorian Gray apply the attributes of the artist to their own selves and engage in a process of self-aestheticization that is characteristic of the dandy-aesthete. Attempting to turn themselves into art, rather than producing external and tangible art objects, both Lord Henry and Dorian Gray emerge as dandy figures. Lord Henry is called a dandy once in the novel, in a rather general remark made by his uncle: "Well, Harry ... what brings you out so early? I thought you dandies never got up till

two, and were not visible till five" (36). Dorian Gray is also termed a dandy once in the novel, and it is in a similarly general comment, this time from Sibyl Vane's brother: "This young dandy who was making love to her could mean her no good" (75). Additionally, the term "Dandyism" is employed once in reference to Dorian: "Fashion, by which what is really fantastic becomes for a moment universal, and Dandyism, which, in its own way, is an attempt to assert the absolute modernity of beauty, had, of course, their fascination for him" (146). Although the words "dandy" and "dandyism" are not used often, there are numerous passages that serve to establish both characters as dandy figures.

It is first helpful to summarize the leading characteristics of the dandy figure: in terms of appearance, he is elegant, refined, and with notable physical distinction; as concerns personality, the dandy is dignified, gentlemanly, witty, blasé, and with discriminating taste; with regard to conduct, he is independent, self-masterful, self-assured, and acts with great aplomb; and with regard to social position, the dandy is elitist, aristocratic, free from work, and with unlimited credit and leisure time. Additionally, the dandy can be described as the artist of the self, whose masterpiece is his own self-portrait which he puts on display as a beautiful, charming, and captivating spectacle for others.

Based on this list of the predominant traits of the dandy, we can begin to assess the extent to which Wilde's presentation and characterization of Lord Henry and Dorian Gray serve to establish them as dandy figures. Let us begin with a consideration of Lord Henry, who intersects with the dandy primarily with regard to his personality and conduct as well as his elevated social position. Lord Henry is driven by the desire to be "in harmony" with himself. As he explains: "To be good is to be in harmony with one's self ... Discord is to be forced to be in harmony with others. One's own life – that is the important thing" (88). This desire for personal harmony establishes the fact that his aesthetic concerns are linked to his own personal self, his own individual life. Furthermore, Harry's aesthetic sense points to a lack of concern with traditional morality and what others might consider "good" or "important," and also establishes him as both independent and self-assured. Mr. Eskine rightly points out Lord Henry's "philosophy of pleasure," which is another sig-nificant dandy attribute (48). Part and parcel of this "philosophy

of pleasure" is the search for beauty and the quest for pleasurable appearances. "To me, Beauty is the wonder of wonders," Lord Henry famously remarks, "[i]t is only shallow people who do not judge by appearances" (25). He insists further that "[o]ne should sympathise with the colour, the beauty, the joy in life. The less said about life's sours the better" (45). Preferring beauty to ugliness, Lord Henry frequently shuns ethical considerations and prefers surface to depth. He insists that he "never approve[s], or disapprove[s], of anything now. It is an absurd attitude to take towards life. We are not sent into the world to air our moral prejudices," and in this regard, he echoes Wilde's belief in the preface that "[n]o artist has ethical sympathies. An ethical sympathy in an artist is an unpardonable mannerism of style" (83, xi). According to Basil, Lord Henry never says "a moral thing" (5). The Duchess describes him as "dreadfully demoralising" (47). Nonetheless, Basil rightly notes that Henry's "cynicism is simply a pose," since he never *does* "a wrong thing" (5). Similarly, Lady Agatha notes that Lord Henry "never means anything that he says" (43). Willing to shock his audience with controversial comments and provocative witticisms, Lord Henry clearly possesses the dandy's desire both to astonish and to be astonished at nothing, that is, the dandy's even mixture of wit and aplomb. Finally, in terms of his social status, Lord Henry is blessed with wealth, leisure time, and freedom from work. He clearly resembles his uncle, Lord Fermor, who "had set himself to the serious study of the great aristocratic art of doing absolutely nothing" (35). And he also notes the importance of credit as a requirement for living the elegant life of the dandy. "I don't want money," Harry explains: "It is only people who pay their bills who want that …, and I never pay mine. Credit is the capital of a younger son, and one lives charmingly upon it" (36). In this regard, he echoes Baudelaire's famous belief that "limitless credit" is needed to ensure that the dandy "possesses a vast abundance of both time and money" (*Painter* 27).

Descriptions of Dorian as a dandy-type also abound in Wilde's novel, yet in his case it is his elegant appearance and keen artistic sense that receive the most praise. Dorian is described by Lord Henry as "a perfect type," as "flawless" and "complete" (246). His "delicate bloom and loveliness," "his exquisite youth and beauty" are frequently noted throughout the novel (102, 254). He is someone the world "has always worshipped" and "always will worship," namely

because, in Lord Henry's estimation, he is "the type of what the age is searching for" (247). In addition to his unchanged and unmatched beauty, Dorian's other dandy traits can be seen by examining the lengthy description of the "little dinners" that he arranges for his upper-class guests:

> His little dinners, in the setting of which Lord Henry always assisted him, were noted as much for the careful selection and placing of those invited, as for the exquisite taste shown in the decoration of the table, with its subtle symphonic arrangements of exotic flowers, and embroidered cloths, and antique plate of gold and silver. Indeed, there were many, especially among the very young men, who saw, or fancied they saw, in Dorian Gray the true realisation of a type of which they had often dreamed in Eton or Oxford days, a type that was to combine something of the real culture of the scholar with all the grace and distinction and perfect manner of a citizen of the world. To them he seemed to be of the company of those whom Dante describes as having sought to "make themselves perfect by the worship of beauty." Like Gautier, he was one for whom "the visible world existed." (145–6)

As this passage reveals, Dorian is admired first and foremost for his aesthetic sense: he possesses "exquisite taste," "grace," "distinction," and "perfect manner"; he appreciates the beauty of the "visible world" and has made himself perfect by worshipping beauty. Dorian is also extolled for combining knowledge with experience, for having "the real culture of the scholar" and being simultaneously a "citizen of the world." Furthermore, the above references to Dante and Gautier serve to link Dorian to a genealogy of artist figures known for their appreciation of beauty and promotion of art. In fact, the significance of Dante to the British Pre-Raphaelites, combined with the importance of Gautier to French aestheticism, connect Dorian to an "art for art's sake" mentality and further underscore his existence as an aesthete. Yet Dorian does not apply his artistic sense to the creation of external art objects, and it is precisely for this reason that Lord Henry applauds Dorian's artistic method: "I am so glad that you have never done anything, never carved a statue, or painted a picture, or produced anything outside of yourself! Life has been your art. You have set yourself to music. Your days are your sonnets" (247).

For Dorian, "Life itself was the first, the greatest of the arts, and for it all the other arts seemed to be but preparation" (146). Because life was Dorian's art, both fashion and dandyism had "their fascination for him" insofar as he used his "most artistic tastes," his "fine instinct for beauty," and his "mode of dressing" to turn himself into an artwork (146, 170, 147, 146).

Despite having just established both characters as dandy figures, I would like now to problematize this idea by pointing out the ways in which Lord Henry represents a "true" or "successful" dandy and Dorian Gray represents a "false" or "failed" dandy. This distinction hinges upon the extent to which each character succeeds in his process of self-aestheticization, that is, in turning himself into an artwork of his own making, rather than existing as a product or a copy of someone else's creative efforts. The main challenge in seeing Dorian Gray as a true dandy stems from the fact that he is repeatedly described – by himself, by Basil, by Lord Henry, and by the narrator – as the product of Lord Henry's influence. This possibility is foreshadowed very early in the novel, when Basil tells Lord Henry not to spoil Dorian and not to try to influence him (15). During Dorian's initial encounter with Lord Henry, he feels "suddenly awakened" and "dimly conscious that entirely fresh influences were at work within him" (21, 23). Although Dorian is under the impression that these new influences "seemed to him to have come really from himself," he still wonders why it had been "left for a stranger," namely Lord Henry, "to reveal him to himself ... to have disclosed to him life's mystery" (24). Throughout the novel Dorian continually admits the extent of Lord Henry's influence: "[y]ou have a curious influence over me" (58); "[y]ou have explained me to myself" (117); "[n]o one has ever understood me as you have" (118). As these statements reveal, Dorian lacks much of the originality and self-determination of the dandy, since Lord Henry's influence and guidance are so much a part of who he is and who he will become. Indeed, Lord Henry rightly recognizes that "[t]o a large extent the lad was his own creation" (64). Dorian himself admits on one occasion: "That is one of your aphorisms. I am putting it into practice, as I do everything that you say" (53).

In addition to the direct influence of Lord Henry on Dorian, there is also the indirect effect of what is generally agreed to be J.-K. Huysmans's novel *À Rebours*. As Robert Keefe rightly notes,

"Lord Henry's influence comes through the spoken, and later (with the gift of the French novel) the written word" (65). Dorian reproaches Harry when he states, "you poisoned me with a book once. I should not forgive that. Harry, promise me that you will never lend that book to anyone. It does harm" (248). *À Rebours*, the unnamed "yellow book," the unidentified "poisonous book," exerted an influence from which "Dorian Gray could not free himself" or from which "he never sought to free himself" (141–3). Des Esseintes, the novel's protagonist, "became to him [Dorian] a kind of prefiguring type of himself," one of his "ancestors in literature," someone who taught him to look on "evil simply as a mode through which he could realise his conception of the beautiful" (143, 165). Finding greater affinities between himself and his literary ancestor Des Esseintes than between himself and his real-life forebears, Dorian strives to embody "in type and temperament" Huysmans's character (162). Once again, Harry's desire to influence Dorian is conscious and deliberate. Despite telling Dorian that there is no such thing as being poisoned by a book, namely because "Art has no influence upon action. It annihilates the desire to act. It is superbly sterile," Lord Henry knows that his young disciple will once again attempt to live out someone else's philosophy, to turn another's art into his own life (248). Just as Dorian was "putting into practice" Lord Henry's aphorisms, so too was he living out the life suggested to him by Des Esseintes (53). In both instances, Wilde's novel seems to suggest that there is a significant difference between a life that copies art (Dorian's) and a life that is artistic (Lord Henry's or even Des Esseintes's).

Dorian's willingness to live out the life suggested to him by others constitutes one of the key differences between him and Lord Henry. Lord Henry's act of fashioning Dorian into a marvelous type means that Dorian can never be a true dandy, owing to his inherent imitation. Despite Dorian's statement to Lord Henry, "I was a school-boy when you knew me. I am a man now. I have new passions, new thoughts, new ideas," we must recognize that these new passions, thoughts, and ideas are not self-created, since they have been inculcated in Dorian, sometimes explicitly, sometimes implicitly, by Lord Henry (125). Lord Henry addresses the dangers and problems of imitation when he explains that "[a]ll influence is immoral":

> to influence a person is to give him one's own soul. He does not think his natural thoughts, or burn with his natural passions. His

virtues are not real to him. His sins, if there are such things as sins, are borrowed. He becomes an echo of someone else's music, an actor of a part that he himself has not written for him. The aim of life is self-development. To realise one's nature perfectly – that is what each of us is here for. People are afraid of themselves, nowadays. They have forgotten the highest of all duties, the duty that one owes to one's self. (20)

Clearly, Dorian becomes the echo of Lord Henry's music, the actor of a part Lord Henry has written for him.[2] And with regard to Lord Henry's "duty" to his own self, we might argue that his "mode of self-development" and his way of "realizing" his own nature involve the creation of Dorian as an extension of himself and as the embodiment of his own dandy ideals.

For these reasons, we must recognize that Lord Henry's influence is not haphazard nor by chance, rather it is calculated and conscious for he clearly enjoys his success in forming, fashioning, and even "vivisecting" the young lad (64). Harry wishes "to be to Dorian Gray what, without knowing it, the lad was to the painter who had fashioned the wonderful portrait. He would seek to dominate him – had already, indeed, half done so. *He would make that wonderful spirit his own*" (41, emphasis added). To understand just what Lord Henry means in this instance with regard to being to Dorian what Dorian had been to Basil, it is worth reviewing Basil's own confessions about the effect Dorian has on him and his art. Basil comments: "I sometimes think ... that there are only two areas of any importance in the world's history. The first is the appearance of a new medium for art, and the second is the appearance of a new personality for art also" (11). He later explains that Dorian's personality "has suggested ... an entirely new manner in art, an entirely new mode of style" and has allowed him to "see things differently" and to "think of them differently" (11). Dorian is to Basil "simply a motive in art," "a suggestion ... of a new manner" (12). Taking this idea from the aesthetic sphere and planting it into the living sphere, Lord Henry will help Dorian become a "new medium," a "new personality," a "new manner," a "new mode of style" – not for or in art, but *for and in life*. Harry elaborates further on his own method:

There was something terribly enthralling in the exercise of influence. No other activity was like it. To project one's soul into some

gracious form, and let it tarry there for a moment; to hear one's own intellectual views echoed back to one with all the added music of passion and youth; to convey one's temperament into another as though it were a subtle fluid or a strange perfume; there was a real joy in that – perhaps the most satisfying joy left to us in an age so limited and vulgar as our own, an age grossly carnal in its pleasures, and grossly common in its aims ... He was a marvelous type, too, this lad, whom by so curious a chance he had met in Basil's studio, or could be fashioned into a marvelous type, at any rate. (40–1)

Lord Henry aims to cultivate Dorian into a "complex personality" that might take the place of and assume "the office of art" and become "a real work of art" transposed into the realm of life (65). As he explains, "Life" has "its elaborate masterpieces, just as poetry has, or sculpture, or painting" (65). In this way, he echoes Wilde's notion as expressed in the essay "Pen, Pencil and Poison," that "[l]ife itself is an art, and has its modes of style no less than the arts that seek to express it" (324). In seeking to make life an art, Lord Henry applies the traits of the dandy not only to his own self-construction, but so too in his construction of Dorian, whose "passion and youth" make him even more fit to play the part of a "a marvelous type" and to be the "visible symbol" of the "new Hedonism"[3] that Lord Henry seeks to revive (25). It is worth noting that the only dandy trait not initially attributed to Lord Henry was that of physical distinction. While he is certainly elegant and refined, there are few descriptions of his outer beauty, as these seem to be reserved solely for the eternally youthful Dorian. Hence, in choosing Dorian to represent – indeed, to live out – his own dandy-aesthete philosophy, Lord Henry adds the outer appearance to the inner essence, the form to the content, and perhaps succeeds finally in his goal of being "in harmony with one's self" (88).

The desire to project his "soul" (which includes both his "intellectual views" and "temperament") onto Dorian's "gracious form" (which is marked by "passion and youth") foreshadows the schism that will later develop between Dorian's inner and outer selves, soul and body, content and form as a result of the Faustian pact to remain forever young and exchange places with the portrait (40–1). Although we will consider the role and function of the portrait

later, it is worth noting here that Lord Henry's method points to the fact that Dorian's "soul" will no longer be his own, since it is Lord Henry's Hedonistic ideas (coupled with Des Esseintes's search for novel sensations and pleasures) that come to guide the younger lad and his subsequent quest for new passions and experiences. What is particularly interesting, however, are the motivations behind Lord Henry's external detour method, that is, his reasons for using Dorian, for transitioning between "vivesecting himself" to "vivisecting others," and for "mak[ing] that wonderful spirit his own" (64, 41). As Barri J. Gold explains in "The Domination of Dorian," Lord Henry's act of making Dorian's "spirit his own" begins with Lord Henry's desire to "make Dorian's spirit over," that is, to alter or change that spirit through influence (Gold 29). In order to "re-produce" Dorian, Lord Henry decides to create him "in his own image," in his own likeness (Gold 29). Finally, Lord Henry "make[s] 'that wonderful spirit his own' in yet a third sense by adopting it," Gold insists, "by making himself over as Dorian" (Gold 29). In other words, "[i]n his effort to dominate Dorian, always-already invested in reproducing Dorian as himself, Henry also reproduces himself as Dorian" (Gold 30). The narrator hints at this final step in the creative process when he discusses Lord Henry's "experimental method": "It often happened that when we thought we were experimenting on others we were really experimenting on ourselves" (66). In response to the inevitable question about what motivates Lord Henry to recreate himself via a process of recreating Dorian, we might consider the following list of reasons – all common to the dandy's mode of self-aestheticization: youth, beauty, pleasurable appearances, perfect form, and physical distinction, on the one hand; being the artist of the self, applying aesthetic creation to the life sphere, putting art into life, on the other hand. Gold agrees, noting that "Henry's desire for self-reproduction is specified to include self-improvement, glorious magnification, rejuvenation" (29). Douglas Robillard, Jr. offers an additional explanation when he notes that "Henry is fascinated by the reflection of himself that Dorian provides" (33). In this way, Lord Henry can be – simultaneously – the artist that creates Dorian, the artistic receptor of Dorian, as well as the art object itself. Thus, although the act of fashioning Dorian may initially seem to cast Lord Henry in the sole role of artistic creator and Dorian in the single role of art object, Wilde actually presents a much more complex series of

interrelationships insofar as Lord Henry is also the artistic receptor or spectator of Dorian as well as a living art object. Whereas all three male protagonists share an interest in Dorian's painted image, only Lord Henry recognizes that the living Dorian can be an equally fascinating medium for observation and artistic appreciation, one that allows him to observe the effects of his influence and experimentation and affords him the aesthetic pleasure that results from creating and viewing life in/as art. Returning to the "life for art's sake" notion discussed at the outset of this chapter, then, we might say that Lord Henry adds life to Dorian's artistic form by providing him with an aestheticist creed or doctrine by which to live, while also adding more art to his own self by recreating himself through Dorian and appropriating some of Dorian's youth and beauty in the process.

The idea of Dorian as a copy of Lord Henry's philosophy and as an actor of the part written for him by Lord Henry parallels the notion of Dorian as a copy of the image captured in Basil Hallward's portrait. If the dandy tries to turn himself into a work of art, Dorian exists as art only insofar as he is the living embodiment of Lord Henry's aestheticist philosophy, on the one hand, and Basil's portrait, on the other hand. There are in fact two artists of Dorian, given that "Basil through his portrait and Lord Henry through his word painting both recreate Dorian in their own image and likeness" (Manganiello 25). Let us turn now to a consideration of the relationship between Basil Hallward, the portrait, and Dorian. Just as Lord Henry's provocative comments serve to reveal Dorian to himself, so too does the portrait trigger a moment of self-discovery and self-awareness. The narrator explains Dorian's reaction to the portrait: "A look of joy came into his eyes, as if he had recognised himself for the first time. He stood there motionless and in wonder The sense of his own beauty came on him like a revelation" (28). Owing to Dorian's revelation of his own beauty as captured by Basil in the painting, he utters his "mad wish that he himself might remain young, and the portrait grow old; that his own beauty might be untarnished, and the face on the canvas bear the burden of his passions and his sins; that the painted image might be seared with the lines of suffering and thought, and that he might keep all the delicate bloom and loveliness of his then just conscious boyhood" (102). When his wish is miraculously granted, Dorian begins to lead a "double life" and to live both in the world and "in the picture" (198, 32). Since only the painted image changes,

since only the portrait reveals Dorian's sinful and aging soul, Dorian can initially maintain both the outward beauty and the external iciness of the dandy. Yet, over time, the picture's function as "the most magical of mirrors," as "the visible emblem of conscience," and the "visible symbol of the degradation of sin" comes to be too much for Dorian, who can no longer sustain the lack of harmony between his inner and outer selves, between his hideous soul and handsome skin, between his external beauty and internal ugliness (120, 104, 108). With his divided, mysterious, and masked identity, Dorian is, to use Elisa Glick's phrasing, "always a contradiction of outward appearance and inner essence" (154). This contradiction partially explains Dorian's failure as a dandy. If, as Baudelaire asserts, the dandy must live and sleep before a mirror, Dorian's magical mirror does not provide him with a true or complete reflection. Furthermore, if, as Barbey d'Aurevilly argues, the dandy represents the fusion of mind and body, Dorian does not succeed in this task either, as indeed the opposite occurs insofar as his downfall and self-destruction stem from the disproportion between his two selves, not to mention the disparity between who he is as the real-life personification of Basil Hallward's artwork and who he is as the living embodiment of Lord Henry's hedonistic doctrine.

Faced with the paradox of realizing himself as someone else's artistic masterpiece (in the case of Basil's portrait) or someone else's self-doctrine (in the case of Lord Henry's aesthetic philosophy), Dorian is clearly a false or failed dandy who lacks the originality and creativity needed to carry out a true or successful process of self-aestheticization. Dorian Gray cannot be a true dandy because he lacks the dandy's individualism and independence; his own artistic self-fashioning is never fully separate from Lord Henry's desire to fashion Dorian "into a marvelous type" and from Dorian's own wish to become someone else's artistic work (40–1). Consequently, he lacks what Rita Felski terms the dandy's "cult of extreme individualism" and what Rhonda Garelick calls the dandy's "self-generated, independent, and tradition-free royalty of the self" (Felski 98; Garelick 24). If, as Barbey d'Aurevilly famously notes, "independence makes the Dandy," Dorian's double dependence "unmakes" him as one (27). More importantly, he does not conform to the dandy's "need *to make of oneself something original* – as the artist creates an original work out of his own being" (Moers 282). Despite Dorian's illusory

belief that he is his own creation, the reader knows the full extent of Lord Henry's tutelage and his Mephistophelean influence as well as the consequences of trying to become an art object of someone else's making. Dorian becomes doubly a disciple, a citation, a copy – even a product – of other men. Unlike Lord Henry's more successful process of self-aestheticization, Dorian's existence as a dandy-aesthete leads ultimately to a loss of self – a self that is not a beautiful artwork, but a hideous appearance that must be destroyed in a significant act of self-annihilation as opposed to self-aestheticization.

The Dandy-Aesthete as Social Climber: Artistic Self-Fashioning and the Fictionalization of Self in Thomas Mann's *Felix Krull*

The middle-class origins and initial need for work that characterize Thomas Mann's titular protagonist, Felix Krull, undoubtedly explain why no critics to my knowledge have noted the parallels between Felix and the dandy-aesthete. I nonetheless wish to establish the ways in which Mann's character does intersect with this figure insofar as he too is an "artist of the self." Once Felix frees himself from work, save for the constant labor of keeping up appearances and conforming to his newly adopted roles, he warrants comparison to this non-traditional artist type. In order to understand this connection, I shall begin by considering how the turn-of-the-century strain of aestheticism, particularly that articulated in Nietzsche's *The Gay Science*, redefines the attributes and characteristics of the artist by expanding the category to include those whose profession does not involve the creation of some external artistic work, as outlined in Nietzsche's aphorism, "*On the problem of the actor*":

> The problem of the actor has troubled me for the longest time. I felt unsure (and sometimes still do) whether it is not only from this angle that one can get at the dangerous concept of the "artist" – a concept that has so far been treated with unpardonable generosity: Falseness with a good conscience; the delight in simulation exploding as a power that pushes aside one's so-called "character," flooding it and at times extinguishing it; the inner craving for a role and mask, for *appearance*; an excess of the capacity for all kinds of adaptations that can no longer be satisfied in the service

of the most immediate and narrowest utility – all of this is perhaps not *only* peculiar to the actor?

Such an instinct will have developed most easily in families of the lower classes who had to survive under changing pressures and coercions, in deep dependency, who had to cut their coat according to the cloth, always adapting themselves again to new circumstances, who always had to change their mien and posture, until they learned gradually to turn their coat with *every* wind and thus virtually to *become* a coat – and masters of the incorporated and inveterate art of eternally playing hide-and-seek, which in the case of animals is called mimicry – until eventually this capacity, accumulated from generation to generation, becomes domineering, unreasonable, and intractable, an instinct that learns to lord it over other instincts, and venerated the actor, the "artist" … (316–17)

Nietzsche asks here whether falseness, simulation, and disguise are "perhaps not *only* peculiar to the actor," and in so doing, he invites us to assign the actor's attributes to a more pervasive group of people whose contact with the thespian profession need not actually exist. He attributes role playing and acting to people of the lower classes (and goes on to make similar connections to Jews and to women), noting that their histrionic impulse aligns them not only with actors, but also with the figure of the artist. Nietzsche's expansive definition of actors and his insistence that it is through the figure of the actor that we can get to the "dangerous concept of the 'artist'" underlie the present examination of the ways in which Felix Krull takes on the attributes of the artist and actor in his attempts to convert himself into an artwork.[4] Mann's novel explores how the modern artist – in a strikingly Nietzschean way – has come to include those of the lower classes, who pass for more than they are and assume roles out of necessity at first, but then find a way to "do just about anything and … *manage almost any role* (Nietzsche 303). This particular type of artist understands the "great and rare art" of "'giv[ing] style' to one's character," which requires "survey[ing] all of the strengths and weaknesses of … nature and then fit[ting] them into an artistic plan until every one of them appears as art" (Nietzsche 232). Put another way, this artist of the self "experiments with himself, makes new experiments, enjoys his experiments; and all nature ceases and becomes art"

(Nietzsche 303). Replacing nature with art, aestheticizing the self – these are the shared goals of the dandy-aesthete as defined here.

When we first encounter the young Felix at the beginning of the novel, he certainly lacks the elitist or aristocratic social standing one typically associates with the dandy-aesthete figure. Mann's protagonist comes from "an upper-class though somewhat dissolute family" whose disreputable reputation stems primarily from "the economic aspect of the situation" (1, 14–15). Felix insists that poverty is "highly sinister" and "extremely repulsive" to its possessor, "and any association with it may lead to unpleasant consequences" (119–20). Yet Felix is surprisingly successful in eluding poverty and its unpleasant consequences, namely because he uses costume-, name-, and role-changing to achieve upper-class status and aristocratic rank. In this way, Felix adopts a theatrical attitude in his self-construction. He demonstrates a delight in acting as a model and in "dressing up in all sorts of costumes" (19). Being "a natural costume boy," that is, having a "Kostümkopf," Felix insists that everything he tries on becomes him (20). As he himself explains: "in each disguise I assumed I looked better and more natural than in the last … whatever the costume, the mirror assured me that I was born to wear it, and my audience declared that I looked to the life exactly the person whom I aimed to represent" (20). Performing before himself, the mirror, and others, Felix reveals his narcissism and his desire to be a spectacle for others.

By changing names in addition to costumes, the young Felix prevents the return to his "real" self, a self that gradually becomes subsumed by his continual performativity. Felix's names exist independently of one another as each new designation utterly replaces, and thereby erases, the previous one. We can thus make sense of Felix's excitement regarding what he deems the "pleasant refreshment and stimulation of the whole being [that] comes … from being able to give oneself a new name and hear oneself called by it" (48). When Felix's sister, Olympia, is presented with the prospect of acquiring a new name through marriage to Lieutenant Übel, Felix likens the impending opportunity to "the charm of novelty" and laments: "How tiresome to sign the same name to letters and papers all one's life long!" (48). Consequently, Felix can delight in the *Generaldirektor*'s insistence that he assume the name Armand in his new position as liftboy: "It gives me the greatest joy … to change

my name" (144). Of course, Mann uses this moment to foreshadow Felix's future success as a forger, a name appropriator, and an identity thief. Simply put, the theme of name changing proves to be part and parcel of Felix's overall penchant for identity shifting.

Interestingly enough, before Felix changes names as a result of his new job, his "whole career of fraud" ("[s]ein ganzes trügerisches Leben") consisted in avoiding "work" via role playing (2). Felix's success in "the imitation of ... [his] father's handwriting" and in "producing the appearance of physical illness," allows him "to work in the interests of ... [his] intellectual freedom" and so avoid actual "work," i.e., school (29, 30, 32). Likewise, in the conscription scene, Felix becomes an actor so as to circumvent military recruitment. In both instances, he manages to create "a compelling and effective reality out of nothing" and so "avoid[s] the painful oppression of school by becoming an invalid," on the one hand, and succeeds in living "like a soldier but not as a soldier," on the other hand (34, 31, 101). As a result of these performances, Felix derives a strange and dreamlike satisfaction from his creative task and uses his skills as an actor in the name of personal and artistic freedom. His *labor* is a form of self-fashioning. Felix *works* on himself rather than for others. He *produces* new versions of himself instead of artworks or commodities for others.

Whereas he initially adopts roles to avoid work and to ensure his freedom, Felix later uses his various occupations as sources for new characters to play. He notes with excitement: "I have never tried on a liftboy's uniform" (145). Yet Felix soon becomes bored with his role as elevator boy and begins to feel "imprisoned" in his "elevator cage" ("Ascenseur-Nische") (193). Hence, when offered a new position in the hotel restaurant, Felix's longing for an expansion of his exist-ence, for richer possibilities, for a new uniform, and for a new occu-pation is granted. Now dressed as a waiter, Felix makes his "debut" in the dining room in full glory ("in voller Parure") (197). As he insists: "The livery was extremely pretty, especially if one knew how to wear it" (196). More importantly, it was his "secret wealth" that prevented work from being a necessity and made it a choice, thereby transform-ing the uniform and the job "into a role, a simple extension of [his] talent for 'dressing up'" (181). Ultimately, Felix and the Marquis "come so close – to the point of interchangeability" thanks in part to Felix's belief in the interchangeability of everyone – since "[w]ith

a change of clothes and make-up, the servitors might often just as well have been the masters, and many of those who lounged in the deep wicker chairs, smoking their cigarettes, might have played the waiter" – and thanks also to his unique ability to imitate or "double" others so perfectly (141, 218). Felix believes wholeheartedly both sides of the ambiguous claim he shares with the Marquis: "Clothes make the man, marquis – or perhaps the other way around: the man makes the clothes" (229).

All of these changes in costumes, names, and roles serve to establish Felix as the living embodiment of the Nietzschean notion of "brief habits," as outlined in aphorism 295 of *The Gay Science*. According to Nietzsche, brief habits are "an inestimable means for getting to know many things and states, down to the bottom of their sweetness and bitterness" (236). Despite the necessary ephemerality of each habit, however, it creates the feeling of endurance and wholeness as one "desire[s] nothing else, without having any need for comparisons, contempt, or hatred" and temporarily believes "that here is something that will give me lasting satisfaction – brief habits" (Nietzsche 237). In a strikingly similar manner, Felix considers the world "a great and infinitely enticing phenomenon" (11). He explains that "[w]hatever is new holds infinite charm for the young" (68). One should see everything "with a fresh eye undimmed by habit," insists Felix, so as "to see the familiar ... with new, astonished eyes as though for the first time" because this "wins back the power to amaze" and allows the world to remain fresh (355). It is during his revelatory conversation with Kuckuck on the train that Felix sees clearly the value of transitoriness, a concept much like Nietzsche's notion of "brief habits" and the exact method by which Felix has modeled his entire existence: "Transitoriness did not destroy value, far from it; it was exactly what lent all existence its worth, dignity, and charm. Only the episodic, only what possessed a beginning and an end, was interesting and worthy of sympathy because transitoriness had given it a soul" (270). It is on account of this belief in the episodic and the ephemeral that Felix differs markedly from the Marquis whose persona he decides to embody and whose personality he chooses to re-enact. Whereas the Marquis does not understand how one can "wish to be a different person from the one he is," Felix knows that "if you should become another person, you would not feel the lack of your present self or regret it, simply because it would no longer be

you" (233). Moreover, Felix's inclination toward the ephemeral cannot and should not be separated from his longing for newness and change. It is for this reason that he rejects Lord Strathbogie's offer to adopt Felix and make him heir to his possessions. Unwilling to be the "plaything" ("Spielzeug") of the Lord's whim and indisposed to returning to his "real name" and "ordinary clothes," Felix "rebelled against a form of reality that was simply handed to [him] and was in addition sloppy – rebelled in favour of free play and dreams, self-created and self-sufficient, dependent, that is, only on imagination" (211, 207, 210, 215). As this passage reveals, Felix takes an active and imaginative approach to his multitudinous adventures, and, as such, his method of self-fashioning should be considered a type of intellectual and artistic labor.

Felix may not wish to labor in the bourgeois sense, but he nonetheless abhors the thought of giving up the toil and exertion that are an essential part of his mode of self-construction. Owing to this paradox regarding his relationship to "work," Felix must accept the challenge posed by the Marquis de Venosta's dilemma, since as Michael Beddow rightly notes, "[t]he exchange with the Marquis ... demands *constant alertness* and the *sustained exercise* of his imagination if he is to carry it off. It offers an escape from Felix's everyday self that calls for the *strenuous application* of his talents for constructing and maintaining a consciously false identity" (82, emphasis added). Being a Proteus rather than a single individual, being not one but many, Felix will have no trouble assuming an identity that "no one" – that "*keiner*" – could adopt. His palimpsestic series of selves has led up to this, the only plausible "adventure that would call upon [his] talents" (240). As his previous "delights of incognito" become reality, he banishes everything from his "no longer valid past" and begins "the change and renewal of ... [his] worn-out self" (247, 252). Just as he had done previously with the imitation of his father's autograph, once again Felix mocks another's signature and so escapes from the world of work and bourgeois duty. With the all-important letter of credit, he can embark on a "new and higher existence," one in which there is a newfound "equality of seeming and being" ("Ausgleich von Sein und Schein") as the "appearance" was now appropriately being added to the "substance" (248, 246).

With this unity of being and appearing as well as this new superior position in society, Felix invites comparison to the dandy-aesthete.

Let us pause to consider Balzac's contention that "[t]he man accustomed to work cannot understand elegant living" as well as his one significant "exception" for the artist, whose "idleness is work, and his work, repose," since this helps explain and justify Felix Krull's mode of labor (Balzac 8–9). In a strikingly dandyesque fashion, his work involves the production of one's carefully tended self and the cultivation of beauty in one's person, which are the only forms of work permissible for the dandy. Moreover, Felix's self-conception clearly reflects the haughtiness and exclusiveness of the dandy. "I should have to be a fool or a hypocrite to pretend that I am of common stuff," insists Felix, "I am of the finest clay" (9). When Felix unsuccessfully looks to his forebears for evidence of hereditary likeness – that is, greatness – he concludes that he must look within himself "in order to explain the source of [his] superiorities" (60). This allows him to underscore – in a typically dandy-artist fashion – that his personal assets were his "own work" ("[s]ein eigen Werk") (61). When interpreting this claim, Eric Downing contends that Felix "goes so far as to insist that we recognize that his corporeal qualities have no origin in anything or anyone natural …, that he composes himself through his own study and industry" (177). This anti-natural and pro-aestheticist thrust serves as further evidence of Felix's dandy-like self-construction, since the dandy's task was to "superimpose himself on his own human nature" by maintaining "constant and rigorous control of himself" (Hinterhäuser 76, translation mine). Had it not been for his continual process of self-fashioning and his watchful soul, claims Felix, "my voice might quite easily have turned out common, my eyes dull, and my legs crooked" (61). Instead, he possesses "an easy and polished style of address, the gift of good form," which allows him to live properly "the whole way of life [he has] adopted" or fashioned for himself (284). Whereas "an aristocrat of money is an accidental and interchangeable aristocracy," the type of aristocrat Felix becomes rests on a purely *meritocratic*[5] basis (218). He manages to achieve, while passing for – or *sur*passing – the Marquis, the longed-for "equality of seeming and being" that is so essential to his self-construction as an elitist dandy figure (246). Unlike the wine sold by his father, whose quality "was not entirely commensurate with the splendor of its coiffure," Felix's outward appearance – his "own striking physical perfection" and his "physical fineness and attractiveness" – is matched by his inner grace and style (4, 298, 7).

In line with the dandy, he possesses "the perfect harmony between the suit, its material, its color, and the character of the person who wears it" (Hinterhäuser 73, translation mine). If Wilde's Dorian is "always a contradiction of outward appearance and inner essence," Mann's titular character disavows any such contradiction by insisting that being is always an act of appearing (Glick 154).

He also succeeds in using his performances to raise his class status and pass for someone from the upper echelons of society. In this regard, Felix parallels George Bryan Brummell – "the greatest Dandy of his time, and of all time" (d'Aurevilly 6). Lacking "high birth or immense wealth," Brummell is nonetheless known for his "meteoric social ascendancy," his "self-created royalty," and "his status as 'a prince of his time'" – all of which he achieved by raising himself "to the rank of a Thing" and becoming "Dandyism itself" (d'Aurevilly 6; Garelick 6; Garelick 21; d'Aurevilly 6). Curiously enough, then, dandyism, which has been described by Françoise Coblence as "the anxious response to a declining aristocracy and the rise of the bourgeoisie," can be embraced from the top (as is generally noted) or the bottom (as the case of Brummell in life and Felix in literature seem to suggest) (qtd. in Garelick 24). In other words, dandyism can be the path that allows one to *maintain* aristocratic status or to *achieve* it as something new. In the first instance, the dandy – existing elegantly without having to work – is above his bourgeois and proletarian contemporaries, and he is even more secure atop the changing class hierarchy than the waning aristocratic class. As Ellen Moers explains: "As a pose and as an attitude it [dandyism] came to serve a social need," since it served as "a necessary badge of class for the disaffected aristocracy" (Moers 121, 122). Rhonda Garelick likewise asserts that dandyism "may reinvigorate or even improve upon a waning aristocracy, refashioning it as pure meritocracy" (29). In the second instance, however, dandyism becomes a way to justify one's "social superiority without reference to wealth and power," which meant that conceivably "anyone" – at least anyone capable of embodying the dandy's "doctrine of elegance and originality" – could elevate his social position through dandyism (Moers 122; Baudelaire, *Painter* 28). If "an aristocracy of self-made elegance replaces one of birth," then dandyism served to "dismantle social distinctions" by allowing the dandy to exist "in a parallel hierarchy based on personal attributes rather than genealogy or property" (Fillin-Yeh 6, 36). In Honoré de

Balzac's 1830 *Traité de la vie élégante* (*Treatise on Elegant Living*) we encounter the notion that actual wealth and class status are not as important as one's inner elegance and personal taste, as these well-known aphorisms suggest: "A man becomes rich; he is born elegant" (25); "Not all the aristocracy's children are born with a feeling for elegance, with that taste that helps give life its poetic stamp" (34); "Clothing does not consist so much in clothes as in a certain manner of wearing them" (71). Balzac clearly aims to separate "a feeling for elegance" and poetic style and taste from any specific class status. Neither wealth, nor aristocratic rank, nor certain clothes can guarantee elegance. This "new kind of aristocracy," as Baudelaire defined dandyism, would be based on "the divine gifts which work and money are unable to bestow" (*Painter* 28).

Whereas we have heretofore examined Felix as the novel's protagonist, we shall now consider his role as retrospective narrator of his younger self and also as the character of a 40-year-old memoir writer in Mann's narrative, since these additional roles further explain Felix's success as a dandy-artist.[6] Both gentleman and worker, both elite and bourgeois, both original and copy, both surface and depth, Felix is doubled as character. Both old and young, both author and actor, both narrator and character, both spectator and spectacle, Felix is doubled as narrator of himself as character. In fact, it is worth noting that *Felix Krull* is the only major work by Mann in which the protagonist is also the first-person narrator, and this warrants our careful consideration of the implications of both Felix's and Mann's narrative methods (Downing 170). Felix's "double life" or "dual existence" takes on many forms as his contrasting roles "go on concurrently" (227, 224, 226).[7] The emphasis on the inner and outer, on being and the appearing, suggests an important duality in Felix's self-construction. In each case, the "charm lay in the ambiguity as to which figure was the real I and which the masquerade" (224). When elaborating on his dual position as waiter and gentleman, for example, Felix astutely observes: "I masqueraded in both capacities, and the undisguised reality behind the two appearances, the real I, could not be identified because it actually did not exist" (224). Unlike Dorian's own dual existence as body and soul, appearance and essence, outer and inner, Felix Krull's doubling does not involve a splitting or fragmenting of the self, perhaps because he is the author and actor at the same time, but is never scripted from without.

In fact, many of the distinctions between Lord Henry and Dorian Gray (author/actor; thought/action; older/younger) are found to coexist in Mann's titular character insofar as the first-person retrospective narration actually presents us with the character's "early years" as recounted during his "later years," which sets up a process of self-duplication and allows Felix to be simultaneously author, actor, and audience.[8] Thus, whereas Lord Henry scripts much of Dorian's life, Felix as memoirist writes the lines and creates the parts for his younger self. The former self's artistic career depends in large part on that of the latter self. Felix assumes a multitude of guises not only as an agent within the narrative, but so too as storyteller of that narrative. In many ways, the performance of Felix as character is mirrored in and constructed through his performance as overtly fictitious narrator.

It is precisely Felix's role as author coupled with his ability to eliminate what Eric Downing terms "backstage reality" that accounts for his overall success. The later Felix sustains the earlier Felix's fiction-making activities as a result of the retrospective and self-conscious narration, and thus Felix's roles never give way to his inner self insofar as he is shown to possess one. More important still, the protagonist's additional role as backward-looking narrator keeps the younger Felix safe within an aesthetic web of illusion and fiction making. When discussing how Felix, in a strikingly anti-Pygmalion gesture, attempts to turn his earlier self into an artwork, Downing notes that "as narrator, Felix contrives, creates, composes and controls his character, frees him from the limitations inherent to reality and thereby destroys and dehumanizes the natural, original grounding, or life, of his former self" (170). Through de-realization and dehumanization, then, Felix replaces life with art in the construction of his aestheticized self. It is true, however, that a careful reading of the novel reveals Felix's inevitable downfall in certain moments beyond the narrated "early years," such as when Felix spends many years in jail and when Schimmelpreester must intervene to rescue him.[9] Yet this "backstage reality" is certainly kept to a minimum so as to ensure that our attention stays with the young and successful dandy-artist. In this regard, we should recognize that just as Felix parallels Brummell's initial social ascendancy, so too does he presumably meet a similarly tragic end. In his study on Brummell, d'Aurevilly briefly notes "the miseries which lacerated his [Brummell's] last days" as

"he was to find prison, beggary, and a lunatic asylum to die in" (59, 58). Yet d'Aurevilly resists recounting Brummell's "humiliations and sorrows" (59). He asks: "Why should they be recounted? It is the Dandy we are studying, his influence, his public life, his social role. What does the rest matter? ... Let us leave all that" (d'Aurevilly 59). Mann makes a similar decision to focus only on Felix's rise to aristocratic rank, rather than his inevitable fall from it, at least in the published volume on Felix's "early years."[10]

Krull uses his performative skills successfully to raise his social status and to attain his desired ends. In an effort to prevent the return of reality and of his "ordinary dull dress," which Felix deems boring by contrast to the exhilaration of his fictive escapes, he finds a way to make role playing a permanent part of his identity, since for him "the glorious hours" were those spent dressing up (20). Felix derives a "strange and dreamlike satisfaction" from his "creative task" and uses his skills as an actor in the name of personal freedom (34). Felix's wardrobe is constantly expanding as he *becomes*, to use Nietzsche's metaphor, whichever coat he wears. Indeed, Felix's natural core has all but disappeared in the palimpsest of fictions and costumes that have replaced the physical body. According to Beddow, "[t]he pull away from the real towards the fictitious figures as a life-sustaining and life-enhancing drive" in Mann's novel (81). Felix's existence as a dandy-aesthete is the cornerstone to both his self-fictionalization and self-aestheticization. Social climber, confidence man, and artist of the self – Mann's protagonist benefits generally from his treatment of life as art and specifically from his artistic approach to his own life.

6
The Artist as Dandy-Flâneur: The World as Art in Manuel Gutiérrez Nájera and Julián del Casal

This final chapter examines how two of the most prominent authors of Spanish American *modernismo* – Manuel Gutiérrez Nájera from Mexico and Julián del Casal from Cuba – used their journalistic publications, or "crónicas,"[1] as a way to take on narrative subjects and create narrative identities that intersected with the late nineteenth-century European dandy and flâneur. The task of finding Spanish American literary protagonists that resemble the fictional dandies and flâneurs frequently found in European aestheticism at the turn of the century, and who adopt a philosophy of "life for art's sake" in their attempts to turn themselves into artworks or to make their worlds more artistic, has indeed been a challenging one. Very little has been written about the Spanish American dandy[2] or flâneur[3] during the late nineteenth century, and this stems in part from an overall scarcity of literary protagonists who fit the mold. Aside from José Fernández, the main character of José Asunción Silva's only novel *De sobremesa* (*After-Dinner Conversation*, written in 1896, first published posthumously in 1925),[4] there really are not any obvious protagonists on par with European literary heroes such as Huysmans's Des Esseintes or Wilde's Lord Henry and Dorian Gray, nor are there any Spanish American manifestos on dandyism or *flânerie* that could rival Balzac's *Treatise on Elegant Living*, Louis Huart's *Physiology of the Flâneur*, Barbey d'Aurevilly's *The Anatomy of Dandyism*, or Baudelaire's *The Painter of Modern Life*. The lack of material on the Spanish American dandy and flâneur leads me to ask the following two questions: What does the dandy need that the Spanish American context does not offer? What does the flâneur require that

is missing in turn-of-the-century Spanish America? By examining the complex portrayal and simultaneous disavowal or undoing of these figures in various chronicles by Casal and Gutiérrez Nájera, I hope to offer provisional answers to these queries, while also exploring the repercussions of adopting – and adapting – in the Spanish American periphery two distinct social and aesthetic models that originated in the European centers of England (the dandy) and France (the flâneur). Ultimately, this analysis shall consider the attempts and shortcomings of trying to treat life artistically.

The Dandy as Subject of the Spanish American Chronicle

Evidence of the dandy figure can often be found in the subject matter of the Spanish American *modernista* chronicle. The Cuban poet and journalist Julián del Casal, for example, describes the following four figures in a dandyesque fashion: Enrique José Varona (from the posthumously published collection of poetry and prose, *Bustos y rimas* in 1893), an unnamed Mexican gentleman (from his "Crónica semanal," published in *El País* on October 24, 1890), "Señor Collazo" (from a chronicle "La sociedad de La Habana," published under the pseudonym "el Conde de Camors" in *La Habana Elegante* on June 24, 1898), and Ezequiel García (from the chronicle "La joven Cuba. Galería Mignon," published in *La Habana Elegante* on February 12, 1888). Varona is an "illustrious writer" with a "glorious literary career" (*Poesía completa* 260).[5] Despite being an actual artist figure, he also intersects with the dandy insofar as he is a "man of thought, more than a man of action," is someone who understands "that the love of beauty has always been the most characteristic trait of civilized societies," and "is a man who truly loves his [artistic] Ideal" (*Poesía completa* 261–2). The unidentified Mexican gentleman is "beautifully masculine" and possesses "the strictest elegance and the most irreproachable distinction" (*Crónicas habaneras* 167). He brings together in exquisite fashion "the gifts of a vast intellectual culture," is able to converse with "sublime irony," and is "a lover of poetry ... especially that of Baudelaire and Mallarmé" (*Crónicas habaneras* 167). Moreover, it is his loyalty to the creation of a beautiful, artistic self that explains his suicide, since, with his "superior spirit" and "aura of greatness," this "heroic man" considered that he had no other choice, upon noticing the first signs of his illness (of "la grippe"),

but "to end his life when faced with the fear of losing his dignity" (*Crónicas habaneras* 167). Not wanting to ruin the masterpiece that was his self, he commits suicide so as to avoid the ugliness associated with this terrible epidemic, or at least this is how Casal interprets his death and presents it us. Collazo is "possessed by the ideal" and has made of art "a kind of religion" from which neither politics, nor mercantilism, nor fortune could divert his gaze (*Poesía completa* 294). The only school of art to which he belongs is that of "good taste" – and he is known both for the numerous objects that he collects as well as the "magnificent collection of suits, authentic and sumptuous, from the last three centuries" and "all of the indispensable accessories: powdered wigs, silk stockings, elegant shoes, and exquisite belts" that he possesses (*Poesía completa* 295). Finally, Ezequiel combines masculine beauty, delightful talent, immutable elegance, and natural grace (*Poesía completa* 275). He is someone who can be contemplated in two ways: in the human and the artistic settings, that is, in the realms of both life and art (*Poesía completa* 276). His verses, which "should have been written with a swan's feather, impregnated with carmine ink, on light blue paper trimmed with silver," are representative of the *modernista* mode and the aestheticist vein (*Poesía completa* 278).

Clearly, the descriptions of these four gentleman intersect in obvious ways with the dandy's appearance (elegant and refined), personality (artistic, dignified, gentlemanly, witty, blasé, and with discriminating taste), conduct (independent, self-masterful, self-assured, and with great aplomb), and social position (elitist, aristocratic, free from work, and with unlimited credit and leisure time), as outlined previously in Chapter 5. Nevertheless, Casal complicates his definition and portrayal of the dandy figure in the last instance, when he dedicates one lengthy paragraph of his chronicle on Ezequiel to explaining why his chosen subject was not "a complete dandy" ("un completo *dandy*"), but rather "a complete dilettante" ("un *dilettanti* completo") (*Poesía completa* 277). Without giving any real explanation of what separates Ezequiel the dilettante from the dandy, Casal nonetheless offers a concise yet accurate definition of the (Baudelairian) dandy:

> The dandy has to be a lymphatic and cold man, who is sick and tired of everything and wants to make himself original.

Indifference is the supreme virtue of the dandy. ... The dandy is not, as is generally thought, a man who is only concerned with the embellishment of himself. This is nothing more than a manifestation of the superiority of the dandy's spirit. ... In order to be a dandy, one must have general knowledge ... and the considerable fortune needed to worship all of the passions. The dandy should feel the pleasure of astonishing and the proud satisfaction of never being astonished. One is born a dandy, just as one is born a poet. (*Poesía completa* 277)

Ezequiel's artistic production, which includes verse, prose, music, and drawings, may be that of a dilettante, but Casal seems to hint at the fact that the real reason he cannot be a true dandy (or a true artist) results from the shortcomings of "the modern world, where no one adores beauty or believes in love," in contrast to "the ancient world, where beauty was adored and love made into a religion" (*Poesía completa* 279). The failings of the modern world definitely impede the emergence of the dandy figure, who lacks the audience capable of appreciating him and his spectacle of a refined and artistic self, and this parallels the situation of the actual artist figures discussed in Chapter 4 who likewise fail to find the proper public for their artistic creations in Spanish America – hence Casal's connection between the dandy and the poet.

In "Cosas del mundo" ("Things of the World"),[6] Gutiérrez Nájera likewise portrays a dandyesque individual. This chronicle recounts a budding friendship between the narrator and his "strange" or "peculiar" friend" Milord Pembroke, "a legitimate *gentleman*," an "extravagant Englishman," who is wealthy and has already begun to experience "the first signs of *spleen*" (110, 109). "[B]ored ... with London and the English, their palaces and horses," Pembroke embarked on "the adventures of the *touriste*" which led him to Paris, Germany, Italy, Portugal, India, and China (109). A true dandy figure, Lord Pembroke has "enviable calm" and is described as "a man made of granite" (109). He is also known for his eccentric and shocking commentaries, such as when he insists that the best way to punish adultery would be to chop the lover into pieces in front of the adulterous wife and then rip out her eyes in the presence of her children (110). The narrator's reaction – "it's easy to understand how *astonished* that response left me" – recalls that of the dandy's

audience, who is astonished by his unconventional and shocking remarks (110, emphasis added). The text continues with lengthy descriptions of the narrator's privileged visit to "the vacation home ["la casa de recreo"] of this eccentric," which represents "the highest degree of beauty and elegance" and is marked by "the opulence and taste of Pembroke" (110, 111). It is also the place where he finds the "most exotic, rarest, and strangest" things (111). Upon finishing his tour of the mansion, the narrator learns that "the best" is still left to be seen, namely the lord's beautiful wife (112). Yet before he can behold "the goddess of that magical place," he wakes from his pleasant vision to discover his room, his bed, and his night-stand, and to realize that it had all been a dream (112). Angered for having been "yanked out of that dream," the narrator protests against this "unfortunate" or "ill-fated" "awakening" and tries desperately to return to the dream (112*).* The world of the dandy may be possible for an Englishman, but for the Spanish American subject (and for Gutiérrez Nájera in particular), it is a dream world that he cannot access for any sustained period of time. Moreover, he is never more than a spectator of that world, rather than a participant in it. Perhaps because of his geographic location or perhaps owing to his lack of that "incomparable power" ("poder incontrastable") that Pembroke possesses, namely "wealth" ("riqueza"), the narrator cannot truly or fully access the subject's dandyesque world (111).

The Flâneur as Subject of the Spanish American Chronicle

The complex description of the world of the dandy in "Cosas del mundo" parallels the ambivalent portrayal of the world of the flâneur in Gutiérrez Nájera's "Stora y las medias parisienses" ("Stora and the Parisian Stockings").[7] In this chronicle, the narrator describes his acquaintance with "one of those street pirates who lived and died without regret or remorse. He was a bohemian and his last name was Stora" (82). A curious combination of the bohemian and the flâneur, Stora is a "poor" poet who lived "between solitude and sadness" (82). "The solitary man, deprived of all luxury, of all festivity, of all squandering" was "captive in a miserable attic room" (82). Yet every time it began to rain in Paris, he would leave his impoverished dwelling, take to the streets, and assume the wanderings of the flâneur.

"[W]henever the rain poured down and the mud gathered on the pavement," the narrator recounts, Stora "could not stay inside for even a second. It was then that he took possession of Paris, believing himself the owner of a domain greater and richer than that of Salomon" (82–3). Once engaged in the act of *flânerie*, which for him consisted in his constant pursuit of elegant, Parisian women, Stora's awareness of his lack of wealth immediately disappears as he becomes the owner of that "grand and rich" city. Whereas initial descriptions of Stora resemble those poor and struggling artist protagonists from Darío's short stories in *Azul*, later descriptions of him as a flâneur underscore his success in viewing the world artistically, in seeing Paris unfold as "an admirable painting for the artists" (81). He is now likened to a prince and a millionaire, and is once again described as "owner" and also as conqueror of Paris (84). His artistic approach to life – which consists in "getting to know and taking note of all of the stockings of the great Parisian women" – is described in detail as follows:

> He fixed his gaze on their shoes, followed them day and night, walking, walking, like the wandering Jew, watching the city squares and streets awaken, leaving behind the boulevards and losing himself in the darkest and muddiest neighborhoods, leaving blue stockings for gray ones, or a little black-skinned boot for a graceful ankle boot of golden leather. (83)

Walking in search of modern beauty, Stora clearly intersects with the late nineteenth-century Parisian flâneur. Curiously enough, however, it is when Stora's economic situation improves and he suddenly becomes rich, that he "found himself forced to renounce his delicious long walks ... under doctor's orders" (84). Rather than travel through the streets of Paris, he must travel to places such as Bordighera, Monaco, and Geneva. His prescribed cure, a journey in search of nature and repose, leads him to "orange and lemon trees, aloe plants, and the blue sea," which only serve to bring him "an incurable sadness and a profound nostalgia" on account of the fact that "it only rains a bit in those sunny lands, and when it does rain the women refuse to lift their petticoats or if they do, one discovers a thin and angular leg with a pronounced instep, covered in irregular or colorless stockings" (84). "Only Parisian women know how to wear their stockings," Stora reflects bitterly (84). Being wealthy, then, does

not appear to be a prerequisite for the flâneur in this text, although living in Paris and having an artistic sensibility certainly are requirements. Ultimately, Stora does return to Paris to resume his acts of *flânerie*, and it is there that he dies from an illness brought about by his constant wandering in the rain. Gutiérrez Nájera's portrayal of Stora offers a complex treatment of the flâneur as bohemian. The poor poet can find happiness in the act of *flânerie*, but only on the streets of Paris, and even then the idea of living life for the sake of art inevitably leads to the artist-as-flâneur's untimely death.

Gutiérrez Nájera clearly associates the flâneur with the great city of Paris, and he considers himself among those who are best described as "French spirits deported to American soil" ("El bautismo de *La Revista Azul*" 537). It is worth noting that unlike Darío and Silva, who did make it to Paris, neither Gutiérrez Nájera nor Casal ever visited the cultural capital and the land of their illusions, the former because he never left his native Mexico, the latter because he ran out of money only a few weeks into his European travels and was only able to visit Spain before having to return to Cuba to resume his journalistic work and once again earn a wage. Perhaps owing to the frustration of getting close but not close enough to Paris, Casal writes the chronicle "La última ilusión" ("The Last Illusion"), published in *La Habana Elegante* on January 29, 1893, which narrates a dialogue between an unnamed first-person narrator and his friend, Arsenio. Since his adolescence, Arsenio had been "dominated by ... the saddest, strangest, and most disconsolate ideas," had abandoned all of his aspirations, and no longer knew how to desire anything (387). The narrator tries to convince his friend that "the remedy" to his problems consists in going abroad to Paris, "this promised land," but Arsenio rejects this solution on account of his belief that "there are two cities in Paris, the one abominable and the other fascinating" (389, 390). "I loathe the famous, rich, healthy, bourgeois, and universal Paris," he explains, "the Paris that celebrates annually the 14th of July; the Paris that is shown at the Grand Opera ...; the Paris that spends summer holidays on the popular beaches and hibernates in Nice or Cannes, ... the Paris of the Universal Exposition; the Paris proud of the Eiffel Tower; the Paris that is interested today in the question of Panama; the Paris, finally, that attracts thousands and thousands of beings of distinct races, distinct hierarchies, and distinct nationalities" (390). Clearly, this is the Paris of the majority and

of the multitude – in short, of the crowd; it is the Paris concerned with the popular, the patriotic, and the political. In contrast to this Paris, Arsenio describes another side of the city:

> I adore, on the other hand, the strange, exotic, delicate, sensitive, brilliant, and artificial Paris; the Paris that searches for strange sensations in ether, morphine, and hashish; the Paris of the women with painted lips and dyed hair; the Paris of the adorably perverse heroines ...; the theosophist, satanic, and occultist Paris; the Paris that visits with the poet Paul Verlaine in the hospital; the Paris that erects fame for Baudelaire and Barbey d'Aurevilly; the Paris that made the night in the mind of Guy de Maupassant; the Paris that dreams before the paintings of Gustave Moreau and Puvis de Chavannes, the landscapes of Luissa Avvema, the sculptures of Rodin, and the music of Reyery de Mlle. Augusta Holmes; ... the Paris that understands Huysmans and inspires the chronicles of Jean Lorrain; the Paris that gets drunk from the poetry of Leconte de Lisle and Stéphane Mallarmé; ... and the Paris, lastly, that the foreigners do not know and whose existence they perhaps do not discover. (390)

The Paris he adores, then, is an artistic city, a city of artists, whose treasures are neither known by nor knowable to the masses. It is also the space accessible to the skilled flâneur who finds beauty and pleasure as a result of his efforts to discover the true nature of the city. Yet, curiously enough, it is simultaneously a place closed off to foreigners, which seems to suggest an impediment to the Spanish American subject seeking to access this side of the metropolis. In the end, when asked why he does not go to Paris, Arsenio responds as follows:

> Because if I went, I am sure that my fantastic dream would vanish, like the aroma of a flower picked by the hand, until it was divested of all its charm; whereas seeing it from afar, I believe that there is still something in the world that sweetens life's bitterness, something that constitutes my last illusion, the one that one always finds, like a fine pearl in a dusty jewelry box, inside the hearts of the saddest of beings, that illusion that one never loses, perhaps. (391)

The unwillingness to satisfy his dream, his illusion, prevents the Spanish American subject from engaging in acts of *flânerie* and from truly getting to experience Paris, save at a distance and vicariously through the cited list of French artists.

The Flâneur as Narrative Persona of the Spanish American Chronicle

In addition to finding some examples of the dandy and the flâneur in the subject matter treated in these chronicles, we encounter numerous instances of the flâneur in the various narrative personas or narrative identities adopted by these two authors. We must consider that Casal frequently wrote under any one of three pseudonyms: Hernani, Alceste, and the Conde de Camors. The name Hernani, probably taken from Victor Hugo's 1830 drama *Hernani, ou l'Honneur Castillan*, which was later treated by Giuseppe Verdi in the 1844 opera *Ernani*, was used in his writings for *La Discusión*; Alceste, most likely a reference to the character Alceste in Moliére's 1666 drama *Le Misanthrope*, but also a possible allusion to the mythical Greek princess Alcestis, was Casal's pen name for many of his publications in *El País*, such as his contributions to the series "Crónica semanal" and "Conversaciones dominicales"; the Conde de Camors, a reference to Octave Feuillet's 1867 masterpiece *Monsieur de Camors*, was the pseudonym used for most of his publications in *La Habana Elegante* and *El Fígaro*, especially his series of chronicles entitled "La Sociedad de La Habana." Significantly, all three pseudonymous identities have their origins in French literature. Similarly, Gutiérrez Nájera is known to have used more than 20 different pseudonyms in his chronicles as a way of "creating the illusion of a new personality" and varying the point of view from which he wrote (Mapes 648–9).[8] As Gutiérrez Nájera explains, "the act of writing without a pseudonym is like going out on the street without a shirt" (qtd. in Mapes 649). The pseudonyms he used that most resemble the figure of the flâneur include "el Duque Job," "Monsieur Can-Can," and "Pomponnet." All three figures are presented as elegant, refined, sophisticated, and upper-class men who see Mexico City's increasingly urban landscape through supposedly French eyes. The name "el Duque Job" was taken from León Laya's 1859 French Comedy *Le Duc Job*. Gutiérrez Nájera's favorite pseudonymous identity, "el Duque Job" was used more than

the author's own name and was often discussed and analyzed as if it referred to a real person. "El Duque Job" was known for his aristocratic taste, elegant prose, and dandyesque pose. Caricatures of him from the period tended to represent him with a cigar in his mouth, a gardenia in the buttonhole of his lapel, and a cane in his hand (Carter 31). According to Boyd G. Carter in "Manuel Gutiérrez Nájera: Caballero andante de culturas," his creed was that of elegance, courtesy, proper dress, and the rejection of sentimentality (31). Although less well known as a pseudonym, "Monseieur Can-Can" was the pen name used for approximately one hundred compositions that were actually written by Gutiérrez Nájera. The chosen name is a reference to the *can-can*, a dance of French origin that was growing in popularity in late nineteenth-century Mexico. "M. Can-Can" or "Mr. Can-Can" is presented as "a sophisticated individual, with a typically French conception of morals and propriety" (Mapes 653). When he is first introduced in the column "Bric à Brac" in *El Republicano* in 1879, he is described as follows: "French by birth, traveler by profession, in possession of 35 years of capital and an income of forty-two *ingleses* per week," which underscores his supposed alliance with the French, the idle, and the wealthy qualities of the flâneur (qtd. in Mapes 651). Pomponnet is described as an "idler by profession" ("vago de profesión"), as someone who is always up to date on all the latest events and frequents "la calle de Plateros" (Mexico City's most famous street for window shopping, people watching, and acts of *flânerie*), donning formal clothes, cologne water, and delicately tinted gloves (Mapes 653–4). The name is probably a reference to the French verb "*se pomponner*," which translates to English as "to get ready with care," "to take care of one's appearance," or "to get dolled up." Both Pomponnet and Monsieur Can-Can contribute to a column entitled "Memorias de un vago" ("Memories of an Idler"). All three of these pseudonyms or narrative personas seemingly enjoy wandering around, observing, and commenting on urban life – and just as with the pen names chosen by Casal, these can be traced back to French origins as well.

Gutiérrez Nájera adopts the stance of the flâneur in many of his chronicles, such as when he writes in "Las misas de navidad" ("Christmas Masses"),[9] "I had gone out to wander ["flanear"] the streets for a while," or when he describes in "En la calle" ("On the Street")[10] the way in which he "fixed his gaze with curiosity in every

one of the accidents and details" of the urban setting, or when he begins "El amigo" ("The Friend")[11] with a description of his walk "through the streets filled by the crowds" (433, 132, 213). The chronicle that best represents the narrative persona as flâneur, however, is Gutiérrez Nájera's "La novela del tranvía."[12] If read as a chronicle, which is how it was initially published, this work presents us with the actions and imaginings of "El Duque Job" or Gutiérrez Nájera himself. If read as a short story, which is how it was later published, the tale presents us with a first-person narrator who is also the protagonist of the tale. In either case, the narrative voice is an obvious mixture of both the dandy and the flâneur insofar as he is elegant, refined, and upper class, has leisure time and does not appear burdened by the need to work, and enjoys wandering through Mexico City. He is someone who believes that

> the best thing that the unoccupied person ["desocupado"] can do is step on to the first streetcar he encounters and travel the streets, as the old Victor Hugo did, sitting on the throne of the vehicle ... for the observer, there is nothing more peculiar nor more curious than the series of living pictures ["cuadros vivos"] that can be examined while travelling in a streetcar. (154)

The trolley takes him to "many unknown worlds and virgin regions" that surround Mexico City (155). The narrator, in the true spirit of the flâneur, declares himself an expert on this urban landscape: "No, Mexico City doesn't begin with the National Palace, nor does it end on the road to the Reform ["en la calzada de la Reforma"]. I give you my word that the city is much larger" (155). It is important to recognize that in contrast to Benito Pérez Galdós's 1871 short story "La novela en el tranvía," Gutiérrez Nájera's chosen title replaces "en el" with "del" and thus reads "the novel *of* the streetcar" rather than "the novel *in* the streetcar." This slight change in wording reflects a major change in thematic focus. In the former text, the protagonist hears of and then reads about "novelistic" events during his journey on a Madrid trolley; in the latter work the protagonist creates a series of fictional stories based on what he observes and invents while on a Mexican streetcar. Gutiérrez Nájera's tale underscores more clearly the idea of turning the world into art and being an artist of life – and it chooses a flâneur as the person best able to do so.

As he travels from the center of the city to its periphery and comments on the "living pictures" that he observes around him, the narrative persona embarks on a series of journeys of varying significance that take him: (1) from the impersonal to the personal, from an observer to a participant, and from boredom to excitement; (2) from the exterior to the interior, from the physical to the psychological, from the objective to the subjective, from the known to the hypothetical, and from the rational to the irrational; and (3) from the ethical to the aesthetic, from the real to the fictional, and from life to art. By examining each of these multiple journeys, we can better understand the ways in which Gutiérrez Nájera presents his narrative persona as a dandy-flâneur striving to uphold a "life for art's sake" position.

The tale records a journey of growing intimacy as we move from an impersonal subject to an intimate, first-person voice. The narrator initially refrains from using "I"; instead, he refers to himself in the third-person form with general terms such as "el desocupado" and "el observador" (154). Eventually, however, he uses the first-person form. Similarly, when he begins to invent the lives of those accompanying him on the streetcar, he uses the pronouns "he" and "she," "him" and "her," but gradually replaces those with "you" as he comes to address his subjects directly in the form of an inner or imagined dialogue. He even goes on to consider these strangers as "almost friends" (160). In a similar vein, the narrator transitions from the perspective of an observer to that of a participant. Consider for example his decision to marry one of the old man's supposed daughters – "And if I married one of them! ... Why not? ... Which one should I marry? The blonde? The brunette? It would be better to marry the blonde ... I'd say, no, the brunette" – or his momentary belief that he has found the 30-year-old woman's husband, informed him of his wife's affair, and gone with him to seek revenge on the pair of lovers: "when you are in your tepid bedroom and your lover heats you with his hands ..., your husband and I will enter stealthily, and a quick blow will bring you to the ground, while I detain the hand of your accomplice" (157, 160). He becomes so engrossed in the thought of his direct involvement that "a cold sweat bathed [his] face" and made him scan the woman's clothes for a "stain of blood" (160). The narrator also takes an emotional journey that allows him to leave his initial state of boredom and find

entertainment and pleasure. We see this in the narrator's belief that "the movement" of the streetcar "dispels some of the sadness" and allows the protagonist to pass "the hours pleasantly" until it seems to him, finally, in the last line of the tale, that "everyone goes along so happily" (154, 155, 160). Priscilla Parkhurst Ferguson's belief that "the *flâneur* sounds very much like an author in search of characters and intrigue" and that "[a]n entire novel can spring forth from a single encounter observed from the street" relates particularly well to this work and to the inventive and active role of Gutiérrez Nájera's narrative persona (29).

Another series of journeys occurs insofar as we travel from the exterior to the interior, from outside to inside. "After slightly examining the crooked lines and mountain chains of the New World through which [he] travelled," the protagonist turned his eyes "to the interior of the streetcar" (155). Additionally, he mentions on two occasions that he is speaking "to his insides": "I said to my insides" ("dije para mis adentros"), "I continued telling my insides" ("continué diciendo en mis adentros") (156, 158). In a parallel way, the story also moves from the physical to the psychological, from the objective to the subjective, from the known to the hypothetical, and from the rational to the irrational. The narrator alternates phrases that show certainty (e.g., "[s]urely," "it seemed indisputable to me," "[u]nquestionably," "I am certain," "I am sure," "undoubtedly," "[t]he only explanation … is," etc.) with others that reflect supposition or even doubt ("[p]robably," "[m]aybe," "it seems," "[i]n my opinion," "[i]t should be," "[i]t could well be," "[it] appears," etc.), even though he can really be sure of nothing, given that the entire "novel" and all of its "characters" are subjective mental creations. The use of rhetorical questions – "Who could my neighbor be?" "Are they beautiful?" "Which one should I marry? The blonde? The brunette?" "Are they hungry?" "Where is she going?" "Might her mother be ill?" "Who might her husband be?" "Will this woman win the lottery?" "Will I follow her?" "Does she have children?" – also serves to underscore the fact that the narrator is seeking knowledge that he does not possess, but that he will nonetheless go on to create.

The most important journey in this tale for our purposes, however, is that which moves from the ethical to the aesthetic, on the one hand, and from life to art, on the other. Many of Gutiérrez Nájera's writings are tinged with moral sympathies and social critique,

especially for Mexico's poor and struggling youth. In fact, the overt ethical concerns in works such as "La hija del aire" ("The Child of the Air") and "La mañana de San Juan" ("The Morning of St. John's Day") have led many critics to classify Gutiérrez Nájera as a Romanticist and to label him a precursor to Spanish American *modernismo*, rather than one of its founding figures. I am interested here in the ways in which the moral critiques in "La novela del tranvía" repeatedly give way to aesthetic musings, as this serves to realign Gutiérrez Nájera with the aestheticist thrust of the *modernistas*. It is true that the narrator shows concern for the imagined children of both the old man and the 30-year-old woman that sit next to him on the streetcar. Describing the former's two daughters as "unfortunate creatures," "poor and decent little girls," and referring to them repeatedly as "poor little girls" ("[p]obrecillas" or "[p]obrecitas"), he demonstrates concern for their socioeconomic condition and personal struggles with poverty (156–8). Deciding that the latter figure must also have children, he laments that they are "poor, defenseless beings" whose mother "abandoned them so as to go and bring them their share of shame and dishonor" on account of her infidelity (160). Despite this seeming morality, we must recognize that the narrator's aesthetic interests trump all moral concerns. Let us consider the narrator's method for rescuing the old man's daughters from their misery, for "sav[ing] them from their hardships" (158). His plan involves, in a strikingly anti-Pygmalion fashion, making one of those lucky daughters his wife: "I will educate her to my liking. I will assign her a piano teacher … I am going to subject her to a hygienic regime, and so she will become in little time as fresh as a rose … with the piano, the books, the flowerpots and the birds, I will have nothing left to desire" (157). His plan does not consider what the woman desires, but rather ensures only that his own needs – mainly aesthetic ones – are met. Similarly, his moral censure of the 30-year-old woman, whose imagined act of infidelity he initially deems "a betrayal," "an infamy," ultimately gives way to indifference followed by aesthetic interest: "After all, what does it matter to me if this woman cheats on her husband. Is she perhaps a friend of mine? The truth is she is a very attractive woman. ["Ella sí que es una real moza"]" (160). In general, then, the concern with ethics repeatedly yields to an interest in aesthetics. Whether someone is "honest," "virtuous," or "respectable" may matter, but it is far more important that they are "beautiful,"

"presentable," and that they pay attention to "delicacies and refinement" (156). The narrator admits from the outset that despite the fact that his journey in a streetcar on a rainy day resembles a voyage on a "miniature Noah's Ark," he himself is "not waiting on the dove that will bring the olive branch in its beak," that is, the symbol of peace and forgiveness, but rather, he is there "in order to observe the delicious picture ["el delicioso cuadro"] that the city presents in that instant" (155). Wanting the delicious over the divine, the aesthetic over the ethical, the narrator also wants to turn life into art.

Many of Casal's narrative voices in his chronicles likewise present themselves as flâneurs who enjoy "wandering around" on "magnificent walks," "travelling through the streets," and "walking aimlessly" (*Poesía completa* 359, 362). Especially when writing under his pseudonymous identity Hernani, he reveals "the desire to roam ["vagar"] the streets alone" (*Poesía completa* 342). This same notion is expressed in one of Casal's most famous poems, "En el campo" ("In the Country"), in which the speaker confesses his "impure love of cities" and his preference for the modern and man-made over the natural: for "the gaslight's glow" over the "sun that illuminates the ages," for "the gloomy slums" over "tropical jungles," for the "hothouse flower" over "the flower that opens along the lane," for the "harmonic music of a rhyme" over "the birdsong atop a tree," for "the queenly sinner's face" over "the virgin visage of a shepherd girl," for "the gold of tresses dyed" to "the ripe and golden fields of spring," for "silken muslins" over "the veils of bright mist the morning hangs in the hills," for "the human throng moaning" over "the torrent that flows down from the heights," for the "tears [... that] bathe a lash" over "[t]he dew that sparkles in the hills," and for "the vivid iridescence of opal, pearl, or diamond" over "the shine of twinkling stars" (79, 81, Washbourne and Waisman's translation).

We see further evidence of Casal's preference for the urban in two of his chronicles – "El fénix"[13] and "El matadero"[14] – which are both signed with the name Hernani. They present the narrative voice as a flâneur who is struggling with the task of finding new and exciting sensations in the city of Havana. In both instances, the speaker leaves the city streets and enters a commercial space: the slaughterhouse in "El matadero" and the department store in "El fénix." Hernani's

decision to dedicate a chronicle to the slaughterhouse results in large part from an overall scarcity of events to narrate:

> Tired of touring the city, of searching for something new to admire, of feeling nostalgia for a museum in which the contemplative spirits might take long baths of antiquity, of not knowing a painter who has a sumptuous and stimulating studio, of travelling through florid lands into which no one wants to follow me, and of witnessing the contagious and incessant discontentment of humanity … I decided yesterday to go to one of the most repugnant places in the capital, to the slaughterhouse, where the contemplation of the bloody spectacle of the incessant throat-cutting of beasts could provide me simultaneously with *a never-before-experimented sensation* and *subject matter* for one of these chronicles that some of my readers demand of me. ("El matadero" 353, emphasis added)

Seeking new sensations to describe in his chronicle, Casal moves inward to the marketplace. Similarly, he chooses to write about "El fénix" on account of the "lack of events for this chronicle, since the present week, like so many others, offers few reasons for blackening sheets of paper ["para ennegrecer cuartillas"]" (322). The department store is described as a "magnificent bazaar," wherein you can guarantee "the immediate satisfaction of the strangest whim that your fantasy harbors" ("El fénix" 322, 321). Whenever one enters the store, "there is something new to admire" (321). Such is the beauty of the jewels and art objects in that "magnificent establishment" that Hernani laments: "my spirit felt painfully affected by the spectacle of the streets. It seemed that I had descended from the height of an ancient Italian palace, populated with marvellous art objects, to the depth of a filthy underground, interminable and narrow, filled with complaints, screams, and blasphemies" (324). Yet despite being able to appreciate the artistic side of "El fénix" and preferring it to the crowd, Casal's narrative persona makes it clear that he felt "a great satisfaction because he did not aspire to have any of the objects that had momentarily dazzled his eyes," namely because he "continued to prefer a good sonnet to the diamond of greatest worth, and he continued preferring it still, despite the incredulous smiles of [his] readers" (324). Hernani wants art, not merchandise; poetry, not

commodities – but his search for new sensations and for material worth publishing in his chronicles inevitably takes him into the marketplace. Additionally, although he may wish to avoid consumption, he knows he must produce for his consuming readers. Aníbal González rightly notes that in Casal's view, journalism "turned the literary text from an object of aesthetic contemplation into merchandise," and this was exactly what Walter Benjamin, in his analysis of Baudelaire, argues, namely that the flâneur "sets foot in the marketplace – ostensibly to look around, but in truth to find a buyer" (*Companion* 26; "The Paris of the Second Empire" 40).[15]

Exactly what Casal's cronista-as-flâneur seeks – something new, an unknown sensation – is linked to the artist's search for beauty. In his poem "A la belleza" ("To Beauty"), Casal bemoans: "Oh, divine beauty! ... I die looking for you in the world / without having found you ... / I will die looking for you in the world / without having found you" (183–5). The reason Casal does not find the beauty he is seeking has to do in part with what he perceives as a lack of newness and scarcity of sensations in his native Cuba. He laments on various occasions that "as soon as our Cuban families with good taste have money, they leave for the European capitals" and that the present times are "so sterile in terms of worldly or artistic events, the only subjects one is allowed to treat in this section, which is almost useless nowadays since all of the causes that warranted its foundation have disappeared, causing it to become a sort of extravagant costume" (*Crónicas habaneras* 182). Casal thus points out the impediments to the true life of the flâneur: an overall lack of modernity, a dearth of noteworthy events or "spectacles" in the budding Spanish American cities that might compare to the "real" world of the flâneur – namely Paris.

The Salaried Scribe as Author of the Spanish American Chronicle

In addition to noting the ways in which the *modernista* chronicle and chronicler intersect with the dandy and the flâneur, I would like to end by addressing the ways in which the authors of these texts resemble a very different nineteenth-century type – one starkly opposed to and at odds with the other two, namely the wage laborer

or salaried scribe. It is this connection that underscores the marginal status of the Spanish American author and points to the peripheral processes of modernization and aesthetic production on the opposite side of the Atlantic at the turn of the century – processes that made it difficult for true dandies and real flâneurs to emerge or to be sustained.

Considering the "crónica" as genre and the "cronista" as profession, we must note that one important feature of the Spanish American chronicle is its ambiguous position somewhere between literature and journalism. On the one hand, this genre was considered, especially by the *modernista* authors themselves, to be more literary than journalistic on account of its overt stylization, imminent expressionism, and obvious subjectivism. The argument has frequently been made that "la crónica" differs from "el reportaje" not on account of *what* is narrated, but rather *how* it is narrated. The "cronistas" focused on the formal aspects of their work; they commented rather than merely reported. Carlos Monsiváis agrees that the "formal" predominates over the "informative" in the chronicle, given that the chronicler distinguishes himself by "the art of recreating reality in a literary way," while the less artistic reporter presents himself "as a greater friend of sensationalism than of syntax" (qtd. in Bielsa 32, translation mine). Writing as the Duque Job, Gutiérrez Nájera bemoans the fact that "in Mexico the value of these *elegant* chronicles are not valued enough, that the act of narrating frivolous things with great, *literary* care is not appreciated as it ought to be appreciated. The genre, as a result of its own *delicacy*, is very difficult" (qtd. in Gutiérrez 96–7, emphasis added). Elegant, literary, and delicate, the chronicle parallels the world of the dandy and is written from the perspective of the flâneur, who acts as interpreter of city life and serves as guide through "the ever-more refined and complex market of cultural goods" in an effort to provide a window into modern life and to showcase foreign modernity (Bielsa 46).

On the other hand, however, we cannot overlook the fact that these chronicles appeared in some of the most important and mass-produced newspapers of the day and that the authors wrote largely – if not exclusively – out of economic necessity. Gutiérrez Nájera, for example, in his chronicle "Mi último artículo," admits that he will continue to write until death determines which is his "last article," namely because "it is necessary to earn one's daily bread"

("es preciso ganar el pan de cada día") (93). The chronicle's place in the periodical subjected it to the laws of supply and demand, defined it as a commodity, and ensured that its audience was not the literary elite, but rather a middle-class, largely female, public in search of foreign modernity. By accepting positions as salaried employees, the "cronistas" were forced to question both the limits of their artistic autonomy and their place as artists in society. Despite being able to publish numerous journalistic writings (Gutiérrez Nájera for instance wrote over 1500 crónicas), these authors had difficulties publishing their poetic works and other literary texts (Casal for example only published two collections of poetry during his lifetime, *Hojas al viento* in 1890 and *Nieve* in 1892, as well as one posthumous collection entitled *Bustos y rimas* in 1893). Gutiérrez Nájera complains that "no one thinks, no one writes, no one reads," and his Mexican contemporary Amado Nervo agrees that "in Mexico one writes for those who write. The man of letters counts on a select group of chosen men who read his work and ends up making of them his only public" (qtd. in Gutiérrez 47). Casal voices an even harsher critique of journalism, calling it "the most nefarious institution for those who, not knowing how to place their pen in the service of petty causes, or disdaining the ephemeral applause of the crowds, are possessed by the love of Art" (qtd. in González *Companion* 25). He insists that "[t]he first thing that is done to the journalist as he takes his post in the newspaper office is to deprive him of one of the writer's indispensable attributes: his own personality. ... Thus the journalist, from the moment he begins his work, has to suffer through immense avatars according to the demands of his newspaper" and also to complete "the thousand menial chores of journalism, the only ones to which young men of letters can aspire" (qtd. in González *Companion* 25). Casal concludes his tirade by expressing his belief that "[j]ournalism can be, in spite of its intrinsic hatred of literature, the benefactor that puts money in our pockets, bread on our table, and wine in our cup, but, alas, it will never be the tutelary deity that encircles our brow with a crown of laurel leaves" (qtd. in González *Companion* 25). Gutiérrez Nájera likewise notes the intersection between aesthetic and economic factors in "La protección a la literatura" ("The Protection of Literature"), where he discusses "the impossibility of creating masterpieces on an empty stomach," on the one hand, and the fact that "writing, as with all commodities, suffers from

the law of supply and demand," on the other hand (65, translation mine). The author is caught in a double bind, since both his hunger and the marketplace prevent him from creating or selling true art.

Of course, the chronicle was also the space wherein these authors "sold themselves" insofar as they tried to gain recognition, exposure, and even fame for their more literary and poetic works. Both authors, but particularly Gutiérrez Nájera, referred to themselves when using any of their various pen names. For example, writing under the pseudonym "Cero," Manuel Gutiérrez Nájera names his other "personalities": "Oh! If only I were a 'Duque Job,' a 'Frú-Frú,' a 'Pomponnet,' a 'Mr. Can-Can,' a Gutiérrez Nájera!" (qtd. in Mapes 650). Similarly, writing as "El Duque Job," he offers a ranking of his own narrative personas in terms of their popularity and talent: "… the Duque Job … yields in part to the requests of his … friend Manuel Gutiérrez Nájera and to the demands of Mr. 'Frou-Frou' and Mr. 'Can-Can,' who are the most famous, discrete, and knowledgeable journalists in the Mexican press, after the 'Duque Job' and the wise … Mr. Gutiérrez Nájera" (qtd. in Mapes 656). Casal referred to himself in the third person on more limited occasions, but he was unique among the Spanish American cronistas from the *modernista* period for inserting one or two of his own poems in the midst of a pseudonymous crónica as a way of disseminating his poetry to larger audiences and increasing exposure to his work.

These Spanish American *modernista* writers may simply have been too concerned with the difficulty of becoming an artist, or of existing as an artist, to focus on the act of turning themselves or their artistic protagonists or external worlds into art – as the dandy and flâneur try to do. In my estimation, the obstacles that limit the dandy's emergence in Spanish America include a lack of wealth and buying power; the need to work and earn a wage; an absence of an aristocratic or elitist position in society; the non-existence of an appropriate public or audience capable of appreciating the spectacle of the self – an elegant, refined, original, and artistic self – that defines the dandy's existence. As concerns the figure of the flâneur, the impediments to his existence involve a relative lack of modernization and cosmopolitanism in the Spanish American cities as compared with their Western European counterparts – since wandering through the periphery was simply not the same as strolling through the metropolises of Paris or London – as well as the fact that

they did not really have the superior social status, the freedom from social obligation and work, or the disengaged, disinterested, or dispassionate attitude that their pseudonymous identities or narrative personas professed. Making the world more artistic and putting art into life may be shared goals among both authors, but the limitations that prevent their success parallel those outlined in Chapter 4. Thus, even as Manuel Gutiérrez Nájera and Julián del Casal describe dandies and adopt the identity of flâneurs in their chronicles, they seem simultaneously to point to what they perceive to be a marked distance separating the real from the imitation, the ideal from the copy, the illusion from the disillusion, the center from the periphery, the truly modern and cosmopolitan from Spanish America's attempts to become – or to be perceived as – modern.

Conclusion: Reconsidering the Relationship between Art and Life, Form and Content, Poetry and Prose

It will not have escaped the attentive reader's attention that this book examines almost exclusively prose works, rather than poetry, which may indeed come as a surprise given the significance of poetic production to both movements, particularly to Spanish American *modernismo*. The introductory chapter considers two short stories from Charles Baudelaire and José Asunción Silva. Chapter 1 examines two philosophical essays or literary dialogues by Oscar Wilde, alongside some well-known essays by Walter Pater. Chapter 2 considers José Asunción Silva's only novel. Chapter 3 discusses a novel by Joris-Karl Huysmans. Chapter 4 analyzes three short stories by Rubén Darío. Chapter 5 explores two novels, one by Oscar Wilde, the other by Thomas Mann. Chapter 6 compares various chronicles and short stories by Manuel Gutiérrez Nájera and Julián del Casal. Given the fact that Silva, Darío, and Casal (not to mention Baudelaire, and to a lesser degree Gutiérrez Nájera) were known primarily as poets, it is indeed significant that I have chosen examples from their prose works. I wish to dedicate this concluding chapter to a discussion of some of the justifications for this decision as well as the varying consequences of it.

First, one might rightly argue that these authors' poetic works only serve to underscore the messages of the prose works as examined in previous chapters. In Rubén Darío's "Yo persigo una forma ..." ("I Pursue a Form ..."), for example, the speaker of the poem voices his frustration as a stifled artist: "I seek a form that my stylus cannot find / ... / I find nothing but the fleeing word" (133). In José Asunción Silva's "Un Poema" ("A Poem"), the poetic voice feels confident that

he has created a poetic masterpiece that reaches formal perfection. The poet explains with regard to his act of "forging a poem": "I called on all of the rhythms with a magic spell / ... / sonorous rhythms, powerful rhythms, solemn rhythms"; "I gave it some rich rhymes, of silver and crystal"; "I embroidered the phrases with gold and gave them strange music"; "I gave my verses the smell of heliotropes and the color of amethyst" (48, translation mine). Ultimately, however, the poet fails to find anyone who can appreciate his poem, which is underscored in the closing two lines, which mention "a marvelous critic" who, after reading the poem six times, was still unable to "understand it" (49, translation mine). Whether or not the poem is meant to be understood in terms of the message of its content or the impressive beauty of its form, it is clear that Silva aims to point out the gulf that separates the poet from the critic, the artist from the society that judges and determines the value of art. Julián del Casal presents a similar argument in his poem "A un crítico" ("To a Critic") insofar as the poetic voice tells the critic that he recognizes that he will never find fame or recognition for his poetic endeavors: "I know that I will never reach the summit / where the artist embraces the chimera / that gave lasting beauty / in the canvas, in the marble, or in the rhyme" (144, translation mine). He nonetheless insists that he must continue to write poetry, even if it means that he will forever remain among the "small" artists (144, translation mine). In his poem "El arte" ("Art"), Casal juxtaposes the negative side of life that "weighs on a tired spirit" on account of its "miserable reality" and "weariness" with the positive side of art that "discovers ignored happiness" (63 translation mine). Despite the preference for art over life in "El arte," Casal's "A la belleza" ("To Beauty") mentions the poet's futile search for beauty in the world: "Oh, Divine Beauty! Chaste vision / of unknown sanctuary, / I already die looking for you in the world / without having found you" (183, translation mine). Again there are limits to what the poet can achieve, despite his obvious "art for art's sake" goals. As these examples suggest, the *modernista* poets wrote many metapoetical poems that were, to use Aníbal González's phrase, "*ars poeticae*, that is, poems about the art of poetry," and these particular poems share many of the dominant thematic concerns of the prose production by the same authors (*Companion* 119).

While it is certainly possible to find parallels such as those noted above between the content of the poetry and prose of the

modernistas, it is also frequently the case that the poetic works from these writers are more in line with traditional interpretations of art for art's sake as striving toward "a 'pure' verse in which beauty was the sole relevant factor, to the exclusion of all moral, civic, or social content" (Bell-Villada 107). According to José Olivio Jiménez, Rubén Darío defined the movement of *modernismo* as "freedom and lightness, and the triumph of beauty over precepts in prose; and novelty in poetry" (15–16). Similarly, Álvaro Salvador describes the *modernistas'* project as a "totalizing" one that aims "to create the pure realm of art" (89); he goes on to enumerate "the signifying nuclei of *modernismo*," which include "the obsession with high culture, individualism, apoliticism, the pursuit of pure discourse – uniquely beautiful, uninvested, free of superficialities" (88). If *modernista* poetry is, as these critics assert, amoral, asocial, apolitical, light, and uninvested in anything save beauty, then it is primarily because formal concerns dominate over, or simply replace, content ones. Gene H. Bell-Villada explains the significance of formal innovation in *modernismo*: "the *modernista* movement considerably expanded poetry's verbal means and resources" by broadening "the linguistic materials constituting their art," inventing new verse meters or importing them from foreign tongues, mixing varieties of lengths in bold and unprecedented ways, creating new or revived rhyme schemes, widening the poetic lexicon, attaching added importance to sensuousness and sonority, to musicality and melody, and increasing the array of subject matter and settings considered worthy of lyric verse to include "exotic Asian latitudes or elegant Bourbon-rococo France, ... medieval Norse country or ... wholly imaginary lands" (106). All of these formal changes serve to ensure that the "form" of the poetry is the only relevant "content." The notion of "form as content" in *modernista* (and aestheticist) poetic production is indeed significant, namely because it suggests that one must stop at the formal level in the search for meaning. The interpretive exercises in which I engage throughout this study, then, would seemingly prove unwarranted with regard to poetic works that exist solely to be beautiful and emit no message beyond their formal or external beauty.

Consequently, an additional justification for my privileging of prose works over poetic ones has to do with the fact that in order to succeed in demonstrating that the "art for art's sake" ideals of both

European aestheticism and Spanish American *modernismo* are part and parcel of their social concern, commitment, and commentary, I must focus on the more engaged or transcendent prose production as opposed to the more escapist or superficial poetic production. I am certainly not alone among critics in noting this distinction, that is, in noting a poetic canon that engages in art for art's sake and a body of prose work that comments on the desire to be aestheticist as well as the obstacles impeding aestheticism in art. Aníbal González, in *A Companion to Spanish American Modernismo*, reveals an important difference between *modernista* prose and poetry: "If prose was the medium in which the *modernistas* conversed with each other and with their readers about their common aesthetic, political, and cultural concerns, poetry was conceived as the site of a symbolic struggle, an artistic contest or tournament, in which poets vied with each other to achieve poetic perfection" (109). González continues by pointing out that "[a]lthough the splendor of *modernista* poetry is still one of its most admired aspects, *modernismo* is now understood as a broad movement whose impact was felt just as strongly in the prose genres: the short story, the novel, the essay, and the journalistic subgenre of the crónica" (*Companion* 1). I agree wholeheartedly with González's contention that "the renewed appreciation of *modernista* prose has allowed for a better understanding of the far-reaching significance of the *modernista* movement in Spanish American culture" (*Companion* 109). Gerard Aching also observes the way in which the recent "critical focus" on *modernismo* has "shifted toward examining how poets and writers perceived their societal role in manifestos, prologues, essays on aesthetics, modernity, and national and regional politics," and this emphasis on prose production has led critics to "attest to the centrality of the *modernista* artist in the production of culture" (Aching 14–15). It is these same prose genres – the short story, the novel, the crónica, the essay, the manifesto, the prologue – that receive the greatest attention throughout this study.

The differences between the "form as content" quality of so much *modernista* poetry and the self-reflective content of the prose can also be explained by the fact that the *modernistas*, especially Darío, Silva, Casal, and, to a lesser extent, Gutiérrez Nájera, "were essentially lyrists whose primary art lacked salability in the new era of journalistic prose" (Bell-Villada 118). Despite Spanish American

modernismo's overt interest in poetic innovation and formal perfection, the carefully and slowly crafted verse of the poets lacked function and salability in the mass print culture of the burgeoning bourgeois marketplace. The overarching concern with form in both aestheticist and *modernista* works of art demands intense labor and prolonged periods of production, not to mention that such "pure" verse generally fails to please the aesthetic demands of the masses. As a result, the application of the concepts of profitability, marketability, and the laws of supply and demand to these specific artistic creations threatened their survival, as artists from both movements struggled with the incompatibility between their own aesthetic criteria and the market's economic criteria for art. For these reasons, "[t]he noble idea of Art for Art's Sake became the consolation prize for those poets who were dissatisfied with prose but couldn't write verse for money" (Bell-Villada 55–6). This fact was equally applicable to the poetic practitioners of European aestheticism as well. "It is no accident," Bell-Villada rightly notes, "that almost all the authors associated with Art for Art's Sake have been essentially poets – Gautier, Baudelaire, the French Parnassians and symbolists, the modernistas in Latin America, and, in the United States, Poe The few major novelists who tended toward aestheticism – Flaubert, Joyce, Nabokov, were authors who, out of temperament or choice, produced slowly" (49–50). What is interesting is the notion that the unsalability or unmarketability of much aestheticist and *modernista* poetry became the topic of much of the prose production by the same authors – who struggled with the disparity between the desire to be poets and the necessity of working and writing in other capacities to earn a wage; "[w]hile their personal passions and chief talents may have been in verse, lyric art became a kind of adjunct activity to their breadwinning chores in journalism and related fields" (Bell-Villada 45). Curiously enough, then, these additional "breadwinning chores" were frequently the place in which the authors vented their professional frustrations and commented on the role of art and the artist in industrial-capitalist society.

As a consequence of studying the lesser-known prose works of the *modernistas* and as a result of the corollary idea that the prose texts are where these authors reflected on the limitations and unprofitability of their poetic works, it appears that Spanish American *modernismo*

is even more concerned with the tension between "art for art's sake" and "art for the market's sake" than European aestheticism, with the possible exception of Huysmans's critique of consumption practices in consumer society and Mann's interest in social mobility and class status. Silva's *De sobremesa*, Darío's short stories from *Azul*, and the numerous crónicas considered by Gutiérrez Nájera and Casal explore in greater depth than their European counterparts the relationship between aesthetics and economics. While the relationship between "art for art's sake" and "art for capital's sake" was the focus of Part II of this study, it could also be related to all three chapters on Spanish American *modernismo*, Chapters 2, 4, and 6. Silva's protagonist in *De sobremesa* (Chapter 2) adapts the concept of the artist as impressionistic critic in an effort to avoid the conversion of the artist into a producer and of the artwork into a commodity. Keenly interested in the relationship between art and the market, Silva reorients the aims of the creative critic so as to ensure that the relationship between artist–art object–artistic receptor is *not* akin to that between producer–commodity–consumer and to thereby manage to save or sever art from the mercantile, capitalistic, bourgeois, and unartistic life sphere that his character so despises. Darío's artist heroes in the short stories from *Azul* (Chapter 4) attempt to isolate themselves from bourgeois society, which they see as hostile to artistic creation and inimical to the appreciation of aesthetic value, and try to establish themselves as creators, rather than producers, of an artistic and pure art. In order to be creators and not producers, however, their art has to remain unsold and uncommodified. The paradox is that the art also remains unappreciated and the poet cannot sustain himself as an artist. The dandy-flâneur narrative personas and narrative identities in Casal's and Gutiérrez Nájera's chronicles (Chapter 6) can frequently be interpreted as problematic versions or purposeful caricatures of their European counterparts, especially since these authors' own positions as salaried scribes and wage-laboring journalists call into question the elegance, refinement, idleness, and disinterestedness of the traditional dandy and flâneur figures.

I would like to end this discussion by considering Kelly Washbourne's detailed and perceptive outline of Spanish American *modernismo*'s prevailing "articles of faith," since this helps to underscore the similarities and differences between the two movements under examination. Although Washbourne does not mention aestheticism or art for

art's sake explicitly, he gives this extensive and illuminating account of Spanish American *modernismo*'s dominant features:

> (a) a preoccupation with the marginalized status of the writer and his or her fall from legislator to "non producer" ...; (b) disdain for the acquisitiveness of the philistine classes and all that was admired by bourgeois values ...; (c) art as a new source of faith; (d) language as incantatory, orphic, and the means to transgressing, transcending, and creating a "double" of the universe; (e) formal refinement and innovation; (f) an aspiration toward beauty ...; (g) a cultivation of the vague and suggestive over the concrete ...; and (h) the awareness of Latin America as a presence emerging from exotic "Other" to exploited source of resources and victim of the foreign policies and cultural hegemony of colonial aggressors. (8–9)

The intersections between these movements are most obvious with regard to (c), (d), (e), (f), and (g) above, which correspond to the sacralization of art, the power of language, the emphasis on form, the quest for beauty, and the non-representational status of art, respectively. The leading figures of Spanish American *modernismo* share with practitioners of aestheticism on the other side of the Atlantic an emphasis on form, style, poetic innovation, the musicality of language, and the renovation and expansion of the linguistic and content material constituting their art. I wish to argue, additionally, that (a) and (b) in Washbourne's list also relate to aestheticism as I have here defined it. Surely, authors from both movements were concerned with changes in the status of the writer and the rise in philistinism. It has been the task of this study, particularly in Part II, to demonstrate that the marginalized status of the writer and the critique of bourgeois values are shared concerns insofar as we observe a continual and communal lamentation regarding the precarious situation of art and the artist in both aestheticism and *modernismo*, although, again, Chapters 2 and 6 also underscore this notion. It is (h), however, that is unique to – or exaggerated in – the Spanish American context: "the awareness of Latin America as a presence emerging from exotic "Other" to exploited source of resources and victim of the foreign policies and cultural hegemony of colonial aggressors." On account of Spanish America's peripheral or marginal

status, uneven development, and delayed or stunted modernization, *modernista* writers appear even more burdened with the societal dictates of creating art for the market's sake, since their elitist art proves particularly unsalable and lacks a corresponding public. Moreover, they suffered from accusations that their work was a copy of European styles and an imitation of European movements, and therefore lacking in authenticity or originality. The *modernistas* were indeed aware of "their dependence, both economic and cultural, on traditional and European models," and, consequently, they felt the need both "to fill the cultural vacuum resulting from this dependence" and "to overcome once and for all – at least, at the cultural level – Spanish America's perceived lack of modernity" (Kirkpatrick 23; González, *Companion* 5). Trying to be culturally modern, yet aware of their relative lack of modernity in other sectors, the *modernistas* struggled with Spanish America's peripheral status and tried to distinguish between their aesthetic or artistic contemporaneity and their social and economic backwardness, that is, between their innovation in art and their (relative) stagnation in life. If *modernista* poetry achieved such "contemporaneity" and "innovation" in art, the prose works commented on the relationship between the extremes of contemporaneity and backwardness, of innovation and stagnation, and thereby provided an undeniable social dimension to the movement's "art for art's sake" approach.

Notes

Introduction

1. All translations of José Asunción Silva's "La protesta de la musa" are mine.
2. The ambiguity of Baudelaire's prose poem is discussed by David Harvey in *Paris, Capital of Modernity*. Harvey presents two differing readings as posed by Irving Wohlfarth and Marshall Berman. According to Wohlfarth, Baudelaire's "Loss of a Halo" signifies "the writer's plight amidst the blind, cut-throat laissez-faire of the capitalistic city: the traffic reduces the poet in his traditional guise to obsolescence and confronts him with the alternative of saving his skin or his halo" (qtd. in Harvey 265). According to Wolfarth's interpretation, then, the poem reflects the way in which Baudelaire "foresees the increasing commercialization of bourgeois society as a cold orgy of self-prostitution" (qtd. in Harvey 266). Berman, however, argues that Baudelaire "wants works of art that will be born in the midst of the traffic, that will spring from its anarchic energy ... so that 'Loss of a Halo' turns out to be a declaration of something gained," rather than the lamentation of something lost (qtd. in Harvey 265). I too struggle with these same conflicting interpretations of Baudelaire's poem as either critical or celebratory in tone and find a similar ambiguity regarding the effects of modernity on the poet in Silva's short story.
3. Bell-Villada offers the following sketch of the aestheticist movement's complicated genealogy, which he traces backwards from Oscar Wilde to Kant and Shaftesbury:

 > [Wilde's] aphorisms are actually a distillation and indeed a simplification of some arguments learned from his high Oxford mentors, John Ruskin and Walter Pater, while his general vision is an outlook consciously akin to that of French Romantic and Symbolist poets such as Gautier and Baudelaire. Baudelaire for his part had learned a few lessons from Poe, who had misread Coleridge, whereas Gautier early on had set forth a much-simplified if memorable version of a theory taught by some Parisian professors, notably Victor Cousin. Meanwhile, Cousin's lectures take their initial cue from the weighty treatises of a remote, recondite thinker named Immanuel Kant; and Kant's magisterial aesthetic arguments in the *Critique of Judgment*, in turn, stem ultimately from the rapt institutionalism of the Third Earl of Shaftesbury. (1–2)

 For an assessment of the movement's post-Wildean evolution, it is helpful to consider the stages of "intermediate" and "new" aestheticism discussed by Nicholas Shrimpton: "intermediate aestheticism" refers to the critical

formalism of the British and North American New Critics; "new aestheti-cism" refers to the resurgence in the 1990s of concepts associated with the creed of art for art's sake in modern critical practices such as camp and deconstruction (8). I am concerned here primarily with the tradition of European aestheticism that starts with Gautier and Baudelaire and extends to Pater and Wilde.

4. The comparison of European aestheticism and Spanish American *modern-ismo* may at first seem a far-fetched endeavor, especially given the general scarcity of scholarship linking these two literary and artistic movements. Whereas book-length investigations of European aestheticism hardly ever look across the Atlantic, save a few transatlantic studies that compare authors of North American aestheticism with leading figures of European aestheticism (e.g., comparisons between Poe and Baudelaire by Preussnes, Patterson, and Wetherhill and between Henry James and Wilde by Mendelssohn and Freedman), the majority of transatlantic research on Spanish American *modernismo* focuses on the relationship between Spanish and Spanish American literary production in the late nineteenth century and contrasts the ethically charged "generación del 98" in Spain with the aesthetically driven *modernistas* in Spanish America (e.g., *Modernismo frente a noventa y ocho* by Guillermo Díaz-Plaja, *La polémica modernista: El modernista de mar a mar (1898–1907)* by Ignacio Zuleta, *Modernismo y la Generación del 98* by Enrique Rull Fernández, *Modernismo y 98: Rubén Darío* by Ana Suárez Maramón, *Límites del modernismo y del 98* by Rafael Ferreres, and the recently published conference proceedings *Modernidad literaria en España e Hispanoamérica*). It is true that the Spanish American *modernistas'* interest in aesthetics has led some scholars to rightly note their deliberate rejection of Spanish sources and conscious imitation of French sources – sources which include French aestheticism, decadence, symbolism, and parnassianism. (See Pineda Franco's *Geopolíticas de la cultura finisecular en Buenos Aires, París y México: las revistas literarias y el modernismo*, Graciela Montaldo's *La sensibilidad amenazada: Fin de siglo y modernismo*, Alfredo Roggiano's "El origen francés y la valoración hispánica del modernismo," and Poe Carden's "Parnassianism, Symbolism, Decadentism and Spanish-American Modernism.") Nonetheless, these studies do not consider the additional influence of European aestheticism beyond France. The present monograph thus aims to fill an important gap in both transatlantic and modernist scholarship.

5. Parts of this introduction are reprinted with permission from Kelly Comfort, "Introduction," *Art and Life in Aestheticism: De-Humanizing and Re-Humanizing Art, the Artist and the Artistic Receptor* (Palgrave Macmillan, 2008).

6. My use of the term "dehumanizing" is meant as a reference to José Ortega y Gasset's 1925 essay "La deshumanización del arte" ("The Dehumanization of Art"). In this work, Ortega y Gasset outlines what are to him the most laudable features of modernist art – the dehumanization of art, the defor-mation of reality, the avoidance of living forms, and the triumph over human matter (14). Art undergoes a process of purification in the modern period, Ortega y Gasset argues, as it experiences "a progressive elimination

of the human, all too human, elements" that were common in romantic, realist, and naturalistic production (12). This "purified" or "pure" art shares much with aestheticist works of art and literature, which also aim to expel life from the sphere of art. As Ortega y Gasset remarks, "life is one thing, art is another ... let us keep the two apart" (31).

7. Recent studies have examined the ways in which aestheticist texts contribute to "the dissemination of dissident views" (Denisoff 2); have the "power to interrupt ideologies of sexual normativity" (Ohi xi); offer "potentially resistive implications in the arena of sexual politics (Felski 102); operate "as a central mode of engaging in and interpreting philosophy, history, and politics" (Loesberg 4); cause "moral, theological, and sexual shock" (Shrimpton 6); register the authors' "reaction against bourgeois mediocrity and the philistine materialism of their times" (Bell-Villada 111). As the present investigation aims to demonstrate, aestheticism's ability to engage with, contribute to, interrupt, resist, interpret, and shock warrants further, comprehensive attention.

8. I will mainly analyze the prose writings (one novel and various short stories and chronicles) of these Spanish American authors, in large part because González is correct in locating those genres as more politically and socially engaged than poetic texts, although I draw connections to Silva's, Darío's, and Casal's poetic production whenever appropriate. It is worth noting that the short story in particular was a very significant and unique *modernista* genre. As José Miguel Oviedo explains: "The short story is the first self-reflexive narrative model – a fiction presented as such, an art object with extensive autonomy from realty – to appear in the Americas" (251, translation mine). Because of its self-reflexiveness as well as its quest for autonomy and distance from reality, the Spanish American short story is frequently the genre that addresses the "art for art's sake" philosophy that we also encounter in aestheticism. For this reason, I analyze short stories from all four of the Spanish American *modernista* authors treated here: Silva, Darío, Casal, and Gutiérrez Nájera.

9. For this reason, I disagree with the notion that there was a "radical reversal in the conception of art ... from the principle of artistic autonomy or even independence to the principle of social representation and responsibility," which occurred at the "the crucial moment ... after the founding of the USSR, at the peak of the influence of Marxism in Germany, and in the midst of the international struggle against Fascism," since it does not take into account the possibility of the coexistence of these tendencies at an earlier historical moment in both aestheticism and *modernismo* insofar as both movements promote autonomy and independence as a means to comment on and critique the social world (Blanco Aguinaga, "On Modernism" 14).

Part I Introduction

1. While Wilde's cultural and artistic recycling involves a return to classical Greece, Silva's process consists in a physical and intellectual journey to

the metropolises of Western Europe, namely Paris and London. Existing already at the center of turn-of-the-century cosmopolitan life in London, Gilbert and Vivian turn to the past for inspiration. Being at the periphery of *fin de siècle* culture, however, José Fernández travels across the Atlantic in search of new artistic models and aesthetic stimulation. Thus, in addition to recycling previous artistic works – Plato's *Republic* and Aristotle's *Poetics* are the most prominently reused texts in the case of Wilde, whereas Dante's *La vita nuova*, Huysmans's *À Rebours*, Poe's "Philosophy of Composition," various works of the Pre-Raphaelite poets and painters, and, as I will argue, the ideas and writings of Wilde are adeptly reworked in the case of Silva – these authors engage in a process of cultural recycling as well, one that differs as a result of these authors' varying points of geographic origin. (We might consider additionally that Wilde, being on the periphery of heterosexual culture, returns to Plato in particular so as to rekindle an older model of homosocial relations.)

Chapter 1 The Artist as Critic and Liar: The Unreal and Amoral as Art in Oscar Wilde

1. This chapter is reprinted with permission from volume 32 (January 2008) of *The Wildean: A Journal of Oscar Wilde Studies* published by The Oscar Wilde Society: "The Critic as Artist and Liar: The Reuse and Abuse of Plato and Aristotle by Wilde" (pp. 57–70).
2. For a consideration of classicism and the varieties of Hellenism in nineteenth- to mid-twentieth-century England, see Christopher Stray's *Classics Transformed: Schools, Universities, and Society in England, 1830–1960*. For a discussion of the connection between Wilde's Oxford Hellenism and his treatment of the Greek notions of *paiderastia*, *symposia*, and *dialektikē*, see Linda Dowling's *Hellenism and Homosexuality in Victorian Oxford*.
3. For obvious reasons, and not all having to do with art, Plato held the greater fascination for Wilde and his generation. Nonetheless, I argue for Aristotle's importance in Wilde's polemic both as an ally used to confront Plato and as a theorist in his own right.
4. In *Oscar Wilde: Eros and Aesthetics*, Patricia Flanagan Behrendt discusses in greater detail the relationship between the speakers in both dialogues. She locates Vivian and Gilbert as the senior speakers who, being more knowledgeable and worldly, intellectually dominate their respective young auditors, Cyril and Ernest; she notes a distinction between Plato's use of "gentle questioning" in the dialogue form and Wilde's use of "playful intellectual bullying" in his adaptation of this form (109).
5. Lawrence Danson agrees that although Wilde does try to enlist Plato in his cause in both "The Decay of Lying" and "The Critic as Artist," he is nonetheless no Platonist. Danson explains: "Platonic idealism posits a world of essential, unchangeable truth beyond the world of appearances; but 'The Decay of Lying' imagines a world in which truth is what we make and unmake, a world where nature prevents us from seeing,

not Plato's eternal forms, but the always new forms of human creation. Platonism, with its ideal reality, and realism, with its sordid reality, are equally unacceptable, since they tie us to a nature not of our own making" (58–9).

6. Plato is somewhat inconsistent on this subject. In the discussion of mimesis in Books 2 and 3 of the *Republic*, art is faulted for its necessary contagion of life, for its all-too-penetrating touching of reality insofar as we become what we pretend to be; in Book 10, however, art is faulted for its never touching reality. Wilde seems to play with the same contradictions, although he reaches different conclusions.

7. See pages XX–XX for a discussion of Todd's terms "weak" and "strong" aestheticism.

8. In "Wilde's Iconoclastic Classicism: 'The Critic as Artist,'" Edward A. Watson characterizes "The Critic as Artist" as "an interpretive-impressionistic critical exercise which attempts, through knowledge, scholarship, and personality, to analyze some aspects of the theoretical foundations of literary criticism in Plato's 'Ion' and *The Republic*, Aristotle's *Poetics*, Pope's *An Essay on Criticism*, and Arnold's 'The Function of Criticism at the Present Time'" (225). The present study expands upon Watson's discussion of how Wilde's "impressionistic criticism" builds on Plato's moralism and Aristotle's aesthetics.

9. In "Arnold, Pater, Wilde, and the Object as in Themselves They See It," Wendell V. Harris sums up the differences between Arnold, Pater, and Wilde thus: "For Arnold, the value of criticism is in discovering the object as it really is; for Pater, who, in emphasizing the impression offered by the artist rather than the critic, considered the results of criticism rather than its larger possible functions, its value is in increasing our delight in art; for Wilde, it offers both insight and delight" (745). For additional considerations of Pater's relationship to Wilde and to impressionistic criticism see Peter Rawlings's "Pater, Wilde, and James: 'The Reader's Share of the Task" and Ruth C. Child's "Is Walter Pater an Impressionistic Critic?"

10. It is in this regard that I contest Julia Prewitt Brown's contention that Wilde's theory of reception here becomes entangled in the "main contradiction of aestheticism – that is, the paradoxical separation yet interdependence of art and life" (72). "Art expresses only itself," she purports, "but in its very energy is one with the generative life force. The work of art is formally independent of daily life, yet our reception of it yokes it *to* life" (72). In contrast to this line of argumentation, I contend that Wilde redefines reception as something even further removed from life than even art was, and it is this interpretive change that frees art – or the artistic receptor – from the social, or, perhaps more appropriately phrased, further "yokes" life *to* art. Matthew Sturgis agrees with my interpretation insofar as he also notes the way in which Wilde promotes "subjective criticism to a place equal or even above artistic creativity: for if art was the criticism of life, 'criticism' was the criticism of art, and – as any disciple of Gautier or Mallarmé knew – art was superior to life" (118–19).

11. See Harris for a discussion of the way in which Pater "stands Plato on his head" (743).

Chapter 2 The Artist as Creative Receptor: The Subjective Impression as Art in José Asunción Silva

1. Much of this chapter is reprinted with permission from volume 37 (December 2010) of the *Revista de Estudios Colombianos*: "The Artist as Impressionistic Critic in José Asunción Silva's *De sobremesa*: Transatlantic Borrowings from Walter Pater, Oscar Wilde, and British Aestheticism."

2. In "José Asunción Silva and Oscar Wilde," Carl W. Cobb writes of Wilde's possible influence on Silva. With regard to *De sobremesa* in particular, he notes the following Wildean ideas in the novel: (1) the "belief 'that Life imitates Art, that Life is in fact the mirror, and Art the reality,'" as discussed in "The Decay of Lying"; (2) the scorn for "bourgeois routine and reality" found throughout *The Picture of Dorian Gray*; (3) the idea of the "critic's inability to comprehend and evaluate the artist's work," as expressed in "The Critic as Artist"; (4) the notion that "[p]leasure is the only thing one should live for," as seen throughout Wilde's *oeuvre*; and (5) the way in which "the weird treatment of the portrait and its relation to the now dead Helen recall Wilde's story of Dorian Gray" (658, 660). Nevertheless, Cobb concludes his essay by arguing that "it would be unprofitable to press similarities between these two authors," and ends up suggesting that a more fruitful comparison would actually be between Silva and Dante Gabriel Rossetti. I, however, wish "to press" these similarities in new ways.

3. For all citations of Silva's *De sobremesa*, I will be using Kelly Washbourne's 2005 translation, *After-Dinner Conversation: The Diary of a Decadent*. When the original Spanish is cited alongside the translation, I have used the 1993 version of *De sobremesa* published by El Ancora Editores.

4. The significance of the reference to one J. F. Siddal is explained on page XX.

5. José Asunción Silva took a European journey similar to that of his protagonist from 1884 to 1886, in which he too visited Paris, London, and various cities in Switzerland. According to Juan Carlos Ghiano in his book *José Asunción Silva*, the real-life author met Oscar Wilde while in London, and this historical event lends additional validity to my analysis of Wilde's influence on Silva (14).

6. See David Jiménez Panesso's "Lectores-mesa y lectores-piano: para una poética del lector artísta en Silva" for a discussion of Silva's notion of the reader as table versus the reader as piano.

7. The novel itself has obvious influences insofar as Silva borrowed from, or "recycled," many contemporary works of fiction: D'Annunzio's *Il piacere*, Valle-Inclán's *Sonatas*, Huysmans *À Rebours*, Wilde's *The Picture of Dorian Gray*, Poe's "The Philosophy of Composition," etc. Moreover, one could argue that *De sobremesa* is already a copy, since the original was lost in

a shipwreck along with what Silva deemed the best ("lo major") of his literary work. The decision to rewrite only this novel, one which speaks to the role of the artist, before tragically committing a staged suicide in 1896 at the young age of 31, is indeed significant.

8. It is worth pausing to consider this passage's concern with the relationship between "Art and life" ("Arte y ... la vida" – in which "Art" is written with a capital A, while "life" begins with a lowercase "l.") Silva's privileging of "Art" over "life" is reinforced visually and formally here, and this foreshadows the novel's desire to promote Art as sacred, elevated, and sublime and to critique life as profane, mundane, and base. Moreover, Fernández's interest in beginning his own diary with a consideration of Nordau's and Bashkirtsteff's understanding of both art and life underscores the importance of this relationship to the work as a whole.

9. Peter Elmore, in "Bienes Suntuarios: El problema de la obra de arte en *De sobremesa*, de José Asunción Silva," rightly interprets Fernández's comparisons of Helen to Dante's Beatrice as revealing "the Pre-Raphaelite anti-capitalist nostalgia, the attempt to abolish the uneasiness and uncertainty of modernity by means of a sentimental solidarity with a utopic past" ("la nostalgia anti-capitalista del prerrafaelismo, el intento de abolir las zozobras e incertidumbres de la modernidad mediante la adhesión sentimental a un pasado utópico") (204, translation mine).

10. For a comparison of these two works see Aníbal González's "'Estómago y cerebro': *De sobremesa*, el *Simposio* de Platón y la indigestión cultural." It is worth noting that González explores Silva's "project of cultural distillation and digestion" ("proyecto de destilación y digestión cultural") and notes both the author's and the protagonist's "critique of 'cultural recycling" ("crítica del 'reciclaje cultural'") (242, 238, translations mine).

11. José Fernández's reaction to Helen's death finds echoes in Silva's series of "Nocturno" poems. "Nocturno" describes an innocent and saintly "sweet, pale girl" ("dulce niña pálida") who is praised for having managed to conserve the treasure of her innocence; for having never been approached with carnal desires; and for only opening her sweet lips in prayer (*Obra completa* 110, translation mine). The poem "Poeta, di paso" (also titled "Ronda" or "Nocturno") recounts how a poet goes from giving furtive kisses, then intimate kisses, and finally a last kiss to his beloved on the "tragic night" of her funeral (*Obra completa* 28–9). "Nocturno (Inédita, para la Lectura)" also narrates the death of the beloved and its effect on the speaker of the poem. Whereas the two lovers were once so close that they formed a single shadow, death causes the shadows to separate as the speaker is "filled with the infinite bitterness and agony" of his beloved's death and feels the cold of the tomb, the cold of death (*Obra completa* 34–5, translation mine). In the end, however, death cannot permanently separate the lovers as they are once again united. The beloved's shadow approaches and goes away with the speaker's: "the shadows of the bodies unite with the shadows of the souls" ("las sombras de los cuerpos ... se juntan con las sombras de las almas") (*Obra completa* 35,

translation mine). Finally, Silva's "Día de difuntos" similarly addresses the topic of death, although not specifically the death of the beloved, in its rather positive portrayal of death as that which causes humans to sleep "far from life, free from desire, far from course, human battles" ("lejos de la vida, libres del deseo, / lejos de las rudas batallas humanas") (*Obra completa* 64–8, translation mine).

12. This focus on the interior of the home recalls the content of Huysmans's *À Rebours* and reminds us of the decorating dandies and aesthetes on which Des Esseintes – and quite likely José Fernández, too – was modeled, namely Ludwig II, Edmond de Goncourt, Barbey d'Aurevilly, Charles Baudelaire, and Comte Robert de Montesquiou. It also points to the rising importance of the decorative arts in late nineteenth-century Western culture.

13. For an illuminating analysis of the parallels between these two passages from Silva's novel and a publicity advertisement that Silva published in 1890 to promote the imported luxury goods for sale in his own store, Almacén Nuevo, see Beckman, who discusses in much detail "the fusion of aesthetic form and commercial interest" in Silva's fictional and commercial writings (763).

14. These ideas are explored in greater detail in Chapter 4's analysis of the ideas of Rubén Darío, and they are also touched upon in my opening discussion of Silva's short story "La protesta de la musa" in the Introduction.

15. Although José Fernández shares much of Silva's own occupational ambivalence, there are important distinctions between author and character. Whereas Silva suffered from continual financial setbacks, his literary personage enjoyed a life of continual wealth and luxury, since his gold would work for him and his riches "let him lead the good life without having to go begging for spare change" (152). Whereas the author failed to find lasting solace in art, the protagonist manages to elude the realm of reality and escape into the world of art. For an autobiographical reading of the novel, see Luis José Villarreal Vásquez's "De José Asunción Silva a José Fernández de Andrade, o la autobiografobomanía del discurso." For what I deem to be a more nuanced consideration of the similarities and differences between author and protagonist, see Aníbal González's "Retratos y autorretratos: El marco de acción del intelectual en *De sobremesa*."

16. In *Mademoiselle de Maupin*, Gautier's D'Albert explains a similar problem with setting out to "chisel," hammer, strike, carve, and shape one's writing in a conscious effort to create a work of art, and Silva may be making an explicit reference to this passage in his own novel: "To take a thought from the imagination's mine ... set it down in front of me, and from dawn to dusk, a chisel in one hand, a hammer in the other, strike, carve, scrape, just to take at the end of the day a pinch of dust to sprinkle over my writing – that is something I will never be able to do" (qtd. in Stanton 96).

17. In this regard, Silva's hero attempts to avoid the negative fate commonly suffered by the *modernista* artist, a fate that is best outlined by Ángel Rama in *Rúben Darío y el modernismo (circunstancia socioeconómica de un arte americano)* and by Rafael Gutiérrez Giradot in his chapter "El arte en la sociedad burguesa moderna" from the book *Modernismo*.

18. I find it necessary to attempt an answer to the highly anticipated question: why do the influences of Wilde and British Aestheticism remain unnamed in the novel if indeed they are so strong? Just as in Wilde's *The Picture of Dorian Gray* we learn that "Dorian Gray had been poisoned by a book," and not just by any book, but by "a novel without a plot, and with only one character, being, indeed, simply a psychological study of a certain young Parisian, who spent his life trying to realise in the nineteenth century all the passions and modes of thought that belonged to every century except his own" (165, 141), yet never get a direct reference to what is clearly J.-K. Huysmans's 1884 novel *À Rebours*, as neither the author nor the title are mentioned, so too can we speculate that Silva refrains from mentioning the author, works, or movement that *most* influenced him or his protagonist. Whereas Rossetti is mentioned eleven times, Nietzsche six times, Baudelaire three times, and Poe and D'Annunzio one time each in *De sobremesa*, authors such as Wilde, Pater, Huysmans, and Mallarmé are not mentioned at all. Arguably, then, it is the unnamed authors of European aestheticism and decadence (along with the seldom-named ones such as Poe and D'Annunzio) that have the greatest impact on Silva and his artist protagonist, as published studies on the influence of Poe (see Englekirk, Torres-Rioseco, and Cross), Huysmans (see Villanueva-Collado), Pater (see Jaramillo), and Wilde (see Cobb) on Silva attest. Furthermore, José Fernández's own claims about the type of art he wishes to create – "The fact is I don't want to *say* but rather suggest, and for the suggestion to work, the reader needs to be an artist" – reveal that he will not "tell," but will only "suggest," and it is thus up to the critical and creative readers of *De sobremesa* to decipher his most significant "suggestions" (236). Similarly, Fernández contends that half of the work of art "lies in the verse, in the statue, in the painting, the other [half] in the brain of the one hearing, seeing, or dreaming," and as such it is our task to hear, see, or dream the influence of (Pater's and) Wilde's impressionistic critic (60). Seeking critical, as opposed to common, readers, Silva requires active and discerning receptors, as does Wilde. Of course, another explanation is simply that the artists and works that influenced Silva are not necessarily those that influenced his protagonist; the author may have been reading Wilde (and indeed he did meet Wilde while in London), while the protagonist was (in theory, of course) reading from the long list of authors and artists mentioned in the novel.

19. The either/or approach to art versus life that Silva's novel suggests is addressed by Ericka Beckman in the opening paragraph of her article "Sujetos insolventes: José Asunción Silva y la economía transatlántica del lujo." She begins by citing a letter written by Silva in 1890 to his friend

Eduardo Zuleta in which the Colombian author apologizes for not writing about artistic topics and offers the excuse that he is too busy worrying about the declining value of paper money and fluctuations in the price of coffee. According to Beckman's analysis of this letter, "an incessant chain of financial setbacks ... obstructed the images of beauty that he [Silva] would have liked to express," since "the possibility of art remains truncated by the economic conditions of a peripheral capitalism" (757). In contrast to Silva's life, in which the real permeated and sometimes prevented the artistic, José Fernández aims to safeguard art from life, the artistic from the commercial.

Part II Introduction

1. See John Xiros Cooper's *Modernism and the Culture of Market Society* and Alissa G. Karl's *Modernism and the Marketplace: Literary Culture and Consumer Capitalism in Rhys, Woolf, Stein, and Nella Larsen* (2009) for a discussion of issues pertinent to this section, such as the relationship of authors and characters to the commercial values of market-driven society, to the uneven marketplace of modernism, and to the effects of consumer capitalism. These studies differ from mine in that Cooper focuses on the modernist avant-garde in Europe and America, while Karl examines women-authored modernist texts from both Britain and the United States.
2. This is particularly true in the case of Spanish America insofar as the generation of *modernista* writers was indeed a brilliant generation of journalists that included Gutiérrez Nájera, Casal, and, above all, Martí and Darío, all of whom wrote for the Spanish American press. These authors turned to journalism out of economic necessity, "given that their society did not need poets, but rather journalists" (Rama 68, translation mine). The *modernistas'* interaction with the journalistic world had an effect on their literary creations. Rama rightly attributes the constant pressure to renovate and renew ("constante tensión renovadora") of Darío's literary production to the "demand for novelty and originality" that the public comes to expect of his journalistic work (75, translation mine). The same traits required of the journalist became part of Spanish American *modernismo*: "novelty, attraction, velocity, shock, rarity, intensity, sensation," namely because they were also traits that belonged to the new market economy (76–7, translation mine).
3. Because mass production was inevitably accompanied by mass consumption, I examine these concepts in relation to one another. Enormous gains in productivity at the turn of the century, resulting in part from various technological advancements, coupled with a steady rise in purchasing power and the increasing availability of credit, meant that there were both more goods available and more money with which to buy them (Williams 9–10). Thus, it is important to recognize that the often

discussed Industrial Revolution and the less familiar consumer revolution "are really two facets of a single upheaval that decisively altered the material basis of human life" (Williams 9).

Chapter 3 The Artist as Elitist Taster: The Unprofaned and Unconsumed as Art in J.-K. Huysmans

1. Huysmans modeled his protagonist on a variety of real-life figures, a combination of dandies, artists, and eccentrics: from King Ludwig II of Bavaria to Edmond de Goncourt, from Jules Barbey d'Aurevilly to Charles Baudelaire, and from Francis Poictevin to Comte Robert de Montesquiou-Fezensac. Additionally, it is commonly accepted that Des Esseintes "became the repository of Huysmans' secret tastes and untold dreams, and that in their sickly sensibility, their yearning for solitude, their abhorrence of human mediocrity, and their thirst for new and complex sensations, author and character were one" (Baldick 81–2).

2. Des Esseintes questions not only the socioeconomic basis of capitalist society, but also that society's delineation of gender and sexual norms insofar as he transgresses the strictness of male gender categories and rejects the middle-class ideals of the industrious, rational, and self-restrained man. Rather than be a producer for society, he will be an avid consumer. As a result of his allegiance to the sensuous, the artificial, and the beautiful, Des Esseintes acquires feminine or androgynous attributes. Such feminization of male subjectivity is a common response to "capitalism's reconfiguration of gender roles," explains Rita Felski in *The Gender of Modernity*, in that some modern men, Des Esseintes being the example par excellence, seem to react positively to the prospect of an "aestheticized and feminized modernity" (91). In particular, the effeminate male dandy adopts modern woman's penchant for shopping and consuming albeit in somewhat altered form, since he juxtaposes his refined and elitist taste with the vulgar or voracious consumption of woman. Thus, despite their shared identities as consumers, the male aesthete shows a "superiority of taste" and makes a "qualitative" judgment in his own aesthetic response when compared to woman (Felski 106). As this analysis will soon show, however, despite Des Esseintes's achievement in transcending gender categories, he does not have equal success in his efforts to escape consumer society.

Chapter 4 The Artist as Creator Not Producer: The Unsold and Unappreciated as Art in Rubén Darío

1. It is worth noting that Huysmans's novel had a profound effect on many Spanish American modernist writers during the final decade of the nineteenth century, as indeed several of them were residing in Europe's "cultural capital" around this time. Rubén Darío went so far as to pay tribute to Huysmans by signing the articles he wrote for the Argentine press with the pen name Des Esseintes. Silva's own French copy of *À Rebours*, supposedly

given to him as a gift by Mallarmé in Paris in 1891, has been scrupulously studied with regard to the Colombian author's marginal comments and notes. (See Alfredo Villanueva Collado's "José Asunción Silva y Karl-Joris Huysmans: Estudio de una lectura.") Also worth mentioning is Cuban modernist Julián del Casal's essay "Joris Karl Huysmans."

2. An obvious difference between Des Esseintes and Darío's characters from the short stories examined here is that only the French aesthete has the luxury of making "purchases of all sorts ... and ransacking the shops from one end of Paris to the other" (25). And even though Des Esseintes, when "taking stock of his fortune, ... discovered to his horror that in extravagant follies and riotous living he had squandered the greater part of his patrimony, and that what remained was invested in land and brought in only a paltry revenue," he is able to sell enough surplus property to free himself from want and from work for the remainder of the novel (24). Reflecting on Des Esseintes's elevated social position, Rosalind Williams astutely notes that the "concept of class, traditionally associated with a person's relationship to the means of production, invades the realm of consumption in *À Rebours*. Des Esseintes's world is rigidly class-structured, but he classifies people by what they consume rather than by what they produce. He frantically resists being declassed from one of the 'chosen few' to one of the 'common herd,' and he is convinced that this would happen were he to handle objects of popular consumption" (138).

3. Cathy Jrade makes a similar claim in "Socio-Political Concerns in the Poetry of Rubén Darío," when she states that Darío "aspired to reorder dominant values, placing transcendental, poetic goals above materialistic ends" (40). Ricardo Szmetan agrees that although "Darío had an aristocratic vision of society," such a vision was "based on, above all, intellectual and artistic merit, rather than economic or social merit" (417, translation mine). Szmetan adds that even if Darío would have liked to be of noble or wealthy lineage, this does not take away the fact that he would have placed the spiritual in the foreground (417).

4. Queen Mab is a well-known figure from Celtic folklore. The most notable reference to her occurs in Act IV of Shakespeare's *Romeo and Juliet*, when Mercutio tells love-struck Romeo: "I see Queen Mab hath been with you." Mercutio goes on to say that the miniature fairy Mab must have visited Romeo at night, when she "gallops ... [t]hrough lovers' brains, and then they dream of love."

5. In addition to the aforementioned studies by Rama, Acereda, and Giradot, it is worth mentioning Cathy L. Jrade's analysis of the "interplay between poetry and society" in her book *Modernismo, Modernity, and the Development of Spanish American Literature* (74). Jrade notes the way in which Darío concerns himself with "the limits, restrictions, and constraints imposed on [the] behavior, language, and vision [of the poet] by society" (73). Graciela Montaldo's thesis that "the world of art is the world of a threatened sensibility" ("el mundo del arte es el mundo de una sensibilidad amenazada") in both "el fin de siglo" and "el modernismo" also contributes to

a better understanding of the fragile relationships between the artist and his society at the turn of the century (17, translation mine).

Chapter 5 The Artist as Dandy-Aesthete: The Self as Art in Oscar Wilde and Thomas Mann

1. Whereas the other literary works examined in this book fall clearly within the turn-of-the-century period that spans roughly from 1880 to 1910, Mann's novel, *Bekenntnisse des Hochstaplers Felix Krull: Der Memoiren erster Teil*, published in 1954, is an exception. Nonetheless, Mann began working on the story as early as 1909 and he finished the first fragment of the novel, a short story entitled "Felix Krull," in 1911. Thus, this work fits thematically within the turn-of-the-century period on account of its early beginnings, and also owing to the fact that the retrospective first-person narration sets the events closer to the beginning of the century than to the middle of it.

2. Dorian is also an actor because he "acts," that is, he takes action in the literal sense of the term, unlike Lord Henry who is content with his "vita contemplativa." In addition to the question of influence, then, we must also consider the fact that Dorian prefers action to thought, doing to being, while Lord Henry is "quite content with philosophic contemplation" (45). Dorian "felt keenly conscious of how barren all intellectual speculation is when separated from action and experiment. He knew that the senses, no less than the soul, have their spiritual mysteries to reveal" (150); he "saw that there was no mood of the mind that had not its counterpart in the sensuous life" (150). By contrast, Lord Henry adopts a more passive or contemplative attitude as he aims only "[t]o become the spectator of one's own life" and does not desire to act or "to change anything" (124, 45). Harry insists that "[i]f a man treats life artistically, his brain is his heart" (244). Wilde seems to suggest through his juxtaposition of these two characters that there are two ways of approaching a "life for art's sake" position – in terms of thought (Lord Henry) or in terms of action (Dorian). The dandy has traditionally intersected with the former category. Consider, for example, d'Aurevilly's description of Brummell's unemotional existence – "No illusions of the heart, no storming of the senses affected the judgments he delivered, to weaken or suspend them" – or Balzac's discussion of the "artist's life" for the "man who thinks" and the "elegant life" for the "man who does nothing," both of which contrast to the "busy life" of the "man who works" (d'Aurevilly 24; Balzac 3–4).

3. The key elements of Lord Henry's "new Hedonism" include: "always searching for new sensations," being "afraid of nothing," recreating life and saving it from "harsh, uncomely puritanism," and, finally, being "experience itself" (25, 147).

4. It is interesting to note that Felix continually comes in contact with various artist figures: Schimmelpreester is a portrait painter, Mme. Houpflé is

a writer, the Marquis de Venosta is also a painter, and ZaZa is an actress. In contrast to the company he keeps, however, Felix is presented as the best "artist" of them all. He not only benefits from his contact with traditional artists, but he also uses such interludes to reassure himself of his own superior abilities and unique talents as a self-fashioned and increasingly dandified individual. Even if he does not produce any external artistic work (unless of course we are to treat the later Felix's memoirs as a literary work), he invites comparison to both the artist figure and the dandy on account of his self-aestheticization and the conversion of himself into a work of art.

5. My use of the term "meritocratic" stems from Rhonda Garelick's contention that "Dandyism may reinvigorate or even improve upon a waning aristocracy, refashioning it as pure meritocracy" (29).

6. For an illuminating analysis of Felix's "'dual voiced,' or layered consciousness" and Mann's "double-writing, or 'dual-voiced' narration," see Downing's *Artificial I's: The Self as Artwork in Ovid, Kierkegaard, and Thomas Mann* (165). Upon noting that *Felix Krull* is the only major work by Mann in which the protagonist is also the first-person narrator, Downing goes on to explore the many implications of both Felix's and Mann's narrative methods (170). Of particular interest is his discussion of Felix's "'anti-Pygmalion' self-fashioning relationship with his character" and "his dialectically self-fashioning relationship with his reader" (163).

7. As an outward manifestation of his own dual nature, Felix reveals a sustained interest in double images or pairs; he has "very little taste for individual persons and wax[es] much more enthusiastic about combinations" (338). When he first sees the brother–sister pair in Book II, he reflects: "they concerned me not as a single image but a double creature," since the beauty lay "in the duality, in the charming doubleness" (76, 77). Once Felix assumes the identity of the Marquis, "the idea that this ZouZou was or must become the travelling LouLou Venosta's ZaZa implanted itself ever more firmly in my imagination" (305). "[I]n search of ZaZa's double," Felix "assumed the obligation" of falling in love with ZouZou (281–2). Yet the exotic and Iberian ZouZou is more interesting when compared not to the Parisian ZaZa, but to her own mother, since Felix's "penchant for twofold enthusiasms, for being enchanted by the double-but-dissimilar, was called into play in this case by mother-and-daughter instead of brother-and-sister" (281). Being able to "behold beauty in a double image, as childlike blossom and as regal maturity" proves to be a source of erotic excitement for Felix (314). Indeed, whether uniting genders, nationalities, or age groups, Felix is drawn far more to combinations than to individuals. In fact, the only individual person who can compete for Felix's attention is Andromache, the circus performer. Yet we cannot deny that Felix's attraction to her stems primarily from her own internalized doubleness as both female and male, both human and divine.

8. In "Felix Krull or: 'All the World's a Stage,'" Donald F. Nelson discusses the theatrical metaphors used to describe Felix's mode of writing or

narrating. He notes the use of words such as "Auftreten" ("appearance") and "Darbeitung" ("performance"), which describe the later Felix's literary venture in theatrical terms. He concludes that the first word, "Auftreten," is "a significant lexical choice by which Krull characterizes his writing as a 'performance' and thus establishes associations with the stage" (44). He likewise reasons that the word "Darbeitung" is "pregnant with stage connotations" (45). According to Nelson, "Krull, the writer, makes his 'appearance' ('Auftreten') as an artist offering us a performance" (45). Rejecting the emphasis on a theatrical metaphor to describe Felix's role as narrator, Eric Downing posits that unlike the character Müller-Rosé, who "achieved his unreality and other-worldliness with 'Licht und Fett, Musik und Entfernung,' that is, with the devices of the theater," Felix, the narrator, "can achieve his imperturbable unreality with the devices of literature instead, devices which differ significantly from those available to a mere actor, and not least in their increased capacity to eliminate any potentially intrusive 'backstage' reality" (198). Certainly Nelson's analysis is valid insofar as Felix the character and Felix the narrator are both performers who act out various characters and roles. Nonetheless, I side with Downing's argument that the narrator takes on the additional traits of an author who scripts the characters that he himself will play.

9. In "The Ultimate Con: Thomas Mann," Robert A. Jones argues:

> Underneath Krull's escapades is nothing other than the challenge of beating the system. That fact, despite the hero's winning charm and philosophizing ratiocination, is the negative force of the work. Mann allows his Krull to create for himself a balloon of ever-increasing size, each episode adding more air until – at some point beyond the unfinished novel sequence – the reader is given to understand that it bursts. (91)

In Jones's estimation, then, the novel "stops before the fall on the 'pinnacle' to which Mann has brought his hero of heroes" (Jones 92). Felix as narrator does allude to several incidents and experiences occurring later in his life, some of which have a negative tinge and reveal a future fall from self-fashioned glory. Nonetheless, I attribute the overall positive portrait of Felix to the narrator's ability to hide for the most part any acts of "falling" or "bursting."

10. Mann was planning on writing a second volume to the novel, but his death in 1954 prevented him from finishing the saga of Krull's life beyond the early years.

Chapter 6 The Artist as Dandy-Flâneur: The World as Art in Manuel Gutiérrez Nájera and Julián del Casal

1. "*Crónica* is the name given in Spanish to a hybrid genre that combines literary and journalistic elements in a variety of ways, resulting in brief texts

that often focus on contemporary topics and issues addressed in a self-consciously literary style," explains Ánibal González in *A Companion to Spanish American Modernismo* (24). The *crónica* was created by the Spanish American *modernistas* during the 1870s and 1880s, as they were "inspired by a similar type of article called *chroniques*, which began to be published in Parisian newspapers such as *Le Figaro* and *La Chronique Parisienne* during the 1850s. In many instances, *crónicas* account for more than two-thirds of the *modernistas'* published writings" (González, *Companion* 24).

2. Perhaps the most extensive study on Spanish American dandyism comes from Mónica Bernabé, who opens her book *Vidas de artista: Bohemia y dandismo en Mariátegui, Valdelomar y Eguren (Lima, 1911–1922)* with a discussion of Rubén Darío's "Los raros" (1896) as an example of a Spanish American literary text that combines the figures of the dandy and the bohemian artist. Her examination of Darío's "construction of the figure of the 'raro'" notes his interest in both the "intersection between art and life" and "the intersection between bohemia and dandyism," that is, in the moment when "life itself becomes a work of art" or when the desire to "live from art" leads one to invent "an art of living" (Bernabé 36, 24, 48, 34, 24, translation mine). According to Bernabé's understanding of Darío's "raro," one can be "rare" or "strange" by being decadent, degenerate, fantastical, prophetic, visionary, redeeming, anarchist, exquisite, or poetic (41). Whatever the reason, the figure of "el raro" combines the dandy's "segregation and separation," "his search for individuality marked by exceptionality and distinction" with the bohemian's "gregariousness" and "desire to belong to a group, a community" of artists (Bernabé 26–7, translation mine). This figure also combines the notion of an "aristocracy of talent" with the reality of a "lack of money" and thus addresses "the contradictory relations between artists and the crowd," on the one hand, and between "artists and money," on the other hand (Bernabé 43, 45, translation mine). In this current chapter, I will examine the ways in which the Spanish American dandy and flâneur figures relate to their audiences, to modern society, and to the marketplace. Additional studies on the dandy include Ana Peluffo's "Dandies indios y otras representaciones de la masculinidad en Manuel González Prada" and Claudia Darrigrandi's "De 'fulano' a dandi: escenarios, performance y masculinidad en *Pot Pourri (Silbidos de un vago)* de Eugenio Cambaceres."

3. I have not come across specific studies on the Spanish American flâneur in literature, although many theorists of the Spanish American chronicle note the similarities between the "cronista" and the flâneur. See Chapter 5, "Decorar la ciudad: crónica y experiencia urbana," in Julio Ramos's *Desencuentros de la modernidad en América Latina*; Chapter 1, "Tras los pasos del crónica modernista," in José Ismael Gutiérrez's *Perspectivas sobre el modernismo hispanoamericano*; Chapter 2, "*Modernismo* and Journalism: the *Crónicas*," in Aníbal González's *A Companion to Spanish American Modernismo*; and Esperança Bielsa'a *The Latin American Urban Crónica: Between Literature and Mass Culture.*

4. In "Preso entre dos muros de vidrio: José Asunción Silva entre la hacienda y los mundos del *flâneur* y del *dandy*," Edison Neira Palacio discusses the ways in which Silva's protagonist, José Fernández, intersects with both the dandy and the flâneur. He makes the interesting argument that Fernández is presented as having the spirit and forms of insolence of the dandy as well as the wandering and observing of the flâneur (42). More specifically, he suggests that Silva's hero is "a caricature of the dandy in Bogotá and a flâneur in the streets of Paris and London" (43, translation mine). The geographic differences that make him a dandy in Latin America and a flâneur in Europe stem in part from the fact that Fernández truly believes: "to my elegant European friends, I'll never cease to be the *rastaquouère* who tries to rub elbows with them, by towering up his bags of gold; and to my compatriots I will not cease to be a swanky show-off who wants to show them to what extent he has managed to insinuate himself into the grand Parisian world and the cosmopolitan high life" (Silva, *After-Dinner Conversation* 194). J. Eduardo Jaramillo-Zuluaga makes a similar observation in "*De Sobremesa* de José Asunción Silva: El joven que llegó de Europa, el Rastacuero," when he explains that Silva's novel binds two opposed yet complimentary images: "the image of the 'rastacuero' [i.e., a wealthy foreigner of South American origin living the "high life" in Paris] and the image of the young [South American] man recently returned from Europe" (202, translation mine). Silva's presentation of José Fernández seems to suggest that he can only be a flâneur in Europe, but even then he will not be seen as a true or authentic Parisian flâneur, being always at most "un rastacuero" or "reastaquiouére." Similarly, Fernández can only be a dandy in Spanish America, but he is a dandy longing for the life of luxury, elitism, and modernity that he witnessed in Europe and misses in his native land. In many ways, the long-standing civilization/barbarism dichotomy made famous by Sarmiento still holds true as the periphery lacks the modernity found in the center as well as the possibility for true *flânerie* or true dandyism. Finally, in "Voice Snatching: *De sobremesa*, Hysteria, and the Impersonation of Marie Bashkirtseff," Sylvia Molloy discusses the complex portrayal of Silva's protagonist in terms of his gender identity:

> José Fernández indeed appears to be, on the one hand, a Latin American version of the "feminized" male subject common to turn-of-the-century literature, a tropical *collectionneur* whose private, heavily ornamented interior smacks of artifice, hypersensitivity, and pose. A dandy, an aesthete, a poet (whose genius is suitably exhausted), he too can be said to be "voic[ing] a protest against prevailing bourgeois values that associate masculinity with rationality, industry, utility, and thrift" (Felski 1096). Yet, on the other hand, this languid aesthete was an amateur scientist, a classical scholar, an archaeologist, a soldier on occasion, and a committed yet utopian politician, all roles conventionally linked to the masculine. (Molloy 21)

Molloy's discussion of José Fernández's allegiances to stereotypical feminine and masculine traits also serves to reveal his (at best) partial intersection with the figures of the dandy and the aesthete.

5. Unless otherwise noted, all translations of Spanish-language primary and secondary sources in this chapter are mine.

6. This work was published four times in the Mexican press: first, in *El Federalista* on September 30, 1877 under the title "Cosas del mundo" ("Things of the World") and signed "Manuel Gutiérrez Nájera"; second, in *Voz de España* on October 5, 1879 under the title "Mi inglés" ("My Englishman") and signed "M. Gutiérrez Nájera"; third, in *El Cronista de México* on December 18, 1880 under the title "Memorias de un vago" ("Memories of an Idler") and signed "M. Can-Can"; and fourth in *El Nacional Literario* in 1882 again under the title "Mi inglés" and signed "M. Gutiérrez Nájera" (*Cuentos completos* 9).

7. This text was published in *Cronista de México* on June 4, 1881 as part of the longer article "Memorias de un vago" ("Memories of an Idler") and signed "M. Can-Can" (*Cuentos completos* 81).

8. In "The Pseudonyms of Manuel Gutiérrez Nájera," E. K. Mapes offers a detailed outline of Gutiérrez Nájera's various pseudonyms and concludes his investigation by arguing: "the foregoing discussion seems to indicate that twelve of the pseudonyms and sets of initials used by Nájera are his exclusive literary property. These are 'El Duque Job,' 'G.N.,' 'M. G. N.,' 'Frú-Frú,' 'M. Can-Can,' 'Fritz,' 'X. X.,' 'Croix-Dieu,' 'Juan Lanas,' 'El Cura de Jalatiaco,' 'Recamier' and 'Juius (Senior).' Three more – 'Rafael,' 'Pomponnet,' and 'Perico el de los Palotes' – are exclusively his with sporadic and unimportant exceptions, sometimes in the form of foreign contributions. Five, including some of the most important, were used by one or more other writers, and it requires much care to determine which of the compositions so signed are by Nájera. These are 'Ignotus,' 'Gil Blas,' 'Junius,' 'Omega' and 'Puck.' Three are on lists of Nájera pseudonyms compiled by his friends and associates, but seem to have no other claim to recognition. Those so classified are 'Nemo,' 'Etincelle' and 'Can-Can.' ... Lastly there are two, 'Titiana' and 'Manuel Gutiérrez,' which obviously are not Nájera's, though some well-informed persons have believed them to be." (Mapes 677)

9. This text appeared twice in newspaper publications: once in *El Nacional* on December 24, 1880 under the title "Cosas del mundo (Las misas de Navidad)" and signed "M. Gutiérrez Nájera," and another time in *La Libertad* on December 24, 1882 under the title "Crónica de Noche Buena" ("Christmas Eve Chronicle") and signed "El Duque Job" (*Cuentos completos* 433).

10. The short story "En la calle" ("On the Street") appeared in the collection *Cuentos frágiles* in 1883, but it is a combination of two earlier chronicles both published on April 30, 1882: "Crónica de las carreras" (Chronicle of the Streets"), which was published in *El Nacional* and was signed "M. Gutiérrez Nájera," and "En las carreras" ("On the Streets"), which

was published in *El Cronista de México* and signed "M. Can-Can" (*Cuentos completos* 131).

11. This chronicle was published once in *La Libertad* on November 2, 1884 as part of an article in the series "Crónicas de mil colores" ("Chronicles of a Thousand Colors") and signed "El Duque Job" (*Cuentos completos* 213).

12. This work was first published in *La Libertad* on August 20, 1882 under the title "Crónicas color de lluvia" ("Chronicles the Color of Rain") and signed "El Duque Job." The text was published three additional times in newspapers: twice with the title "La novela de tranvía" and signed "Manuel Gutiérrez Nájera" (in *El Correo de las Señoras* on July 17, 1887 and in *El Pabellón Nacional* on November 13, 1887) and once with the title "Humoradas dominicales" ("Sunday Witticisms") again under the pseudonym "El Duque Job" (in *El Partido Liberal* on September 30, 1888). The chronicle was later published as a short story, again with the title "La novela del tranvía" and this time under Gutiérrez Nájera's name, in his collection *Cuentos frágiles* (1883) (*Cuentos completos* 154).

13. "El fénix" was published under the pseudonym Hernani in *La Discusión* on March 13, 1890.

14. "El matadero" was published under the pseudonym Hernani in *La Discusión* on June 12, 1890.

15. In "The *Flâneur*: From Spectator to Representation," Bruce Mazlish makes important connections between the flâneur and the journalist, the poet, the dandy, and the man of commerce: "the *flâneur*, in fact, is more than a journalist, though that is how he earns his living. He is a poet, who observes daily, urban capitalist life – and writes up his observations in prose. He is the 'dandy', protesting with his sometimes feigned idleness the bourgeois work ethic and clinging to the remnants of an aristocratic aura, but now forced to go on the market. He is the genius, whose spirit has been capitalized" (47). Mazlish's awareness of the various roles of the flâneur as well as his commentary regarding the commodification of art are particularly relevant to the case of both Gutiérrez Nájera and Casal.

Bibliography

Acereda, Alberto. *Rubén Darío, poeta trágico (una nueva visión)*. Barcelona: Editorial Teide, 1992.

Aching, Gerard. *The Politics of Spanish American Modernismo: By Exquisite Design*. Cambridge: Cambridge University Press, 1997.

Adorno, Theodor. *Aesthetic Theory*. Eds. Gretel Adorno and Rolf Tiedemann. Trans. Robert Hullot-Kentor. *Theory and History of Literature 88*. Minneapolis: University of Minnesota Press, 1997.

———. "Letters to Walter Benjamin." *Aesthetics and Politics*. Trans. Ronald Taylor. Norfolk: Lowe and Brydone, 1977. 100–41.

Appadurai, Arjun. "Consumption, Duration, and History." *Modernity at Large: Cultural Dimensions of Globalization*. Minneapolis: University of Minnesota Press, 1996. 66–85.

Aristotle. "De Poetica (Poetics)." *The Basic Works of Aristotle*. Ed. Richard McKeon. New York: Modern Library, 2001. 1455–87.

Baldick, Robert. *The Life of J.-K. Huysmans*. Oxford: Clarendon Press, 1955.

Balzac, Honoré de. *Treatise on Elegant Living*. Trans. Napoleon Jeffries. Cambridge, MA: Wakefield Press, 2010.

Baudelaire, Charles. *The Painter of Modern Life and Other Essays*. Trans. and ed. Jonathan Mayne. New York: Da Capo, 1986.

———. "Perte d'Auréole"/"Loss of a Halo." *Petits poèmes en prose (ou Le Spleen de Paris)*. Trans. Cat Nilan. Baudelaire Online. January 18, 2011. http://www.piranesia.net/baudelaire/spleen/46perte.html

Beckman, Ericka. "Sujetos insolventes: José Asunción Silva y la economía transatlántica del lujo." *Revista Iberoamericana* 75.228 (2009): 757–72.

Beddow, Michael. "Fiction and Meaning in Thomas Mann's *Felix Krull*." *Journal of European Studies* 10 (1980): 77–92.

Bell-Villada, Gene H. *Art for Art's Sake and Literary Life: How Politics and Markets Helped Shape the Ideology and Culture of Aestheticism, 1790–1990*. Lincoln: University of Nebraska Press, 1996.

Benjamin, Walter. "On Some Motifs in Baudelaire." *Illuminations*. Ed. Hannah Arendt. Trans. Harry Zohn. New York: Schocken Books, 1968. 155–200.

———. "The Paris of the Second Empire in Baudelaire." *The Writer of Modern Life: Essays on Charles Baudelaire*. Cambridge, MA: Belknap Press of Harvard University Press, 2006. 46–133.

———. "The Work of Art in the Age of Mechanical Reproduction." *Illuminations*. Ed. Hannah Arendt. Trans. Harry Zohn. New York: Schocken Books, 1968. 217–51.

Bernabé, Monica. *Vidas de artista: Bohemia y dandismo en Mariátegui, Valdelomar y Eguren (Lima, 1911–1922)*. Lima: Beatriz Viterbo, 2006.

Bielsa, Esperança. *The Latin American Urban Crónica: Between Literature and Mass Culture*. Lanham, MD: Lexington Books, 2006.

Blanco Aguinaga, Carlos. "La ideología de la clase dominante en la obra de Rubén Darío." *Nueva Revista de Filología Hispánica* 29.2 (1980): 520–55.

———. "On Modernism from the Periphery." *Modernism and Its Margins: Reinscribing Cultural Modernity from Spain and Latin America*. Eds. Anthony L. Geist and José B. Monleón. New York: Garland, 1999. 3–16.

———. *Sobre el modernismo, dese la periferia*. Peligros (Granada): Editorial Comares, 1998.

Bürger, Peter. *Theory of the Avant-Garde*. Trans. Michael Shaw. *Theory and History of Literature 4*. Minneapolis: University of Minnesota Press, 1984.

Burton, Richard, D. E. *The Flâneur and His City: Patterns of Daily Life in Paris, 1815–1851*. Durham: University of Durham, 1994.

Carter, Boyd, G. "Manuel Gutiérrez Nájera: Caballero andante de culturas." *Romance Literary Studies: Homage to Harvey L. Johnson*. Ed. Marie A. Wellington. Potomac, MD: Porrua Turanzas, 1979. 27–35.

Casal, Julián del. "A la belleza." *Poesía completa y prosa selecta*. Ed. Álvaro Salvador. Madrid: Editorial Verbum, 2001. 183–5.

———. "A un crítico." *Poesía completa y prosa selecta*. Ed. Álvaro Salvador. Madrid: Editorial Verbum, 2001. 144.

———. *Crónicas habaneras*. Las Villas: Universidad Central de Las Villas, 1963.

———. "El arte." *Poesía completa y prosa selecta*. Ed. Álvaro Salvador. Madrid: Editorial Verbum, 2001. 63.

———. "En el campo./In the Country." *An Anthology of Spanish American Modernismo: In English Translation with Spanish Text*. Ed. Kelly Washbourne. Trans. Kelly Washbourne and Sergio Waisman. New York: MLA, 2007. 78–81.

———. "El fénix." *Poesía completa y prosa selecta*. Ed. Álvaro Salvador. Madrid: Editorial Verbum, 2001. 321–4.

———. "Joris Karl Huysmans." *Poesía completa y prosa selecta*. Ed. Álvaro Salvador. Madrid: Editorial Verbum, 2001. 379–86.

———. "El matadero." *Poesía completa y prosa selecta*. Ed. Álvaro Salvador. Madrid: Editorial Verbum, 2001. 353–4.

———. *Poesía completa y prosa selecta*. Ed. Álvaro Salvador. Madrid: Editorial Verbum, 2001.

———. "La última ilusión." *Poesía completa y prosa selecta*. Ed. Álvaro Salvador. Madrid: Editorial Verbum, 2001. 387–91.

Child, Ruth C. "Is Walter Pater an Impressionistic Critic?" *Publications of the Modern Language Association of America* 53.4 (1938): 1172–85.

Cobb, Carl W. "José Asunción Silva and Oscar Wilde." *Hispania: A Journal Devoted to the Teaching of Spanish and Portuguese* 45.4 (1962): 658–61.

Comfort, Kelly, ed. *Art and Life in Aestheticism: De-Humanizing and Re-Humanizing Art, the Artist, and the Artistic Receptor*. Hampshire, UK and New York: Palgrave Macmillan, 2008.

Coomaraswamy, Amanda K. "Art for Art's Sake." *Catholic Art Quarterly* 20 (1957): 39–43.

Cooper, John Xiros. *Modernism and the Culture of Market Society*. Cambridge: Cambridge University Press, 2004.

Cross, Leland W. "Poe y Silva: unas palabras de disensión." *Hispania: A Journal Devoted to the Teaching of Spanish and Portuguese* 44.4 (1961): 647–51.

Danson, Lawrence. *Wilde's Intentions: The Artist in His Criticism*. Oxford: Clarendon Press, 1997.

Darío, Rubén. "Nocturno". *Azul* ... / *Cantos de vida y esperanza*. Madrid: Cátedra, 2000. 399–400.

———. "El pájaro azul/The Blue Bird." *Stories and Poems/Cuentos y poesías (A Dual-Language Book): Rubén Darío*. Ed. and trans. Stanley Appelbaum. Mineola, NY: Dover, 2002. 44–51.

———. "Palabras liminares." *Prosas profanas y otros poemas*. París: Librería de la Vda de C. Bouret, 1901. 48.

———. "Prefacio." *Cantos de vida y esperanza*. In *Azul... / Cantos de vida y esperanza*. Madrid: Cátedra, 2000. 333–4.

———. "El Rey Burgués/The Bourgeois King." *Stories and Poems/Cuentos y poesías (A Dual-Language Book): Rubén Darío*. Ed. and trans. Stanley Appelbaum. Mineola, NY: Dover, 2002. 2–11.

———. "El velo de la reina Mab/The Veil of Queen Mab." *Stories and Poems/Cuentos y poesías (A Dual-Language Book): Rubén Darío*. Ed. and trans. Stanley Appelbaum. Mineola, NY: Dover, 2002. 32–7.

———. "Yo persigo una forma ..."/"I Pursue a Form." *Stories and Poems/Cuentos y poesías (A Dual-Language Book): Rubén Darío*. Ed. and trans. Stanley Appelbaum. Mineola, NY: Dover, 2002. 132–3.

Darrigrandi, Claudia. "De 'fulano' a dandi: escenarios, performance y masculinidad en *Pot Pourri (Silbidos de un vago)* de Eugenio Cambaceres." *Entre hombres: Masculinidad del siglo XIX en América Latina*. Eds. Ana Peluffo and Ignacio M. Sánchez Prado. Madrid: Iberoamericana, 2010. 145–66.

d'Aurevilly, Barbey. *The Anatomy of Dandyism, with some Observations on Beau Brummell*. Trans. D. B. Wyndham Lewis. London: Peter Davies, 1928.

Denisoff, Dennis. *Aestheticism and Sexual Parody, 1840–1940*. Cambridge: Cambridge University Press, 2001.

Díaz Rinks, Gloria. "Máscaras y símbolos: hacia la poética modernista. Divagaciones sobre la escritura y el artista en *De sobremesa* de José Asunción Silva." *Lucero: A Journal of Iberian and Spanish American Studies* 6 (1995): 28–36.

Dowling, Linda. *Hellenism and Homosexuality in Victorian Oxford*. Ithaca, NY: Cornell University Press, 1994.

Downing, Eric. *Artificial I's: The Self as Artwork in Ovid, Kierkegaard, and Thomas Mann*. Tübingen: Max Niemeyer, 1993.

Elmore, Peter. "Bienes Suntuarios: El problema de la obra de arte en *De sobremesa*, de José Asunción Silva." *Revista de Crítica Literaria Latinoamericana* 22: 201–10.

Englekirk, John, E. *Edgar Allen Poe in Hispanic Literature*. New York: Russell and Russell, 1972.

Felski, Rita. *The Gender of Modernity*. Cambridge, MA: Harvard University Press, 1995.

Fillin-Yeh, Susan, ed. *Dandies: Fashion and Finesse in Art and Culture*. New York: New York University Press, 2001.

Flanagan Behrendt, Patricia. *Oscar Wilde: Eros and Aesthetics*. New York: St. Martin's, 1991.

Fox, Paul. "Dickens À La Carte": Aesthetic Victualism and the Invigoration of the Artist in Huysmans's *Against Nature*." *Art and Life in Aestheticism: De-Humanizing and Re-Humanizing Art, the Artist, and the Artistic Receptor*. Ed. Kelly Comfort. Basingstoke, UK: Palgrave Macmillan, 2008. 62–75.

Garelick, Rhonda K. *Rising Star: Dandyism, Gender, and Performance in the Fin de Siècle*. Princeton, NJ: Princeton University Press, 1998.

Gautier, Théophile. "Preface." *Mademoiselle de Maupin*. Trans. Joanna Richardson. New York: Penguin, 1981. 19–53.

Ghiano, Juan Carlos. *José Asunción Silva*. Buenos Aires: Centro Editor de América Latina, 1967.

Glick, Elisa. "The Dialectics of Dandyism." *Cultural Critique* 48 (2001): 129–63.

Gold, Barri J. "The Domination of Dorian." *Victorian Newsletter* 91 (1997): 27–30.

González, Aníbal. *A Companion to Spanish American Modernismo*. Woodbridge, UK: Tamesis, 2007.

———. "'Estómago y cerebro': *De sobremesa*, el *Simposio* de Platón y la indigestión cultural." *Revista Iberoamericana* 63 (1997): 233–48.

———. "Retratos y autorretratos: El marco de acción del intelectual en *De sobremesa*." *Leyendo a Silva*. Vol. II. Santafé de Bogotá: Instituto Caro y Cuervo, 1994. 269–306.

Guérard, Albert. "Art for Art's Sake." *Southwest Review* 28 (1953): 173–84.

Gutiérrez, José Ismael. *Perspectivas sobre el modernismo hispanoamericano*. Madrid: Editorial Pliegos, 2007.

Gutiérrez Giradot, Rafael. "El arte en la sociedad burguesa moderna." *Modernismo*. Barcelona: Montesinos, 1983. 33–71.

Gutiérrez Nájera, Manuel. "El amigo." *Cuentos completos y otras narraciones*. Ed. E. K. Mapes. Mexico City: Fondo de Cultura Económica, 1958. 213–14.

———. "El arte y el materialismo." *Obras. Crítica Literaria*. Eds. E. K. Mapes and Ernesto Mejía Sánchez. Mexico City: Centro de Estudios Literarios Universidad Nacional Autónoma de México, 1959. 49–64.

———. "El bautismo de *La Revista Azul*." *Obras. Crítica Literaria*. Eds. E. K. Mapes and Ernesto Mejía Sánchez. Mexico City: Centro de Estudios Literarios Universidad Nacional Autónoma de México, 1959. 537–9.

———. "Cosas del mundo." *Cuentos y cuaresmas del Duque Job*. Ed. Francisco Monterde. Mexico City: Editoria Porrúa, 1970. 109–12.

———. *Cuentos completos y otras narraciones*. Ed. E. K. Mapes. Mexico City: Fondo de Cultura Económica, 1958.

———. "En el campo." *An Anthology of Spanish-American Modernismo in English Translation with Spanish Text*. Ed. Kelly Washbourne. New York: Modern Language Association, 2007. 79–81.

———. "En la calle." *Cuentos completos y otras narraciones*. Ed. E. K. Mapes. Mexico City: Fondo de Cultura Económica, 1958. 131–4.

———. "Las misas de Navidad." *Cuentos completos y otras narraciones*. Ed. E. K. Mapes. Mexico City: Fondo de Cultura Económica, 1958. 433–42.

———. "Mi último artículo." *Divagaciones y fantasias: Crónicas de Manuel Gutiérrez Nájera*. Ed. Boyd C. Carter. Mexico City: SepSetentas, 1974. 93–6.

———. "La novela de tranvía." *Cuentos completos y otras narraciones*. Ed. E. K. Mapes. Mexico City: Fondo de Cultura Económica, 1958. 154–60.

———. "La protección a la literatura." *Obras. Crítica Literaria*. Eds. E. K. Mapes and Ernesto Mejía Sánchez. Mexico City: Centro de Estudios Literarios Universidad Nacional Autónoma de México, 1959. 65–7.

———. "Stora y las medias parisienses." *Cuentos completos y otras narraciones*. Ed. E. K. Mapes. Mexico City: Fondo de Cultura Económica, 1958. 81–4.

Harris, Wendell V. "Arnold, Pater, Wilde, and the Object as in Themselves They See It." *Studies in English Literature, 1500–1900* 11.4 (1971): 733–47.

Harvey, David. *Paris, Capital of Modernity*. New York: Routledge, 2003.

Hazera, Lydia D. "The Spanish American Modernist Novel and the Psychology of the Artistic Personality." *Hispanic Journal* 8.1 (1986): 69–83.

Hinterhäuser, Hans. *Fin de siglo: Figuras y mitos*. Trans. María Teresa Martínez. Madrid: Taurus Ediciones, 1980.

Huysmans, J.-K. *Against Nature*. Trans. Robert Baldick. New York: Penguin, 1959.

Jaramillo, María Dolores. "Los cánones modernos de la 'Carta abierta.'" *Cuadernos Americanos* 85 (2001): 119–25.

Jaramillo-Zuluaga, Eduardo, J. "*De Sobremesa* de José Asunción Silva: El joven que llegó de Europea, el Rastacuero." *Alma de América* 14.27 (1996): 201–10.

Jiménez, José Olivio. *Antología crítica de la poesía modernista*. Madrid: Ediciones Hiperión, 1985.

Jiménez Panesso, David. "Lectores-mesa y lectores-piano: para una poética del lector artísta en Silva." *Universidad de Antioquia* 209 (1987): 14–27.

Johnson, R. V. *Aestheticism*. London: Methuen, 1969.

Jones, Robert A. "The Ultimate Con: Thomas Mann." *Perspectives on Contemporary Literature* 6 (1980): 89–96.

Jrade, Cathy L. *Modernismo, Modernity, and the Development of Spanish American Literature*. Austin: University of Texas Press, 1998.

———. "Socio-Political Concerns in the Poetry of Rubén Darío." *Spanish American Literary Review* 18 (1990): 36–49.

Karl, Alissa G. *Modernism and the Marketplace: Literary Culture and Consumer Capitalism in Rhys ,Woolf, Stein, and Nella Larsen*. New York: Routledge, 2009.

Keefe, Robert. "Artist and Model in *The Picture of Dorian Gray*." *Studies in the Novel* 5 (1973): 63–70.

Kirkpatrick, Gwen. *The Dissonant Legacy of Modernismo: Lugones, Herrera y Reissig, and the Voices of Modern Spanish American Poetry*. Berkeley: University of California Press, 1989.

Knapp, Bettina L. "Huysmans's *Against the Grain*: The Willed Exile of the Introverted Decadent." *Nineteenth-Century French Studies* 20.1–2 (1991–2): 203–21.

Lloyd, Christopher. *J.-K. Huysmans and the Fin-de-siècle Novel*. Edinburgh: Edinburgh University Press, 1990.

Loesberg, Jonathan. *Aestheticism and Deconstruction: Pater, Derrida, and De Man*. Princeton, NJ: Princeton University Press, 1991.

Loveluck, Juan. "*De sobremesa*, novela desconocida del Modernismo." *Revista Iberoamericana* 31 (1965): 17–32.

Manganiello, Dominic. "Ethics and Aesthetics in *The Picture of Dorian Gray*." *Canadian Journal of Irish Studies* 9.2 (1983): 25–33.

Mann, Thomas. *Confessions of Felix Krull: Confidence Man (The Early Years)*. New York: Vintage Books, 1969.

Mapes, E. K. "The Pseudonyms of Manuel Gutiérrez Nájera." *PMLA. Publications of the Modern Language Association of America* 64.4 (1949): 648–77.

Marx, Karl. *Capital: A Critique of Political Economy*. Trans. Ben Fowkes. London: New Left Review, 1976.

———. *Die Frühschriften*. Ed. Siegfried Landshut. Stuttgart: Kröners Taschenausgabe, 1953.

Marx, Karl and Frederick Engels. *Literature and Art*. (Translator anonymous.) New York: International Publishers, 1963.

Mazlish, Bruce. "The *Flâneur*: From Spectator to Representation." *The Flâneur*. Ed. Keith Tester. London: Routledge, 1994. 43–60.

Miller, Daniel. "Consumption as the Vanguard of History." *Acknowledging Consumption: A Review of New Studies*. Ed. Daniel Miller. New York: Routledge, 1995.

Moers, Ellen. *The Dandy: Brummell to Beerbohm*. London: Secker & Walburg, 1960.

Molloy, Sylvia. "La política de la pose." *Las culturas de fin de siglo en América Latina*. Coloquio en Yale, 8 y 9 de abril de 1994. Ed. Josefina Ludmer. Rosario, Argentina: Beatriz Viterbo Editora, 1994. 128–38.

———. "Voice Snatching: *De sobremesa*, Hysteria, and the Impersonation of Marie Bashkirtseff." *Latin American Literary Review* 25 (1997): 11–29.

Montaldo, Graciela. *La sensibilidad amenazada: Fin de Siglo y Modernismo*. Laprida, Argentina: Beatriz Viterbo, 1994.

Neira Palacio, Edison. "Preso entre dos muros de vidrio: José Asunción Silva entre la hacienda y los mundos del *flâneur* y del *dandy*." *Estudios de Literatura Colombiana* 8 (2001): 41–52.

Nelson, Donald F. "Felix Krull or: 'All the World's a Stage.'" *Germanic Review* 65 (1970): 41–51.

Nietzsche, Friedrich. *The Gay Science: With a Prelude in Rhymes and an Appendix of Songs*. Trans. Walter Kaufmann. New York: Random, 1974.

Ohi, Kevin. *Innocence and Rapture: The Erotic Child in Pater, Wilde, James, and Nabokov*. New York: Palgrave Macmillan, 2005.

Ojala, Aatos. *Aestheticism and Oscar Wilde*. Folcroft, PA: Folcroft Library, 1971.

Olson, Robert C. "A Defense of Art for Art's Sake." *Lamar Journal of the Humanities* 4.1 (1978): 59–64.

Ortega y Gasset, José. *The Dehumanization of Art and Other Essays on Art, Culture, and Literature.* Trans. Helene Weyl. Princeton, NJ: Princeton University Press, 1968.

Oviedo, José Miguel. *Antología crítica del cuento hispanoamericano: Del romanticismo al criollismo (1830–1920).* Madrid: Alianza, 1989.

Parkhurst Ferguson, Priscilla. "The *Flâneur* on and off the Streets of Paris." *The Flâneur.* Ed. Keith Tester. London: Routledge, 1994. 22–42.

Pater, Walter. *Plato and Platonism: A Series of Lectures.* New York: Macmillan, 1925.

———. *Walter Pater: Three Major Texts (The Renaissance, Appreciations, and Imaginary Portraits).* Ed. William E. Buckler. New York: New York University Press, 1986.

Peluffo, Ana. "Dandies indios y otras representaciones de la masculinidad en Manuel González Prada." *Revista Iberoamericana* 73.220 (2007): 471–86.

Picon Garfield, Evelyn. "*De sobremesa*: José Asunción Silva: El diario íntimo y la mujer prerrafaelita." *Nuevos asedios al modernismo.* Ed. Ivan A. Schulman. Madrid: Taurus, 1987. 262–81.

Plato. "Republic." *The Collected Dialogues of Plato, Including Letters.* Trans. Edith Hamilton and Huntington Cairns. Princeton: Princeton University Press, 1961. 575–844.

Prewitt Brown, Julia. *Cosmopolitan Criticism: Oscar Wilde's Philosophy of Art.* Charlottesville: University Press of Virginia, 1997.

Rama, Ángel. "Los poetas modernistas en el mercado económico." *Rubén Darío y el modernismo (circunstancia socioeconómica de un arte americano).* Caracas: EBVC, 1970. 49–79.

Ramos, Julio. *Desencuentros de la modernidad en América Latina.* Mexico City: Fondo de cultura económica, 1989.

Rawlings, Peter. "Pater, Wilde, and James: 'The Reader's Share of the Task.'" *Studies in English Language and Literature* 48 (1998): 45–64.

Robillard, Douglas, Jr. "Self-Reflexive Art and Wilde's *The Picture of Dorian Gray.*" *Essays in Arts and Sciences* 18 (1989): 29–38.

Salvador, Álvaro. "The Limits of Modernity in Latin American Poetry." *Modernism and Its Margins: Reinscribing Cultural Modernity from Spain and Latin America.* Eds. Anthony L. Geist and José B. Monleón. New York: Garland, 1999. 81–97.

Schanzer, George O. "Lo 'mod' del Modernismo: *De sobremesa.*" *La literatura iberoamericana del siglo XIX: Memoria del XV Congreso Internacional de Literatura Iberoamericana.* Eds. Renato Rosaldo and Robert Anderson. Tucson: University of Arizona Press, 1974. 43–50.

Shakespeare, William. *Romeo and Juliet. The Complete Works of William Shakespeare.* January 17, 2011. http://shakespeare.mit.edu/romeo_juliet/full.html.

Shewan, Rodney. *Oscar Wilde: Art and Egotism.* London: Macmillan, 1977.

Shrimpton, Nicholas. "The Old Aestheticism and the New." *Literature Compass* 2.1 (2005): 1–16.

Silva, José Asunción. *After-Dinner Conversation: The Diary of a Decadent.* Trans. Kelly Washbourne. Austin: University of Texas Press, 2005.

————. *De sobremesa.* Bogotá: El Ancora Editores, 1993.

————. *Obra completa.* Ed. Héctor H. Orjuela. Madrid: Consejo Superior de Investigaciones Científicas, 1990.

————. "Un poema." *José Asunción Silva/Obra completa.* Ed. Héctor H. Orjuela. Madrid: Consejo Superior de Investigaciones Científicas, 1990. 48–9.

————. "La protesta de la musa". *Antología del cuento modernista hispanoamericano.* Eds. Julio E. Hernández Miyares and Walter Rela. Buenos Aires: Editorial Plus Ultra, 1987. 69–72.

Stanton, Domna C. *The Aristocrat as Art: A Study of the Honnête Homme and the Dandy in Seventeenth- and Nineteenth-Century French Literature.* New York, Colombia University Press, 1980.

Stray, Christopher. *Classics Transformed: Schools, Universities, and Society in England, 1830–1960.* Oxford: Clarendon Press, 1998.

Sturgis, Matthew. *Passionate Attitudes: The English Decadence of the 1890s.* London: Macmillan, 1995.

Swenson, Eric, J. "Beyond Naturalism via the Impressionistic Perspective of J.-K. Huysmans." *Proceedings from the Pacific Northwest Council on Foreign Languages* 29.1 (1978): 51–3.

Szmetan, Ricardo. "El escritor frente a la sociedad en algunos cuentos de Rubén Darío." *Revista Iberoamericana* 55 (1989): 415–23.

Tester, Keith. "Introduction." *The Flâneur.* Ed. Keith Tester. London: Routledge, 1994. 1–21.

Todd, Jeffrey D. "Stefan George and Two Types of Aestheticism." *A Companion to the Works of Stefan George.* Ed. Jens Rieckmann. Rochester, NY: Camden House, 2005. 127–43.

Torres-Rioseco, A. "Las teorías poéticas de Poe y el caso de José Asunción Silva." *Hispanic Review* 18.4 (1950): 319–27.

Villanueva-Collado, Alfredo. "José Asunción Silva y Karl-Joris Huysmans: Estudio de una lectura." *Revista Iberoamericana* 55 (1989): 273–86.

Villarreal Vásquez, Luis José. "De José Asunción Silva a José Fernández de Andrade, o la autobiografobomanía del discurso." *Thesaurus: Boletín del Instituto Caro y Cuervo* 49.2 (1994): 394–8.

Washbourne, Kelly. "An Art Both Nervous and New." Introduction. *After-Dinner Conversation: The Diary of a Decadent.* By José Asunción Silva. Ed. and trans. Kelly Washbourne. Austin: University of Texas Press, 2005. 1–48.

Watson, Edward A. "Wilde's Iconoclastic Classicism: 'The Critic as Artist.'" *English Literature in Transition (1880–1920)* 27.3 (1984): 225–35.

Wilde, Oscar. "The Critic as Artist." *The Artist as Critic: Critical Writings of Oscar Wilde.* Ed. Richard Ellmann. Chicago: University of Chicago Press, 1982. 341–408.

———. "The Decay of Lying." *The Artist as Critic: Critical Writings of Oscar Wilde*. Ed. Richard Ellmann. Chicago: University of Chicago Press, 1982. 290–320.

———. *The Letters of Oscar Wilde*. Ed. Rupert Hart-Davis. New York: Harcourt Brace and World, 1962.

———. "Pen, Pencil and Poison." *The Artist as Critic: Critical Writings of Oscar Wilde*. Ed. Richard Ellmann. Chicago: University of Chicago Press, 1982. 320–40.

———. *The Picture of Dorian Gray*. New York: Modern Library, 1998.

———. "The Portrait of Mr W. H." *The Artist as Critic: Critical Writings of Oscar Wilde*. Ed. Richard Ellmann. Chicago: University of Chicago Press, 1982. 152–220.

———. "The Preface." *The Picture of Dorian Gray*. New York: Modern Library, 1998. xi–xii.

———. "The Soul of Man under Socialism." *The Artist as Critic: Critical Writings of Oscar Wilde*. Ed. Richard Ellmann. Chicago: University of Chicago Press, 1982. 255–89.

Williams, Rosalind H. *Dream Worlds: Mass Consumption in Late Nineteenth-Century France*. Berkeley: University of California Press, 1982.

Ziegler, Robert. "De-Compositions: The Aesthetics of Distancing in J.-K. Huysmans." *Forum for Modern Language Studies* 22.4 (1986): 365–73.

Zuleta, Ignacio. *La polémica modernista: El modernista de mar a mar (1898–1907)*. Bogotá: Instituto Caro y Cuervo, 1988.

Index

Note: An "n" after a page reference refers to a note on that page.

Acereda, Alberto, 84–5
Aching, Gerard, 14, 15, 139
 detachment as assertive
 engagement, 15
Adorno, Theodor, 8–10, 15
 aestheticism as socially significant
 art, 9–10, 15
 Aesthetic Theory, 8–10
 defense of art for art's sake, 9
 "Letters," 9
aesthete, 5, 7, 19–20, 52, 87–8,
 91–3, 96, 100, 104, 105, 106,
 109, 154n1, *see also* art for
 art's sake v. life for art's sake;
 dandy
 alternative to traditional artist
 figure, 19, 88, 91, 104
 artistic life, 19–20, 88, 91
 artist of the self or
 self-aestheticization, 19–20,
 87, 88, 91–3, 96, 104
 elitism, 7, 88, 91
 importance of beauty and
 pleasure, 7, 88
 performativity of, 19–20, 106
 social status, 19–20, 91, 109
 solipsism of, 7, 88, 92
aesthetic value v. commodity form
 of value, 17, 57, 59, 60, 65,
 70, 76, 78, 83–5, 139–40, 141,
 155n3
aestheticism 4–12, 16–21, 23–4,
 30, 38, 39–40, 41, 42, 52–3,
 56, 57–8, 65, 72, 73–5, 77–8,
 82–5, 87–9, 91, 136–9, 141–3,
 148n10, *see also* art for art's
 sake v. art for life's sake;
 art for art's sake v. art for
 money's sake or art for the
 market's sake; art for art's sake
 v. life for art's sake
 artistic autonomy, 6–7, 23, 87, 143
 as engaged art, 14–16, 142–3
 as escapist art, 13–14, 23, 142–3
 as social critique, 8, 11–12, 16,
 18–19, 65, 73, 143
 contemplative aestheticism, 6–7,
 87, 115, 135
 content v. form, 6–7, 136–9
 importance of beauty and
 pleasure, 6, 65, 77, 87, 143
 parallels with Spanish American
 modernismo, 14, 16, 20–1,
 52–3, 56, 57, 58, 141–3
 poetry v. prose, 59, 136–9
 relationship to avant-garde, 8–10
 weak v. strong aestheticism,
 10–11, 30, *see also* Todd,
 Jeffrey
Appadurai, Arjun, 55, 69
 aesthetics of ephemerality, 69
Aristotle, 25, 28, 31–4, 35, 39, 40,
 146–7n1, 147n3, 148n8
 artist as maker of likenesses, 33
 catharsis, 32–4
 ethics v. aesthetics, 31–2
 Poetics, 25, 31–4, 146–7n1, 148n8
 rules of the probable and
 necessary, 32–4
Arnold, Matthew, 36, 37–8, 148n8,
 148n9
art, *see also* aestheticism; artist
 as commodity, 17, 24, 51–3, 58,
 60, 65, 130–1, 141
 autonomy of, 5–6, 8, 30
 lack of social function, 4, 23
 under capitalism, 17, 21, 24, 52–3,
 57, 58, 60–1, 65, 139–40

art for art's sake, *see* aestheticism
art for art's sake v. art for life's sake,
 5, 6–7, 16–17, 21, 23–4, 30,
 38, 40, 41, 45, 51, 52, 53, 56,
 82
art for art's sake v. art for money's
 sake or art for the market's
 sake, 4, 5, 8, 17–18, 21, 57–8,
 60–1, 65, 72, 73–5, 77–8,
 82–5, 139–43, 152–3n19,
 153n1, 155n2
art for art's sake v. life for art's sake,
 5, 7, 19–20, 21, 87–9, 91,
 93–4, 96–7, 99–102, 114,
 115–16, 121, 125–6, 135,
 159n2
artist figure, 2–3, 4, 5, 17–18, 24, 60,
 65, 74–5, 131–5, 155n2
 as aesthete, *see* aesthete
 as consumer, 5, 17–18, 24, 60, 65,
 155n2, *see also* Huysmans, J.-K.
 as dandy, *see* dandy
 as elitist taster, *see* Huysmans, J.-K.
 as flâneur, *see* flâneur
 as impressionistic critic, *see*
 impressionistic critic or
 criticism; Pater, Walter; Silva,
 José Asunción; Wilde, Oscar
 as producer, 5, 17–18, 24, 60,
 74–5, 141
 as worker, 2–3, 4, 74–5, 131–5,
 155n2, *see also* Darío, Rubén;
 Silva, José Asunción

Balzac, Honoré de, 110, 111–12,
 115, 156n2
Baudelaire, Charles 1–4, 21, 88–9,
 95, 103, 111–12, 115, 116,
 122, 131, 136, 140, 144n2,
 144–5n3, 145n4, 151n12,
 154n1
 "Loss of a Halo," 1–4, 21, 144n2
 The Painter of Modern Life, 88–9,
 95, 111–12, 115
Beckman, Ericka, 151n13, 152–3n19
Beddow, Michael, 109, 114

Bell-Villada, Gene H. 12–13, 58, 59,
 138, 139, 140, 144n3, 146n7
Benjamin, Walter, 3–4, 131
 "On Some Motifs in Baudelaire," 3
 Baudelaire's "Loss of Halo," 3
 poet as supernumerary, 3
 "The Paris of the Second Empire,"
 131
 "The Work of Art in the Age of
 Mechanical Production," 3–4
 art based on politics, 4
 art based on ritual, 4
 art for art's sake as "pure art," 4
 loss of aura, 3–4
Berman, Marshall, 144n2
Bernabé, Mónica, 159n2
Bielsa, Esperança, 132, 159n3
Blanco Aguinaga, Carlos, 14, 74–5,
 146n9
Brown, Julia Prewitt, 11
Brummell, George Bryan, 87–8,
 111, 113, 156n2, *see also*
 d'Aurevilly, Barbey
Bürger, Peter, 8–10
 aestheticism v. the avant-garde,
 8–10
 social ineffectuality of
 aestheticism, 9–10
 Theory of the Avant-Garde, 8–10
Burton, Richard D. E., 88

Carter, Boyd C., 124
Casal, Julián del, 15–16, 20, 82,
 83–4, 88–9, 115–18, 121–3,
 129–31, 133, 136, 137, 141,
 146n8, 154–5n1
 "Art," 137
 as chronicler and journalist, 20,
 89, 131–5, 141
 dandy as subject matter, 116–18,
 134–5, 141
 dandy defined, 117–18
 flâneur as narrative persona, 123,
 129–31, 134–5, 141
 flâneur as subject matter, 121–3,
 134–5, 141

Casal, Julián del – *continued*
 "In the Country," 129
 "The Last Illusion," 121–3
 "The Phoenix," 129–31
 pseudonyms, 123, 129, 134, 135
 Hernani, 123, 129–31
 Alceste, 123
 Conde de Camors, 123
 "The Slaughterhouse," 129–30
 "To a Critic," 137
 "To Beauty," 131, 137
Child, Ruth C., 148n9
Chronicle, *see modernismo,* Spanish
 American, chronicle as
 modernista genre
Cobb, Carl W., 149n2
Coblence, Françoise, 111
Comfort, Kelly 11–12, 145–6n6
 dehumanization v.
 rehumanization of art, 11–12,
 145–6n6
commodity, *see* art, as commodity
Cooper, John Xiros, 153n1
creative critic, *see* impressionistic
 critic or criticism

dandy, 5, 7, 19–20, 87–9, 91–106,
 109, 110–14, 115–19, 125,
 126, 132, 134, 154n1,
 156–7n3, 157n4, 159n2,
 see also aesthete, art for art's
 sake v. life for art's sake;
 Mann, Thomas; Wilde, Oscar
 alternative to traditional artist
 figure, 19, 88, 91, 104
 artistic life, 19–20, 88, 91, 94, 101,
 115, 118, 126
 artist of the self or self-
 aestheticization, 19–20, 87–8,
 91–3, 96, 101, 103, 104, 110,
 114, 115, 118, 156–7n3
 characteristics of dandy figure,
 94–95, 117–18
 elitism, 7, 20, 88, 89, 91, 95, 117
 importance of beauty and
 pleasure, 7, 88, 94–5

in Spanish American *modernista*
 chronicle, 20, 88, 115–19,
 125, 126, 132, 134–5
 performativity of, 19–20, 106
 refinement of, 20, 88, 89, 94, 117,
 118, 125
 social status of, 19–20, 91, 94,
 109, 111–12, 113, 117, 125
 solipsism of, 7, 88, 92
Danson, Lawrence, 147–8n5
Darío, Ruben 16, 18–19, 56, 59–60,
 73–85, 120, 136, 138, 141,
 146n8, 151n14, 154–5n1,
 155n2, 155n3, 155n4,
 155–6n5, 159n2, *see also*
 art for art's sake v. art for
 money's sake or art for the
 market's sake
 art as unsold and unappreciated,
 not commodity, 18–19, 60,
 73–4, 79–81, 83–5, 141
 artist as creator, not producer,
 18–19, 59–60, 73–5, 79–81,
 83–5, 141
 "The Blue Bird," 18, 56, 60, 73,
 78–80, 81, 83–5, 120, 141,
 155n2
 "The Bourgeois King," 18, 56, 60,
 73, 74–8, 79, 80, 83–5, 120,
 141, 155n2
 elitist Element in Art, 60–1, 74,
 78, 79, 155n3
 History of My Books, 77
 "I Pursue a Form," 136
 "Nocturne," 81
 notion of dandy figure, 159n2
 "Queen Mab's Veil," 18, 60, 73,
 80–2, 83–5, 120, 141, 155n2,
 155n4
 "Preliminary Words," 83
 problem of poet and poetry, 73,
 74–5, 83, 84–5
 social critique, 73, 74, 84–5,
 155n3
 Songs of Life and Hope, 78
Darrigrandi, Claudia, 159n2

d'Aurevilly, Barbey, 87–8, 103,
111, 113, 115, 122, 151n12,
154n1, 156n2
dehumanization of art, 8, 11–12,
145–6n6, *see also* Comfort,
Kelly; Ortega y Gasset, José
Denisoff, Dennis, 146n7
Díaz Rinks, Gloria, 46
Downing, Eric, 110, 112, 113,
157n6, 157–8n8
Dowling, Linda, 147n2

Elmore, Peter, 47–4, 150n9

Felski, Rita, 103, 146n7, 154n2
Flanagan Behrendt, Patricia, 147n4
Fillin-Yeh, Susan, 111
flânerie, *see* flâneur
flâneur, 5, 19–20, 87–9, 115–16,
119–32, 134–5, 162n15, *see
also* art for art's sake v. life for
art's sake; Casal, Julián del;
Gutiérrez Nájera, Manuel
free and idle, 20, 89, 124, 125
in Spanish American *modernista*
chronicle, 20, 88–9, 115–16,
119–31, 132, 134–5
Paris as flâneur's city, 120–3, 131
world as art, 115, 120–1, 122, 125,
126, 135
Fox, Paul, 69

Garelick, Rhonda, 103, 111,
157n5
Gautier, Theophile, 34–5, 38, 44,
140, 144–5n3, 148n10,
151n16
criticism of the critics, 34–5, 38
"Preface" to *Mademoiselle de
Maupin*, 34–5, 38, 44
Ghiano, Juan Carlos, 149n5
Glick, Elisa, 103, 111
Gónzalez, Aníbal, 15–16, 131,
133, 137, 139, 143, 146n8,
150n10, 151n15, 158–9n1,
159n3

Gold, Barri J., 101
Guérard, Albert, 8
Gutiérrez, José Ismael, 132, 133,
159n3
Gutiérrez Giradot, Rafael, 85,
152n17
Gutiérrez Nájera, Manuel, 13, 15–16,
20, 88–9, 115–16, 118–21,
123–9, 131–5, 136, 141,
146n8, 161n8
"Art and Materialism," 13
as chronicler and journalist, 20,
89, 131–5, 141
"The Child of the Air," 128
"Christmas Masses," 124
dandy as subject matter, 118–19,
134–5, 141
flâneur as narrative persona,
123–9, 134–5, 141
flâneur as subject matter, 119–21,
134–5, 141
"The Friend," 125
"The Morning of St. John's Day,"
128
'My Last Article," 132–3
"The Novel of the Streetcar,"
125–9
art v. Life, 127–9
ethical v. aesthetic, 127–9
"On the Street," 124–5
"The Protection of Literature,"
133–4
pseudonyms, 123–4, 134, 135,
161n8
El Duque Job, 123–4
Monsieur Can-Can, 123, 124
Pomponnet, 123, 124
"Stora and the Parisian Stockings,"
119–21
"Things of the World," 118–19

Harris, Wendell V., 148n9, 149n11
Harvey, David, 89, 144n2
Hazera, Lydia, D., 44, 46
Hinterhäuser, Hans, 46, 110, 111
Huart, Louis, 115

Huysmans, J.-K., 18–19, 59–60,
 63–72, 74, 76, 97–8, 101, 115,
 122, 136, 141, 146–7n1,
 149–50n7, 151n12, 154n1,
 154n2, 154–5n1, 155n2
 Against Nature, 18–19, 59–60,
 63–72, 74, 76, 97–8, 115,
 146–7n1, 149–50n7, 151n12,
 154–5n1, 155n2
 art as unconsumed and
 unprofaned, 18–19, 59–60,
 63–4, 68, 70
 artifice over nature, 67, 68, 71
 artist as elitist taster, 18–19, 60–1,
 63, 66, 67, 69, 70–1
 consumption of art, 18–19, 59, 60,
 63–4, 66–7, 69, 70, 72, 74
 Des Esseintes, 18–19, 60, 63–72, 76,
 98, 101, 115, 154n2, 155n2
 as artist figure, 66
 aesthetic experimentation,
 67–70
 commodity fetishism, 70, 72
 contemplative power, 68, 71
 isolation of, 65, 68, 70, 71
 search for newness, 69, 70

impressionistic critic or criticism, 5,
 16–17, 23–4, 32, 36–40, 41–6,
 49, 54–5, 74, 141, 148n8,
 148n9, 149n6, 149–50n7,
 152n18, *see also* Pater, Walter;
 Silva, José Asunción; Wilde,
 Oscar
 as form of artistic recycling, 17,
 24, 46, 49, 54–5, 149–50n7

Jaramillo-Zuluagam Eduardo, 160n4
Jiménez, José Olivio, 138
Jiménez Panesso, David, 149n6
Johnson, R. V. 6–7, 87
Jones, Robert A., 158n9
Jrade, Cathy, 155n3, 155–6n5

Karl, Alissa G., 153n1
Keefe, Robert, 97–8

Kirkpatrick, Gwen, 14, 15, 143
Knapp, Bettina L., 66, 70, 71

l'art pour l'art, see aestheticism
Lloyd, Christopher, 71
Loesberg, Jonathan, 146n7
Loveluck, Juan, 47

Mangianiello, Dominic, 102
Mann, Thomas, 19–20, 87, 91,
 104–114, 136, 141, 156n1,
 156–7n3, 157n6, 157n7,
 157–8n8, 158n9, 158n10
 *Confessions of Felix Krull:
 Confidence Man (The Early
 Years)*, 19–20, 87, 91–2,
 104–14, 156n1, 156–7n3,
 157n6, 157n7, 157–8n8,
 158n9, 158n10
 Felix as artist of self, 19–20, 87,
 92, 104–8, 110, 114, 156–7n3
 Felix as dandy-aesthete, 19–20,
 87, 92, 104, 106, 110, 113–14,
 156–7n3
 Felix as narrator, 112–13,
 157n6, 157–8n8, 158n9
 Felix as memoir writer, 112,
 157–8n8
 Felix as performer, 106–8, 111,
 114, 157–8n8
 Felix as social climber, 104, 106,
 109, 110, 111, 113–14
 Felix and relationship to
 work, 104, 107, 109, 110,
 156–7n3
 value of transitoriness, 108–9
Mapes, E. K., 123, 134, 161n8
Martí, José, 15
Marx, Karl, 3
 Capital, 70
 commodity fetishism, 70
 The Communist Manifesto, 3
 poet as wage-laborer, 3
 role of the writer under
 capitalism, 3, 58
 Theories of Surplus Value, 58

Mazlish, Bruce, 162n15
Miller, Daniel, 66–7
modernismo, Spanish American,
 4–5, 12–16, 20–21, 52, 57–8,
 73, 74, 89, 115, 116, 141–3,
 145n4, 146n8, 153n2, 160n4
 art for art's sake philosophy, 5,
 12–13, 16, 20–1, 52, 56, 57,
 58, 61, 73, 74, 82, 128, 137,
 141–3, 145n4, 146n8, 150n8
 as engaged art, 14–16, 73, 139,
 142–3
 as escapist art, 13–14, 15, 139,
 142–3
 as periphery, not center, 20, 52,
 89, 116, 119, 132, 134–5,
 142–3, 160n4
 chronicle as *modernista* genre, 15,
 20, 88–9, 115, 116, 131–5,
 158–9n1, 159n3
 content v. form, 136–9
 importance of the aesthetic 13–14,
 142
 importance of artistic autonomy,
 13, 14, 142
 importance of beauty, 13, 142
 parallels with aestheticism,
 see modernismo, Spanish
 American, art for art's sake
 philosophy
 poetry, lack of salability, 59,
 139–40, 153n2, *see also*
 aesthetic value v. commodity
 form of value
 poetry v. prose, 59, 75, 84–5,
 136–41, 143, 146n8, 153n2
 rejection of realism in art, 13, 142
 rejection of utilitarianism in art,
 13, 142
 relationship to modernization, 20,
 89, 132, 134–5, 143, 153n2,
 160n4
 social critique in, 12–13, 15–16,
 61, 73, 84–5, 139, 143
Moers, Ellen, 103, 111
Molloy, Sylvia, 14, 160–1n4

Monsiváis, Carlos, 132
Montaldo, Graciela, 13–14, 145n4,
 155–6n5

Neira Palacio, Edison, 160n4
Nervo, Amado, 133
Nelson, Donald F., 157–8n8
Nietzsche, Friedrich, 104–6, 108, 114
 The Gay Science, 104–6, 108
 "Brief Habits," 108
 "On the problem of the actor,"
 104–6
 to "give style," 105–6

Ohi, Kevin, 146n7
Ojala, Aatos, 30
Olsen, Robert C., 6
Ortega y Gasset, José, 11, 145–6n6
 The Dehumanization of Art, 11,
 145–6n6
Oviedo, José Miguel, 146n8

Parkhurst Ferguson, Priscilla, 72, 127
Pater, Walter, 32, 36–7, 38–9,
 43, 51, 136, 144–5n3,
 148n9, 148n10, *see also*
 impressionistic critic or
 criticism; Wilde, Oscar
 artistic temperament, 37
 beauty as relative, 36
 in Wilde, 37, 38
 knowing one's impression of art,
 32, 36
 *The Renaissance: Studies in Art and
 Poetry*, 32, 36–7, 43, 51
 "Plato and Platonism," 38
Peluffo, Ana, 159n2
Pérez Galdós, Benito, 125
Picon Garfield, Evelyn, 52
Plato, 25, 26–30, 31, 35–6, 39–40,
 146–7n1, 147n3, 147n4,
 147–8n5, 148n6, 148n8,
 148n10, 150n10
 art as copy of a copy, 28, 29,
 148n6
 artist's distance from truth, 27–9

Plato – *continued*
 element of contagion in art, 29,
 148n6
 noble lie, 26–7
 on art criticism and the critical
 spirit, 35–6, 40
 The Republic, 25, 26–30, 31, 35–6,
 39–40, 146–7n1, 148n6,
 148n8
 The Symposium, 47, 150n10
 three levels of creators, 27, 29
Prewitt Brown, Julia, 148n10
producer, *see* artist figure, as
 producer

Rama, Ángel, 84–5, 152n17, 153n2
Ramos, Julio, 159n3
Rawlings, Peter, 148n9
rehumanization of art, 11–12,
 see also Comfort, Kelly; Ortega
 y Gasset, José
Robillard, Douglas, Jr., 101

Salvador, Álvaro, 138
Schanzer, George O., 46
Shewan, Rodney, 40
Shrimpton, Nicholas, 8, 144–5n3,
 146n7
Silva, José Asunción, 1–4, 15–17, 21,
 23–4, 41–6, 74, 76, 79, 115,
 136–7, 141, 146n8, 146–7n1,
 149n2, 149n5, 149n6,
 149–50n7, 150n8, 150n9,
 150n10, 150–1n11, 151n12,
 151n14, 151n15, 152n17,
 152n18, 152–3n19,
 154–5n1, 160–1n4, *see also*
 impressionistic critic or
 criticism
 After-Dinner Conversation, 16–17,
 23–2, 41–56, 74, 76, 115,
 149n2, 149n6, 149–50n7,
 150n8, 150n9, 150n10,
 152n18
 artistic production v. capitalist
 production, 52, 152–3n19

 art v. life, 45, 51, 53, 56, 150n8,
 152–3n19
 Bashkirsteff, María, 45–6, 150n8
 British Romanticism, 41
 English Arts and Crafts
 Movement, 41, 51–2
 figure of Helen, 44, 46–52,
 150–1n11
 as art object or artistic creation,
 49–51
 as fictional construct, 46–7, 49
 comparisons to Dante's Beatrice,
 46–7, 49, 150n9
 comparisons to Plato's Diotima,
 46–7
 in pictorial images, 47–9
 image of Ophelia, 45, 48–9
 José Fernández, 24, 41–56, 74,
 76, 79, 115, 149n5, 149n6,
 150n8, 150n9
 as dandy-aesthete, 41, 51,
 160–1n4
 as flâneur, 160n4
 as impressionistic critic, 41, 42,
 43, 44–6, 49, 51–4, 74, 149n6,
 152n18
 on "hard work," 52
 refusal to publish work, 24, 41,
 44, 52, 53, 79
 rejection of label of poet, 43,
 44, 54, 56
 lack of public for artist, 43–4, 53
 Nordau, Max, 45, 150n8
 on art as raw material, not
 consumer good, 41, 45–6, 54–5
 Pre-Raphaelites, 41, 48–9, 56,
 146–7n1, 150n9
 protesting commodification of art,
 41, 49, 53–6, 150n9
 protesting consumption of art, 41,
 49, 53–6, 150n9
 reader as artist, 43–4, 45, 56,
 149n6, 152n18
 relationship to British
 Aestheticism, 42, 51, 53,
 152n18

relationship to Oscar Wilde, 41,
42, 43, 44, 45, 51, 53, 55, 56,
146–7n1, 152n18
relationship to Walter Pater, 43,
51, 152n18
Villa Helena, 44, 51–2, 151n12
"The Muse's Protest," 1–4, 21, 79,
151n14
art as commodity, 1–3
poet as profit seeker, 1–3
poet as wage laborer, 1–3
"Nocturno" poems, 150–1n11
"A Poem," 43–4, 136–7
Stanton, Domna C., 53, 54, 69
Stray, Christopher, 147n2
Sturgis, Matthew, 27, 148n10
Swenson, Eric J., 65
Szmetan, Ricardo, 73, 155n3

Tester, Keith, 88
Todd, Jeffrey D. 10–11, 30, 148n7
weak aestheticism, 10–11, 148n7
strong aestheticism, 10–11, 30,
148n7

Villanueva-Collado, Alfredo,
152n18
Villarreal Vásquez, Luis José,
151n15

Washbourne, Kelly, 141–2
Watson, Edward A., 148n8
Wilde, Oscar, 16–17, 23, 24–40,
42–3, 45, 51, 52, 53, 55, 56,
87, 91–104, 111, 112–13,
115, 136, 144–5n3, 145n4,
146–7n1, 147n3, 147n4,
147–8n5, 148n8, 148n9,
148n10, 149n2, 149n5,
149–150n7, 156n2, 156n3,
see also impressionistic critic
or criticism; Pater, Walter;
Silva, José Asunción
"The Critic as Artist" 16–17, 23,
25–6, 31–40, 43, 51, 53, 56,
147–8n5, 148n8, 149n2

"The Decay of Lying" 16–17,
23, 25–30, 39, 40, 147–8n5,
149n2
ethical v. aesthetic in art, 31–3, 40
natural v. artificial in art, 30, 40
on aestheticization of social and
natural world, 25, 27, 28–9,
30, 31, 34, 38, 40, 149n2
on amoral art, 27, 31, 33, 40, 56
on anti-mimetic art, 27, 28, 33,
38, 40, 56
on anti-realist art, 27, 28, 30, 33,
38, 40
on Aristotle, 25–6, 28, 29, 31–4,
39, 40, 146–7n1
on artistic receptor or aesthetic
reception, 25, 26, 29, 31–2,
37, 38, 53, 55, 56, 148n10,
see also impressionistic critic
or criticism
on lying in art, 25–7, 34, 40
on Pater, Walter, 37, 38
on Plato, 25–30, 39, 40, 146–7n1
on role of art critic or critical
faculty, 34, 36–40, 51, 53, 55,
56, *see also* impressionistic
critic or criticism
The Picture of Dorian Gray, 19, 87,
91–104, 111, 112–13, 115,
149n2, 149–50n7, 156n2
art v. life, 92–3, 96, 149n2,
156n2
Basil Hallward, 92–3, 99, 102–3
danger and problem of
influence, 98–101, 103
Dorian Gray as false or failed
dandy or aesthete, 19, 92,
94–104, 111, 112–13, 115,
156n2
Lord Henry as successful dandy
and aesthete, 19, 92, 93, 94–8,
102, 104, 113, 115, 156n2,
156n3
role and function of the
portrait, 102–3
Sibyl Vane, 92–3

Wilde, Oscar – *continued*
 "Pen, Pencil and Poison," 100
 "The Portrait of Mr. W. H.," 30–1
 "Preface" to *The Picture of Dorian Gray*, 38
 "The Soul of Man under Socialism," 31

Williams, Rosalind H., 55, 64, 65, 69–71, 153–4n3, 155n2
Wohlfarth, Irving, 144n2

Zuleta, Ignacio, 14, 145n4